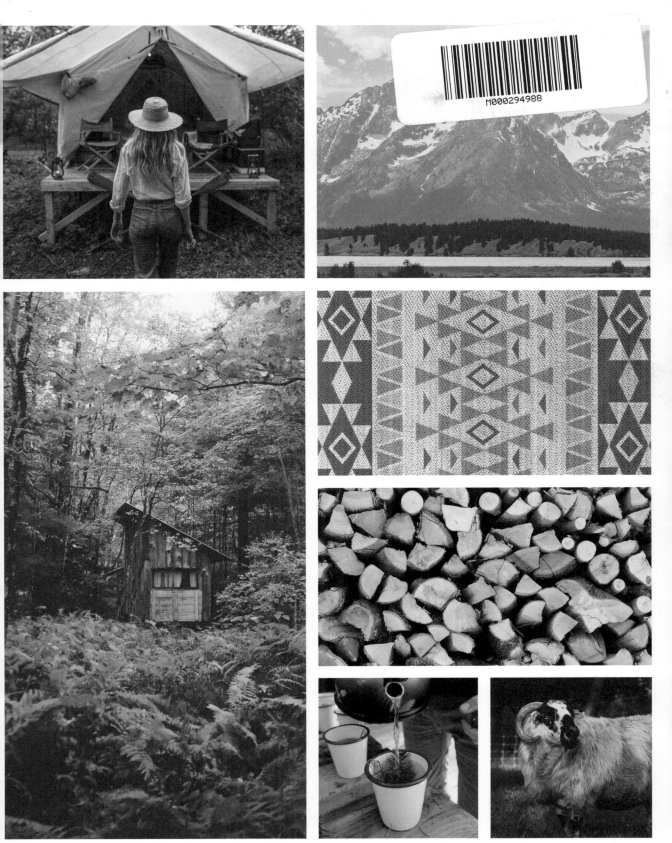

FARM + LAND'S
BACK TO THE LAND

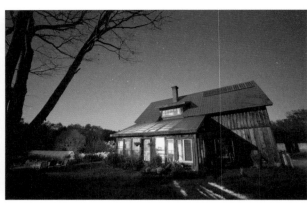
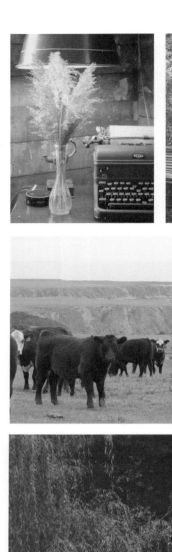

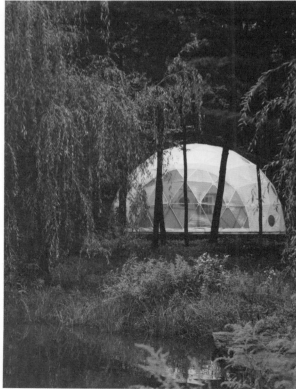
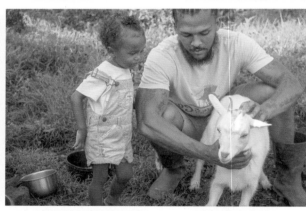

FARM + LAND'S
BACK TO THE LAND

A Guide to Modern Outdoor Life

Frederick Pikovsky

and Nicole Caldwell

CHRONICLE BOOKS

SAN FRANCISCO

Pages 271–72 constitute a continuation of the copyright page.

Library of Congress Cataloging-in-Publication Data available.

ISBN 978-1-4521-7333-7

Manufactured in China.

MIX
Paper from
responsible sources
FSC™ C008047

Design by Sara Schneider and Frederick Pikovsky.
Written contributions from Meghan Caracci.
Illustrations by Lucy Engelman.

Note: check local building codes and permit requirements before beginning a project.

10 9 8 7 6 5 4 3 2 1

Chronicle Books LLC
680 Second Street
San Francisco, CA 94107
www.chroniclebooks.com

Dedicated to all the craftsmen, local farmers, conservationists, and incredible people we met in the making of this book. You are an inspiration and a catalyst for those who will go on to protect and steward this earth for many generations to come.

CONTENTS

INTRODUCTION:
A RETURN TO THE LAND

Before I founded FARM + LAND, I'd spent eight years grinding away in New York City, hustling to build an ambitious start-up company. From the moment I woke up to the time I went to sleep, you could find me pacing around office buildings and boardrooms on my cell phone or sitting in front of my laptop for hours on end. I was obsessed with work and thrived on the frantic pace of the city; it kept me going and normalized the chaos.

But eventually, I burned out. I grew dissatisfied with sitting in front of my laptop all day. I began to spend more time looking through romantic images of beautifully crafted cabins, farm-table dinners inside rustic barns, and campfires in the woods. I was drawn to the idea of a slower pace of life, and envied those who took the time to craft meals from their own garden and gather with friends around a firepit beneath starry skies.

A DISCONNECT

As I grew more detached from my work and intrigued by a change in lifestyle, I decided it was time to escape the daily routine and head out on a summer-long backpacking adventure in the hopes it could provide me with a fresh perspective. It was on that trip that I had my epiphany, as I found myself hiking through mind-blowing scenery in the Jungfrau region of the Swiss Alps, surrounded by massive mountain peaks and rolling grassy hills with herds of cows roaming freely in the bracing fresh air. I watched as the cows munched on fields of organic greens and sipped water from mountain springs. These cows, with their smug-looking faces. It was like they were saying, "Yep, we got this all figured out." And for a moment, I was genuinely envious of their lifestyle. It was simple, yet incredibly fulfilling and sensible to be living among the beauty and abundance of the natural resources around us.

I continued my hike, approaching a wild vegetable garden in the meadow. I felt daring and plucked a sprig of green onion from the soil. I was struck with excitement as I chewed on the spicy greens, as if I were the first person to ever discover that onions were a thing that grew out of the dirt.

That was the precise moment I realized how disconnected I had become from the very basics—the essentials of what it means to be part of the natural world and how fulfilling it

is to engage our primal senses in the outdoors. This personal discovery was a reflection of a broader phenomenon in our society. Many of us are so caught up in the frenetic pace of modern life that we haven't even noticed what we've been missing.

A MODERN BACK-TO-THE-LAND MOVEMENT

In the late 1960s, urban and suburban life in America was fueled by a movement back to the land. It was a time of rapid growth in industrialization, consumerism, and political tensions, from the civil rights movement to the Vietnam War. In an act of rebelliousness, many counterculturists (hippies) decided to disconnect from society and reconnect with a simpler life in nature. Eager to get back to a more intentional way of living, "back-to-the-landers" bought up plots of land all over the country, armed with the *Whole Earth Catalog*'s instructions and resources for a DIY lifestyle off the grid.

Eventually, the realities of relying on their own crops and local resources for survival, combined with the difficulties of maintaining shelter from the elements, became more of a challenge than most were prepared for. Many abandoned the lifestyle and headed back to the comforts of town and city life.

Now, a half-century later, a contemporary version of getting back to the land is stirring up. With the ingredients of polarizing politics, environmental distress, and technology inducing an exponentially faster pace of life, the stage has been set for a movement back to the land—one that is inspiring more people to consciously slow down and realize that to do better for ourselves globally, we must start locally. Unlike the back-to-the-land movement of the 1960s, this generation has the world's wealth of knowledge available at our fingertips, the growing ability to work remotely, and creature comforts that make it altogether possible to live and work from just about anywhere on the planet. Today's movement is already taking on many different shapes—reviving, replanting, repopulating—making a lifestyle back on the land more accessible, practical, and sustainable for our generation and many to come.

You'll discover a range of experiences and approaches in these pages—from a family that abandoned urban life to raise their children in a canvas tent to a group of friends that transformed a rundown piece of property into a fly-fishing destination.

MY FARM + LAND JOURNEY

Over the past two years, I've traveled around the United States, from mountainside to countryside to desert lands, meeting incredibly inspiring people who have chosen to find their own path back to nature. I've slept in cabins deep in the mountains, bathing in rivers and hanging out with cabin builders dedicated to crafting incredible structures in the wilderness. I've stayed in barns with local farmers, learning about sustainable agricultural practices. I've slept in funky off-the-grid desert homes, in casitas with chefs committed to foraging their own ingredients for intimate supper club dinners, and with city dwellers who have found a balance of city life during the week while constructing a weekend escape paradise to enjoy with their tribe of friends.

Along the way, I met Nicole Caldwell, an incredibly passionate journalist who left New York City to take over a farm her uncle left

behind in upstate New York. Together, we have curated a collection of inspirational stories, perspectives, and knowledge on what I call a FARM + LAND lifestyle.

YOUR FARM + LAND JOURNEY

We hope this book serves as a catalyst for more people to discover their place in the outdoors, to reconnect with the land and everything it has to offer. We take you on a journey deep into the mountains, countryside, and desert to reveal the ways people are getting back to nature—from modern cabins to rustic farmhouses and cozy handcrafted yurts—mastering the methods, tools, and skills necessary to build shelter, grow food, and thrive in the great outdoors.

Whether you're looking for inspiration for a weekend escape from city life, an impetus for an outdoor adventure, or the nudge you've been waiting for to take your life off the grid, FARM + LAND is here to guide you back to the land.

Frederick Pikovsky
Cofounder of FARM + LAND

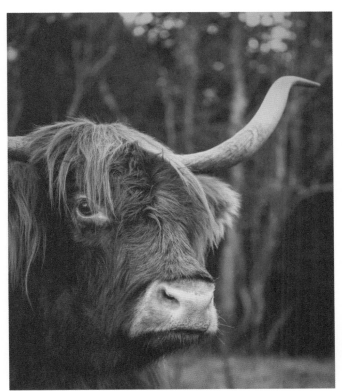

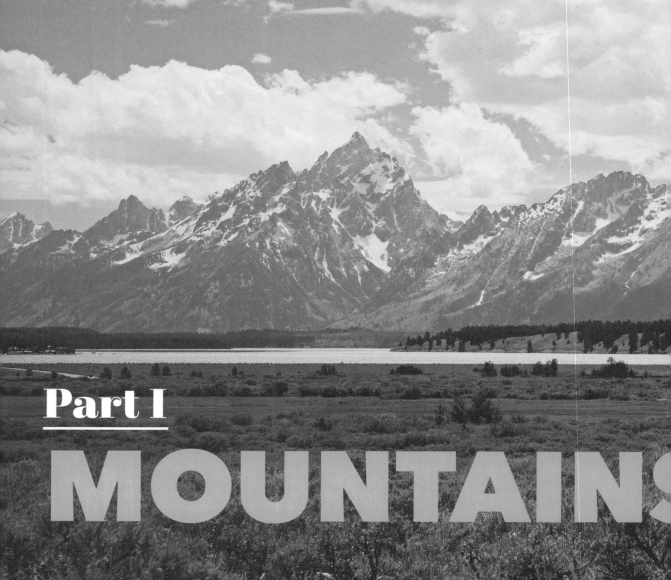

Part I

MOUNTAINS

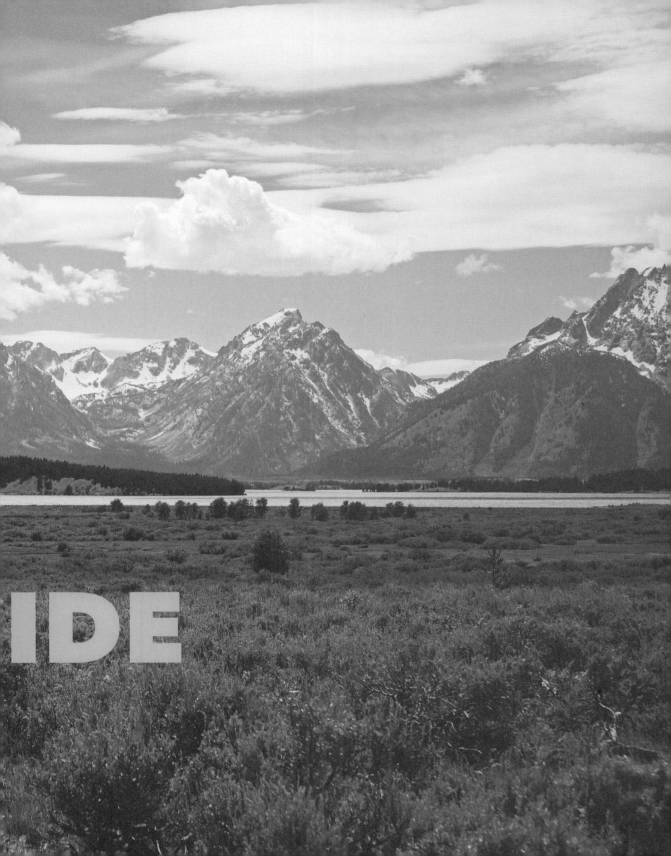

Inspiration

Dwellings

Provisions

Essentials

But in every walk with Nature one receives far more than he seeks.
—John Muir

When a hurried life begins to feel untamable, we often find solace in the thought of a cozy mountainside cabin in the woods. The mountains replenish us with a sense of calm, while awakening a primitive sensibility to build fires and cook over open flames, sitting in circles with our tribe, forming deeper bonds in the wilderness solitude.

A modern renaissance is underway, driven by young craftspeople, artisans, and farmers who are forming new bands of inspiring collaborative communities and bringing us back to the outdoors. They are reviving past practices with touches of modernism, making the natural world more accessible to all.

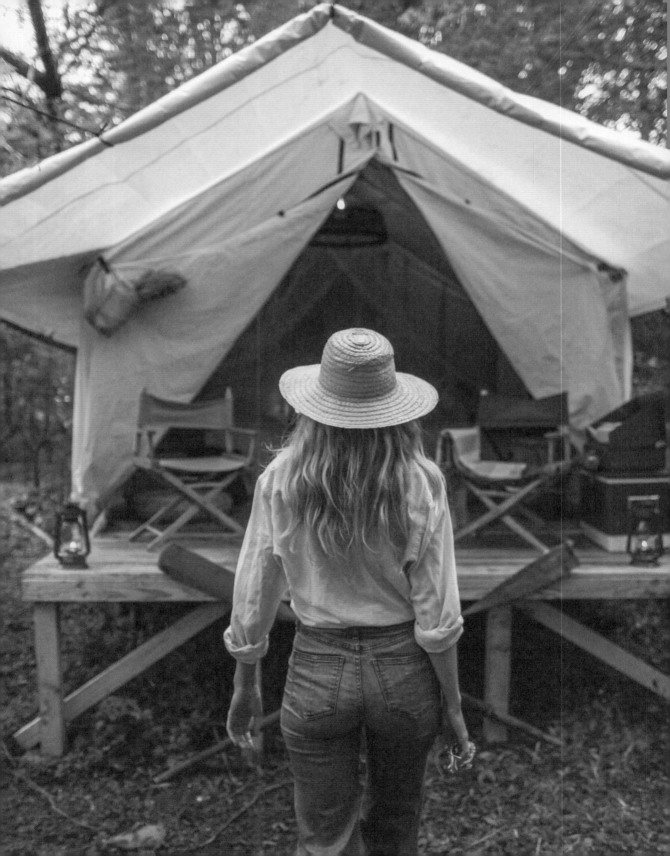

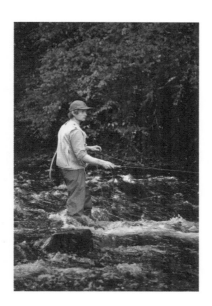

THE FLY FISHING CLUB: LIVINGSTON MANOR

Livingston Manor, New York

To fly-fish is to stay poised, standing patiently, constantly re-draping your line over the water, waiting for a bite. The experience is an opportunity to get outside—to contemplate, to escape from the rigors of everyday life. Fly-fishing forces a person to adopt a slower way of being.

The sport immerses you in nature and all its meditative qualities. The strategy—and the kinship surrounding it—has inspired many fly-fishing clubs throughout Britain and the United States over the last two centuries. And it inspired the Livingston Manor Fly Fishing Club (not an actual club, at least in the traditional sense) to adopt the practice of fly-fishing as a course of camaraderie.

Livingston Manor is a 1,200-person town a couple of hours northwest of New York City. A sign reading "Small Town, Big Back Yard" welcomes you. Just a few blocks from the town center sits the Livingston Manor Fly Fishing Club. The hidden 5-acre (2-hectare) property runs along the banks of Willowemoc Creek, a tributary of Beaver Kill River, historically one of the world's most popular trout-fishing streams. The club's riverfront property comprises two homes full of donated furniture and curbside finds, generating an eclectic vibe.

The trio behind all this—Tom Roberts, Anna Aberg, and Mikael Larsson—are Manhattan transplants who share a common goal: to get themselves and their city-dwelling friends outside.

DRAW OF THE BIG CITY

Tom Roberts grew up in the United Kingdom. His hometown was far from any major city center, and he had constant access to the outdoors. As an adult, he made a living in London working in marketing for a well-known liquor brand. Though he didn't enjoy office culture, he'd already tried other forms of work and found it hard to put down roots. "When I started working, I explored a few avenues before going to London to see if I could do something besides working in an office," he said. "I was working on sailboats for a while, but that's a tough thing when you turn a hobby into a living. It was an extremely nomadic lifestyle that made it difficult to feel at home anywhere."

A few years later, Tom was offered a position that required relocating to New York City. "It was the kind of promotion I could not turn down, but the bright lights of the city did not hold as much draw for me as they would for most. I thought, *Well, I'll do it for a year.* But I got to New York City and became fascinated by and addicted to the mentality of the people there, how easy it was to make friends, and

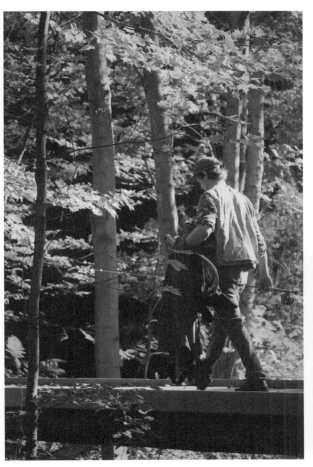

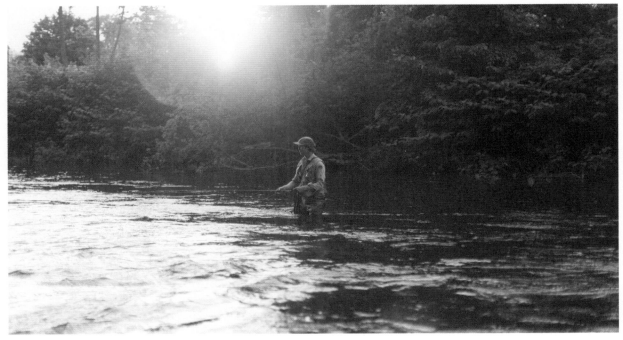

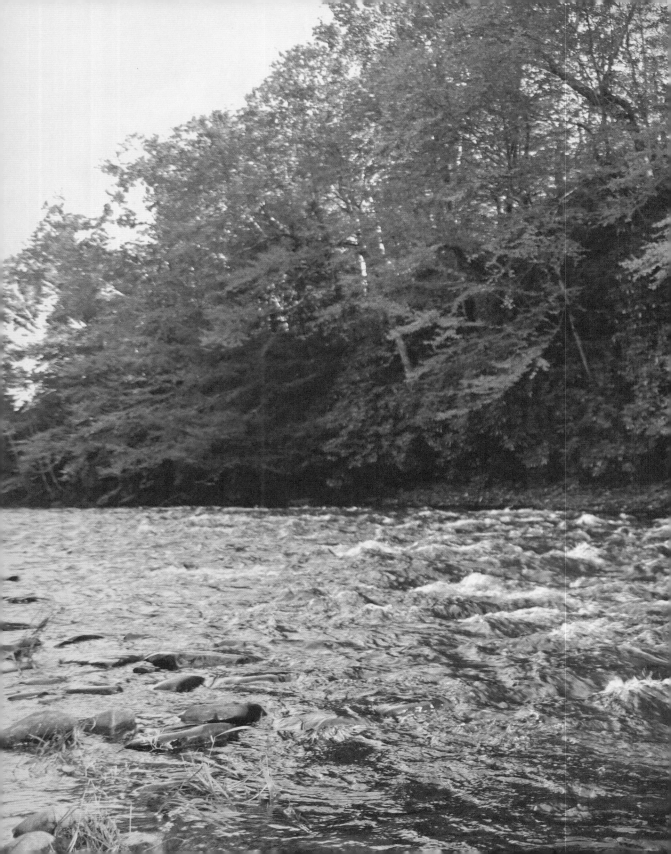

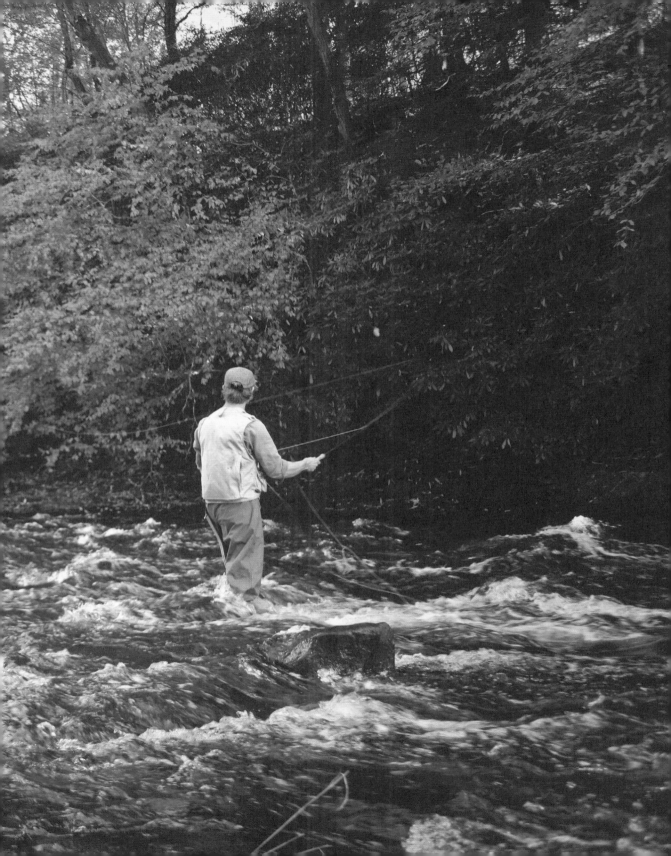

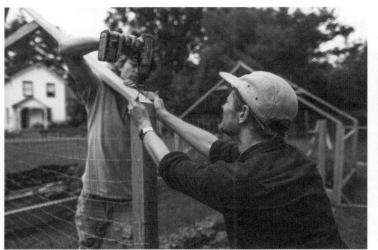

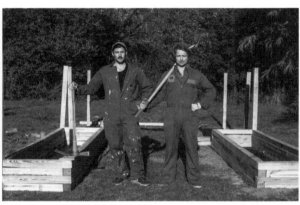
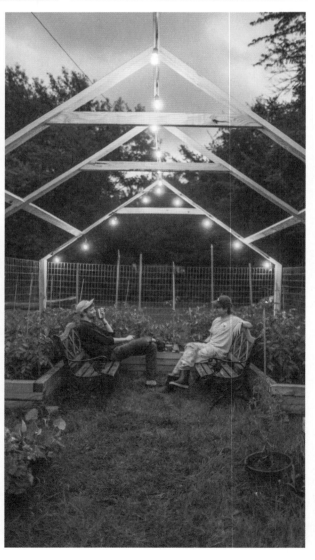
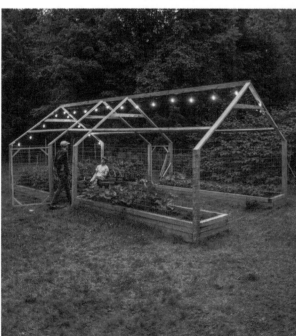

the positive mentality of following crazy dreams. I think that fueled my time in the city for way longer than I ever expected. I was there for six or seven years."

"And one day he called me and said, 'Let's go fly-fishing.'"

With each passing year, Tom sought more opportunities for escape. "My first protocol was going out to the ocean," he said. "I would go out to Montauk and Rockaway Beach and go surfing. I had a friend who had a car—a rare thing in New York City—and we would go together on a Friday and wake up Saturday morning with a sense of self-loathing, like the weekend was already slipping away from us," Tom said. "And one day he called me and said, 'Let's go fly-fishing.'"

Tom had grown up fly-fishing alongside his brother, father, and grandfather, but hadn't practiced the sport since leaving his hometown in England. And since then, Tom had come to realize that fly-fishing back in England was a somewhat pretentious sport. "It was always kind of an elitist, exclusive activity reserved for the upper class," he said.

TAKING THE LEAP

Nevertheless, in his quest to find outlets for adventure away from the city, Tom joined his friend on a trip to Roscoe, New York (a town just over from Livingston Manor), for his first fly-fishing trip in years. "The fishing was great," Tom said, "and anyone can go fly-fishing up there with a $15 license. This sport I had considered to be highly elitist in

the United Kingdom was accessible to many people here, and there were all sorts of people on the river. The whole process of fly-fishing was this meditative thing. I wasn't going out on the river to hunt fish; I was going out to the river to slow down and get closer to nature.

"We were doing this more steadily every weekend, and this one weekend in particular, we stayed in a kind of glamping spot. While sitting around the campfire with Anna (then my girlfriend, now my wife) and our friend Mikael, we got to talking about how much we loved it up here. We realized there wasn't much standing in our way from taking the leap to getting our own place on the weekends that we could bring our friends up to," he said.

From there, a search for property ended in Livingston Manor, where they found two houses that were total wrecks along a riverbank. Tom said, "This area is known as the Land of Little Rivers. It seems like the march of agriculture and civilization has tamed so much of the planet, but here it feels like a truly wild outpost."

"I wasn't going out on the river to hunt fish; I was going out to the river to slow down and get closer to nature."

Tom explained, "The river we're on is one of the few on the East Coast that flows from source to sea, uninterrupted by dams. This creates exceptionally clean water and a superior ecological integrity that hosts wildlife in abundance. It's an increasingly rare glimpse

at what natural abundance and balance looks like." Although their newly acquired homes were in rough shape, "We figured the river was enchanting enough," he said.

THE CLUBHOUSE

"Initially, the idea was to just own a house that doesn't own you—get something cheap, commercialize it to a degree, but don't work harder in the city to maintain it. Go up and enjoy it, but don't feel stressed when bills come around," Tom said.

They set about creating an identity for the space they'd found. "And that's where the name 'Livingston Manor Fly Fishing Club' came from," he said. "The river we were on was just a few miles upstream from where George LaBranche cast the first dry fly in 1891, starting the practice of fly-fishing in the United States. It's a heritage that we wanted to honor in our own way. We also loved this little mountain town and wanted more people to know about it. So connecting 'fly-fishing' to the town's name made perfect sense."

In November 2016, the demolition work on the clubhouse began. "We tore out a whole lot of horrible shit and found a local contractor to start putting the house together in a way that worked for us. We designed it to have communal space to host a lot of people, but not make it feel like a full-on lodge. The first thing we built was a firepit in the back, which immediately attracted local friends to start popping over for a beer at our place," he said.

The three friends searched far and wide to decorate and furnish the space with items that would bring character and stories into the club. "We found a teepee from the 1980s that an amazing woman had lived in while she built her own home. We also found the materials for a wood-burning sauna from someone in Albany who'd never got around to building it," he said. "We were collecting things and picking up anything we could use."

"We discovered this phenomenon where people in New York City needed to get rid of nice big things like sofas and bed frames—'My lease is expiring in two days and I just have to get rid of it.' Our typical week would be working four or five days, then a blitz of driving around Brooklyn and loading stuff into the caravan," Tom said.

Tom recalled in particular driving to New Jersey in the dead of a snowy winter night to pick up twelve wooden doors from a 1920s house that was being gutted. He dropped the

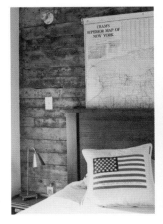

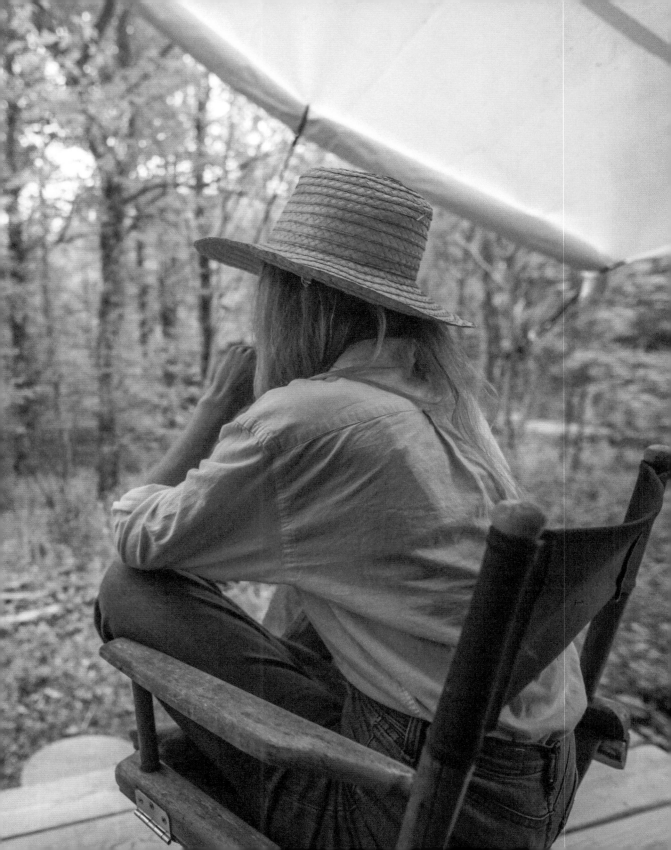

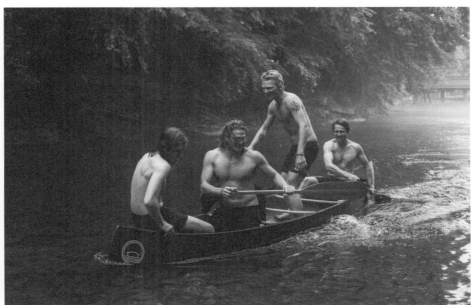

doors off at the club past midnight, then drove back to New York City to make it in time for work that morning. "I dropped those doors through a hole in the wall that later became our front door. They're the same doors we now have on every room of the house," he said.

LAUNCHING A FLY-FISHING CLUB

By the following spring, the first house had gotten to a point of relative comfort. Word had spread to their friends in the city, who were asking to come up to help. "We started a casual format of what became builders' weekends. Friends from various industries, most of whom had never gotten to use their hands, would sit around the fire and come up with ideas like building a platform for an A-frame tent. It would be built that same night. We'd trade accommodations and beer for a bit of work. And that's when everything started to come together," he said. Anna, Mikael, and Tom realized that after all the time they had spent driving around looking for the perfect fishing hole, "Everything we could have ever wanted was right here," Tom said.

"We're on the edge of this interesting town that has incredible access to the river, where you could fish, swim, and jump into a wood-burning sauna," he said. "So we decided to organize a program that reflected the perfect weekend in the Catskills."

With the rooms decorated, the wood-fired sauna steaming, and the creek gurgling outside, the Livingston Manor Fly Fishing Club was officially launched.

It started with a few weekend retreats for friends and family and grew into a rotating weekend program for guests. The weekend would kick off with a stroll out to the river

for a glass of Prosecco and trout on crackers, along with an introduction to what made the area particularly special. He said, "The rest of the weekend could be spent hiking, swimming in the river, canoeing, taking a fly-fishing lesson, or dipping into the wood-burning sauna. We would take people out for scenic drives, a tour of the trout hatchery, and dinners in town."

The experiences were transformative.

"It sounds cliché, but people arrive as strangers, and through shared experiences together in nature, they leave as friends with a far deeper connection than you could ever get from an encounter at a bar or in an artificial environment. People leave with a renewed appreciation of and excitement for the outdoors, as well as a deep sense of relaxation and calm," he said.

Anna, Mikael, and Tom realized that after all the time they had spent driving around looking for the perfect fishing hole, "Everything we could have ever wanted was right here."

It can be tough to find an abundance of quality ingredients in a small mountain town's grocery store. Fortunately for the city transplants of Livingston Manor, there is easy access to the freshest trout around, and an expanding culture of local farming, markets, and gardens. "Whether it's eating a fish that

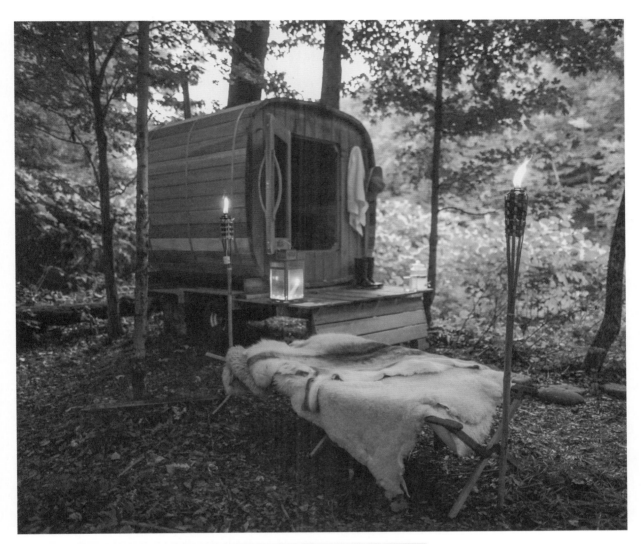

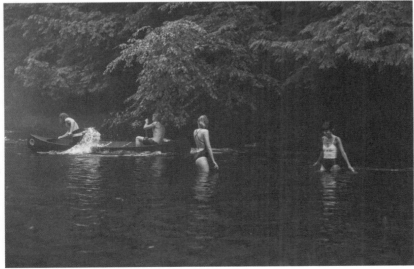

has come straight out of the river or a vegetable that's grown in our garden, I definitely feel that my understanding and appreciation of quality food has increased," Tom said. "It's not until you catch, or grow, your own food first-hand that you truly appreciate the miracle of the cycle of life and food. Not to mention the food tastes much better when you've earned it yourself."

A SIMPLER WAY OF LIFE DOESN'T COME EASY

Of course, renovating a house and running a weekend club while also holding down a full-time job in the city was no easy task. Even today, with Tom working fewer hours in the city, the upkeep and maintenance at the club isn't always as romantic as one may think.

> *"But one of the biggest psychological struggles for me has been reassessing my perception of what work is and recalibrating what value looks like."*

"Some days, I'll spend four hours scraping mold off a carpet, or fixing a leak on a pipe in the basement. I've had a lot of highs and lows, suddenly thinking, *What the fuck am I doing with my life?* Going from steering multimillion-dollar budgets for companies to spending hours trying to fit two pipes together," Tom said. "All of it is fairly rewarding. But one of the biggest psychological struggles for me has been reassessing my perception of what work is and recalibrating what value looks like."

Still, Tom concedes that manual labor is a rite of passage with this sort of project. "A lot of people have the idea of wanting to have it all. You can leave a city to go and start something in the country and think, *Now I'm going to free myself of debt and live off the land.* The reality is, you're going to spend your time doing tedious work you may feel overqualified to do."

And it's that commitment to solving problems large and small, challenging and tedious, along with all the partners' specialties and devotion to their vision, that has made the club what it is today. They set out to create a space that encouraged friends to get outside and slow down. Now they share a place for all to take a pause from city life, appreciate a natural environment, and make connections with other humans on a deeper level. "This connects the dots to why I went up to the Catskills to go fly-fishing," Tom said. "It was the mindset that fishing put me in. We just encourage people to cherish these moments and get outside."

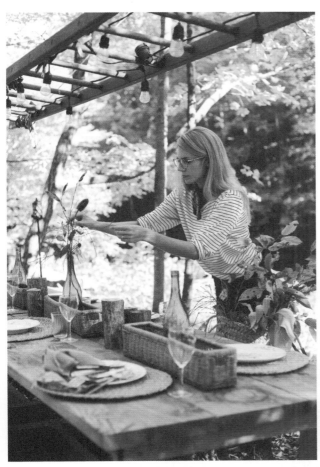

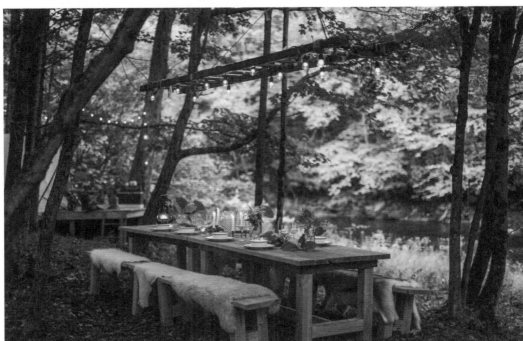

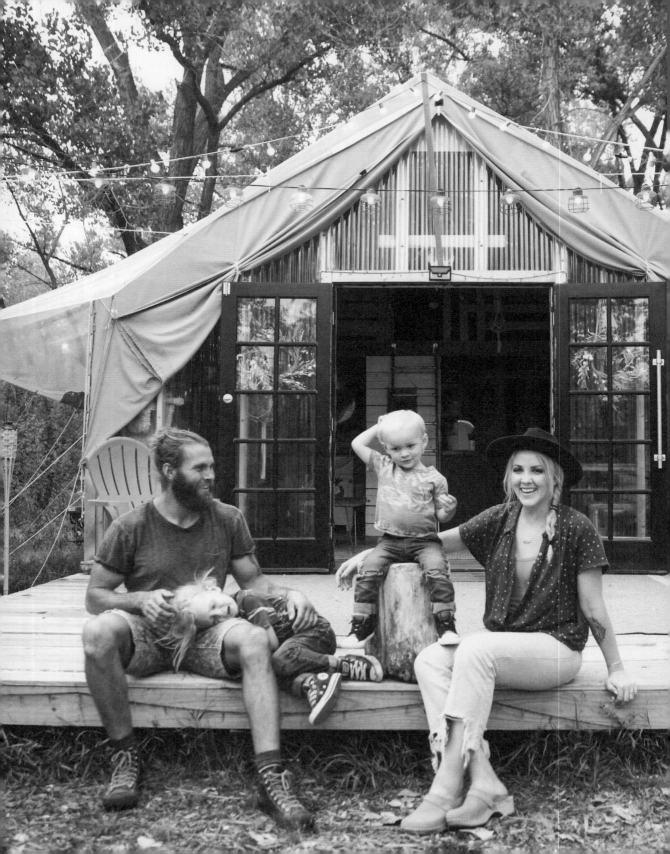

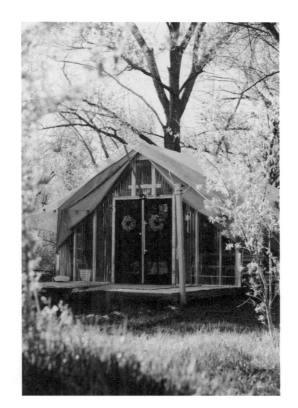

TINY TENT LIVING: A DEN FOR CUBS

Aztec, New Mexico

For Katie and Zac Ruiz, life in California's sunny Orange County gave them everything they needed: steady work, gorgeous landscapes, and time spent with the ones they loved. Leaving that world and getting back to the land wasn't a rejection of city life or a pursuit of conservation (although those things would come later)—it was born of necessity.

Katie grew up in New Mexico and moved to Southern California to attend cosmetology school. Zac was born and raised in Orange County, and hadn't lived outside that same five-mile (eight-kilometer) radius in the duration of his twenty-eight-year life. A mutual friend introduced the two, which launched a whirlwind romance. The couple quickly fell in love, tying the knot just five months later. They settled into an apartment in Rossmoor, California, one of the founding cities of Orange County, which had a "cool, old-school feel to it, a real nice little city," Zac said.

As Katie pursued her career, Zac became a full-time personal trainer. He got certified as a CrossFit instructor and quickly grew his clientele. "We both got really into fitness, eating healthy, and just living a healthier lifestyle. We didn't know it then, but it's what started us on this whole path."

The couple soon had their first child, Fox. That was when they began to realize Rossmoor might not be the most suitable place to nurture their young family.

A SPACE FOR PLAY

When Fox turned one and started walking around on his own, Zac and Katie realized their 4-by-8-foot (1-by-2.5-meter) concrete patio outside the apartment was too small to be his only play area. "We were watching him getting sucked into just sitting in front of an iPad, watching TV. It was at that point the two of us got talking about possibly moving," Zac said. "I was super closed off to it at first—even before kids, she was talking about it and I was like, there's no way I'm moving."

Then they found out they were pregnant again.

"The thought of raising a family in that little apartment? No, this is not the life I want for my kids. I thought about how some of the best times I ever had as a kid were when we would go out camping, or being outside with

my slingshot. So we started leaning toward the idea of: What if we could make those outdoor experiences part of their everyday life?

Katie and Zac explored their options and turned their attention to Aztec, New Mexico, where Katie's family still lived. It's a northern high-desert region, 5,500 feet (1,676 meters) above sea level, just south of Colorado's San Juan National Forest. The couple made the leap, first into a 2,700-square-foot (250-square-meter) house with twice the space for less rent than they paid in California. "It got us into the outdoors and out of the city," Zac said. "We had a 3-acre (1.2-hectare) lot, a lot more room—and our neighbors had horses." But moving to New Mexico also meant the couple had to sacrifice their California careers.

LESS IS MORE

To help make ends meet, Zac and Katie started working on side projects they hoped would

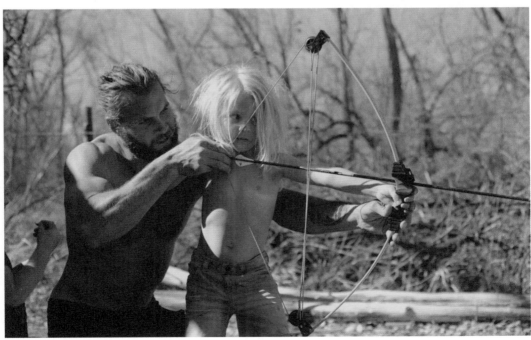

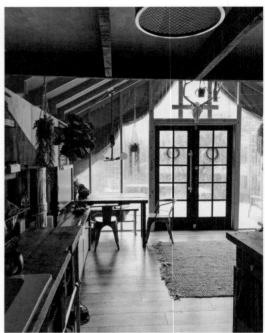

eventually become full-time jobs—and allow them to spend more time at home with their cubs. Katie hand made baby pants and Zac handcrafted uniquely designed lighting fixtures using copper and thick rope—items they marketed and sold online. Getting a small business off the ground took time, and the bills piled up. "We made this move to have more with less, but still found ourselves in a hole," he said.

That's when they started looking into tiny living. Katie and Zac realized they might not need all that extra space in the home they were renting. Making do with less space indoors meant more time outdoors, exactly what they had originally envisioned.

Katie's mom had a plot of land nearby with an acre (.4 hectare) of undeveloped property titled in Katie's name. If they could find an affordable way to construct a structure on that lot, they could make that their home.

The search began. Zac looked into container homes, shed houses, yurts, and even RVs. In the meantime, the family ditched the rental house and settled into a 20-foot-long (6-meter-long) camper on the 1-acre (.4-hectare) property, which they lived in for four months while figuring out a more permanent solution.

"I came across canvas tents, which are essentially what people use to go hunting in," Zac said. "Hunters stay in them for two or three weeks at a time in the winter. So I thought, *Why couldn't you make a permanent structure out of it?* If you can tough it out for the winter season in one of those, why couldn't you spend a whole year in one?" The build was estimated to cost $5,000. "If it didn't work out, the worst-case scenario was that we'd be out $5,000 and move back into an apartment."

The couple found a used canvas tent they could make basic adjustments to and fortify for year-round living. "It's so crazy to look back on. From the apartment in California, into the big house, straight into this camper on this field with our kids. Our lifestyles went through some quick and dramatic changes," he said.

A CANVAS TENT HOME FOR A FAMILY OF FOUR

When Zac was a kid, his father was a woodworking hobbyist who made things like birdhouses to sell at local boutiques. He and his father would spend countless hours playing around with table saws and tools. Two decades later, Zac put those skills to use building his family's new tent home. For help, he called on a local friend, conveniently a carpenter by trade. The two went at it, starting with the firepit.

"We grabbed these large stones from the river and basically built everything around that, the whole design of the tent—the chairs and tables on the inside of the house all face the firepit outside," he said.

Once the deck and framing went up, it was as simple as securing the thick canvas over the top and outfitting the interior. "The heavy canvas helps keep the heat in and the moisture out. It's also really breathable, so it doesn't keep the humidity in," Zac said. "We've had some hailstorms come through the area, but so far no issues with leaks—it's been good."

The interior was outfitted with old rustic wood from an Idaho barn that was disassembled and hauled down to New Mexico. "I made everything I could from that barn wood, including all of our tables," he said.

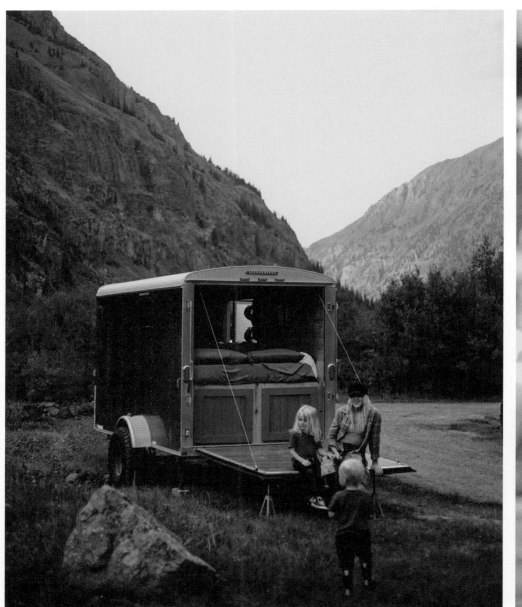

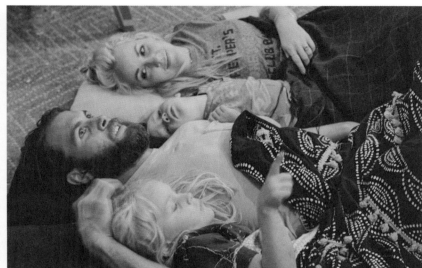

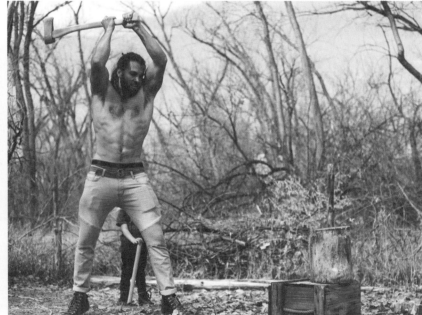

"The walls are just plywood, but we added a lot of our own style to it, painting the walls with some unique lines, adding some shelving and paintings—basic design stuff that makes the place pop."

With its large extended deck, the 300-square-foot (28-square-meter) tent doesn't really feel like a tent. "We built it out to feel like a modern little home or cabin. Once we open the doors, it adds another 150 square feet (14 square meters). It never really feels like we're living in a tiny home," he said.

When it came to the basics, like water and heat, the family kept it simple. A large stream flows 300 feet (91 meters) away, supplying the home with unlimited fresh water. "It's just a matter of getting it into the house. We have a gravity-fed sink in the kitchen that we fill up whenever we need to clean the dishes. But essentially, we have free water for the rest of our lives," Zac said.

For heat in the freezing winter months, the family uses a portable propane heater. He said, "Propane is super affordable in this area, and we can move it around the tent anywhere we need it. As long as we have some sweatpants on, it works out perfectly fine." Electric power is sourced from the grid, but they've started to consider solar options to get more off the grid.

The tent lifestyle comes with certain concessions, of course. "Sure, there are times when it's frustrating and you don't want to do certain chores," he said. "But the reality is, we accept it because it allows us to do what we love—the payoff is so much greater than the annoyances. If I have to dump a pee bucket, I'll do it!"

A commitment to conservation and tiny living was born of necessity for Zac and Katie.

Living in a tent without the usual creature comforts forced them to learn the values of minimizing waste, keeping the river water clean, and saving energy firsthand. "You don't realize how disconnected you are from all that stuff until you move out here," he said. "I had an idea of conservation and always had a heart for it, but it took moving here to truly start understanding the importance of caring for these things. It's completely changed our point of view on life."

DAYS SPENT OUT IN THE WILD

With their tiny home built, expenses down to a minimum, and side projects taking off, the couple finally was able to take advantage of their dream scenario. "Working from home has taken off a lot of the stress of being gone all day. You think about how much you miss being gone eight hours of the day—that's a huge chunk. In the morning, I'll climb down from the loft to see deer grazing in the front yard. I hear geese start their southern migration and watch how excited our boys get to see hundreds of them fly overhead," he said.

On any given evening, you'll find the family down by the river tossing rocks into the water, taking in the scenes surrounding their home. "We'll sit for a good hour by the water. We'll see a pair of red-tailed hawks that nest behind us in the woods. We have a pair of bald eagles about 1 mile (1.6 kilometers) down the river, and every once in a while they come fly around by us," Zac said. "Sometimes we'll see our local fox poke his head out of the tall grass. It's something so surreal. I only ever got to see those things a couple times a year when we would go on family vacations to the High Sierra, but now we see it almost daily."

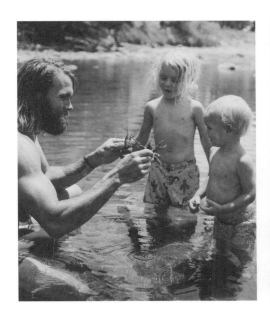
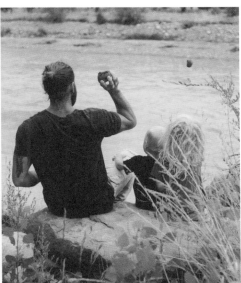

Zac also likes to spend time teaching the boys useful tactics for surviving in the wilderness and living off the land. "I have tons of room to practice shooting my bow, and I've been working with Fox, teaching him how to shoot his own. The goal is to shoot a duck someday. We've both had a lot of fun learning to throw knives and axes over the last year, too," he said.

When they first moved onto the property, the family dreamed of having chickens to provide fresh eggs, a couple goats for milk, and a pig or two. But other priorities took precedence. "That lifestyle requires being home a lot, and we now enjoy being able to travel throughout the year. So for the moment, that dream is on hold," he said. The family does, however, get their supply of fresh farm produce from local neighbors. They also keep their own small garden in front of the tiny home; Zac admits they started the garden by simply "throwing" seed everywhere. "It's far from a perfect attempt, but watching the boys see the seeds sprout into carrots, pumpkins, and cantaloupes was something special for us," he said.

Zac also plans to add to their food supply by hunting: "I have my first elk hunt coming up, and hopefully I can bring home a ton of meat. I think that part of life and death has been lost on us in modern society. We've lost connection with what we're eating. Throughout the winter, I'll bring home lots of ducks and geese. It's important to show the boys how to go from taking a living bird, to helping us process it, to cooking and eating it."

Now, over a year after making the move into the tent, Zac and Katie have no regrets. "It comes down to, what are we going to be thankful for in thirty years?" he said. "Are we going to be thankful for working forty hours a week at an office, or are we going to enjoy the times and memories we had on all the trips we took and the time spent outdoors with our kids? We're getting to live our whole idea of being able to sit down as a family, put the phones down, hang out, be in nature, and get back to the heart of conversation."

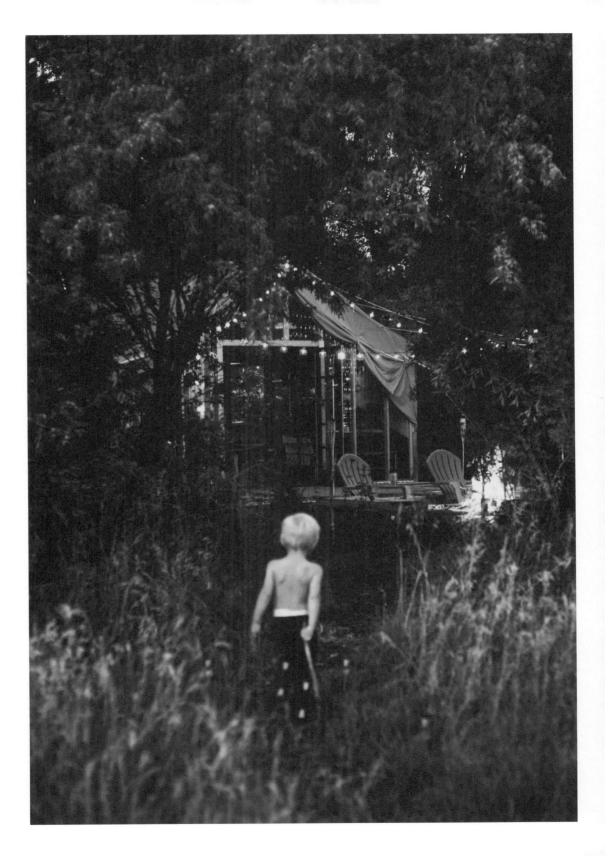

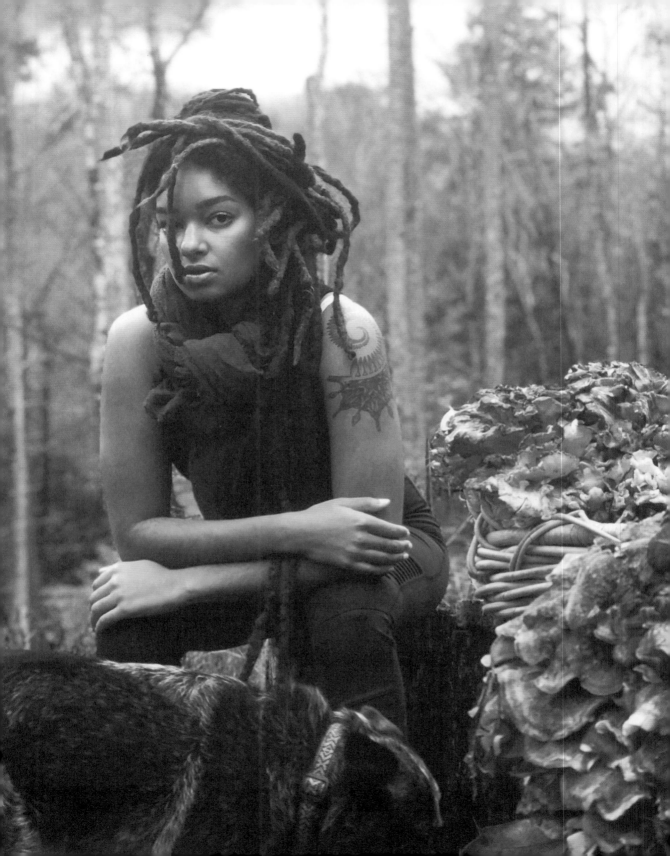

WANDERING AND WILDCRAFTING: EAGLE ROCK FARM

Asheville, North Carolina

Indy Srinath spent her formative years in the small town of Mount Airy, North Carolina. She and her mother, a single black woman, were "an anomaly in a redneck town." But though Mount Airy was a conservative place, Indy's mother, a child psychologist, took a progressive, enlightened approach to raising her daughter. She helped Indy cultivate an avant-garde spirit that eventually gave Indy the courage to create a life she could live freely, on her on terms.

By her late-teens, Indy was ready to leave North Carolina. After four years of rigorous education at an all-girls school, and a year at a small liberal arts college, Indy became convinced that conventional education and claustrophobic, small-town living was not for her, so she decided to forge her own path in the world. "I wanted to be outside, not in classrooms or a small town," she said. She relocated to Austin, Texas, where she worked for a nonprofit. She found the work rewarding but longed for a life that would allow her to spend more time outdoors interacting with nature. So she decided to sell most of her possessions and travel west in an old Volvo station wagon.

She eventually made it to San Francisco, where her beloved station wagon finally broke down. Searching for opportunities to spend more time in the outdoors, she found a WWOOFing (World Wide Opportunities on Organic Farms) volunteer opportunity at Isis Oasis, a retreat center and sustainable farm in Sonoma county, just north of San Francisco. At Isis Oasis, she learned permaculture, the practice of creating sustainable agricultural ecosystems, and immersed herself in farm life: "I helped build tiny houses on the property and got into bird keeping. I spent from sunrise to sundown gardening, building, taking care of birds—it was amazing."

This back-to-the-land experience was the life that Indy had been looking for. It wasn't long before love and land would pull her back East. During a trip to North Carolina to visit her mom, Indy reunited with Everest, an old friend from college, and the two started dating. Everest's family had recently purchased 7 acres (2.8 hectares) of heavily wooded forest in the

Great Smoky Mountains, just thirty minutes outside Asheville. Indy decided this was an opportunity to implement her farm and sustainability skills in North Carolina, a place in need of people committed to replenishing natural resources.

Indy and Everest moved onto the property and for the next year and a half, they lived in an off-the-grid barn while they built a home on the property, using rain barrels to collect their water and a wood stove for heat. They enrolled in herbalism school, spending three years learning about foraging and identifying edible and medicinal plants, and started growing their own herbs and mushrooms. Now, the couple cares for over 500 shiitake logs, hardwood logs that have been injected with mycelium (mushroom spawn), which eventually produce mushrooms. They grow them outdoors along-side oyster mushrooms in wild-simulated conditions. The small operation soon began selling to farmers' markets and local restaurants, and even fielding international orders.

Living off the land and working closely with the local community has given Indy a sense of belonging in North Carolina, which eclipsed her disillusion with small-town living. In addition to growing mushrooms and herbs, she teaches writing at the local school and manages a community garden for a low-income, predominantly African American neighborhood, empowering residents to grow their own food. Now she spends every day outside, getting paid to do what she loves. "It's the greatest thing I can imagine," Indy said. Much like the mushrooms she carefully cultivates, Indy's life proves that with time and the right conditions, it's possible to thrive.

THE CITY ESCAPE: BOULDER CREEK

Santa Cruz Mountains, California

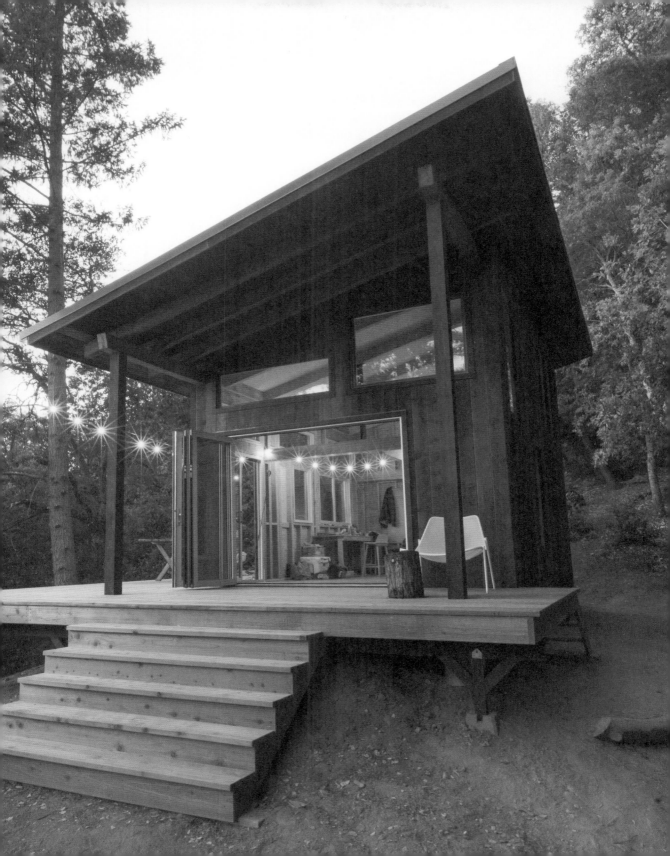

Jeff Waldman and Molly Fiffer's land project began with prioritizing the desire to get outdoors with friends; to learn, create, and build together; to form deeper bonds and connections with one another in the solitude of nature.

Many could look at what Jeff and Molly have created and think it's completely unattainable. For a young couple to maintain an apartment in San Francisco's Nob Hill while designing and constructing beautiful modern structures on a gorgeous 10-acre (4-hectare) property in the nearby Santa Cruz Mountains—surely, you may think, they must have a trust fund, or perhaps the salary of a tech executive, or at least the experience of a dedicated carpenter. But you would be wrong.

"I've always been my happiest when collaborating with friends on some creative and problem-solving endeavor, and there just wasn't much room for that in our day-to-day life," Jeff said. "I felt cooped up. Building stuff in our small space, drilling holes in the floor, and piling up sawdust by the couch." Jeff is not a builder by trade. "My desire to tinker is innate, and frankly problematic as much as it is productive: taking apart things better left whole."

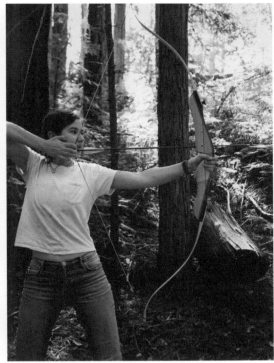

BEFORE IT ALL STARTED

Jeff grew up in the desert, outside of Los Angeles. "I had the space and time to work on projects, but few resources. I'd build skate ramps and dirt jumps and forts." He took solace in the outdoors, volunteered at a nature center, climbed lots of trees, and loved to go camping. Jeff read books about being outside and self-sufficiency. "I've always been drawn to stories of survival, ingenuity, craft, and resourcefulness, especially when set against the backdrop of rugged nature and a testing environment."

Molly, who spent her childhood in the suburbs of Chicago, admits, "I grew up without any inkling of the outdoors. As a kid, I wasn't terribly adventurous. I didn't climb trees or tinker with things or attempt my own projects.

I'm not even sure we had a usable toolbox in my house." Yet today you'll see Molly marching around their wooded property, sporting Kevlar pants, totally at ease revving up a chainsaw, chopping an oak tree, and handling commercial drills.

Molly left Chicago for college in Claremont, California, and discovered her connection to the outside world upon her arrival. "Once I moved to California, I realized I felt most like myself when I was outside," she said. "I found myself backpacking, hiking, and being outside during most weekends and school breaks. I'm a dabbler by nature. Rather than focusing on specific hobbies or activities or even job tracks, I prefer to diversify. I'd rather be proficient at a lot of things than master a few things."

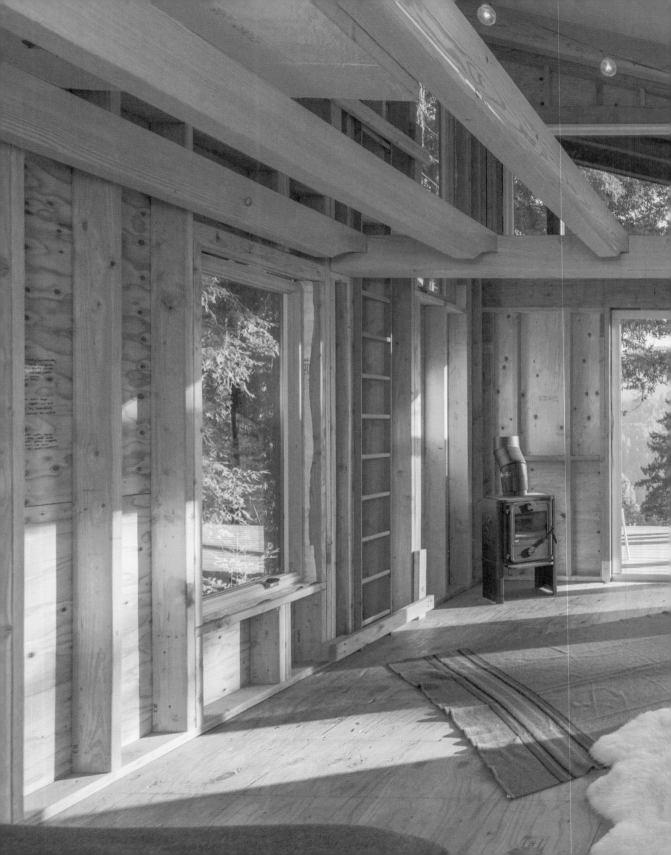

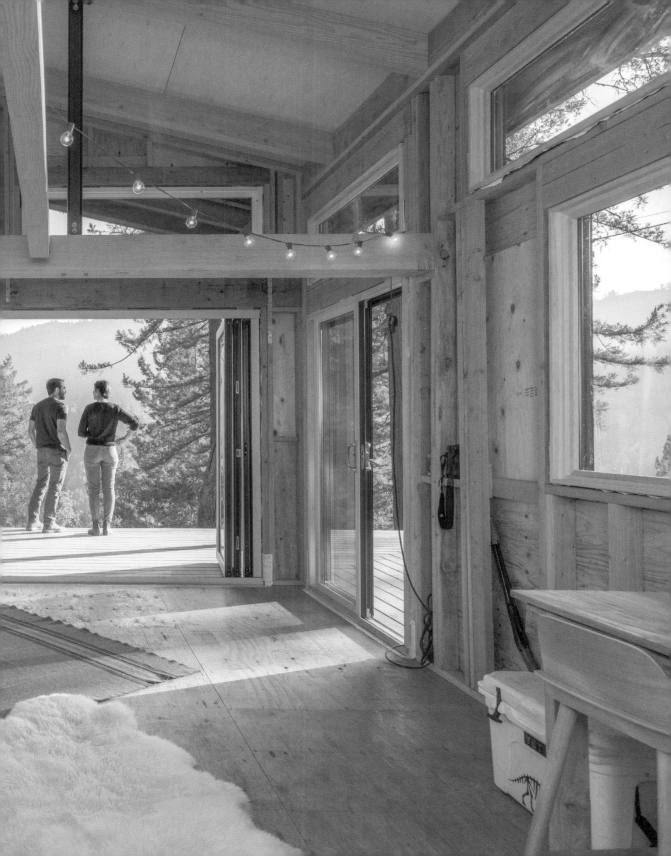

THE TRANSFORMATION

Jeff and Molly met through a group of mutual friends in San Francisco, finding connection in their love for the outdoors and eagerness to organize events for their social network in the city.

> *"Working and learning together stood in sharp contrast to digital inter- actions and more super- ficial hangouts. "*

"We started hosting butchering events, where we would buy a side of pig directly from a local ranch and lead a group through break- ing it down into cuts that everyone could take home for a potluck. That connection to the land, our food, and doing something so viscer- ally authentic as a group was highly rewarding," Jeff said. "Working and learning together stood in sharp contrast to digital interactions and more superficial hangouts."

More organized communal events followed, but the final push was a weekend retreat. "We rented a timber frame cabin in the woods for a few days with our close friends who'd agreed beforehand to spend the time without their cell phones so they could focus on each other," Jeff said. "It was special: quality time we simply don't get meeting for the sporadic coffee or lunch, where we go through the motions and check off the conversational boxes. When Molly and I left the retreat that weekend, we resolved to continue the practice and that the next year's retreat would be on our own property."

MAKING IT HAPPEN

Molly and Jeff worked hard to save so they could invest in their dream plot of land. Many young couples wouldn't think twice, given the choice to spend their savings on a full-time home versus a patch of dirt in the woods for weekend activities. But Jeff and Molly were fortunate enough to have a rent-controlled apartment in the city, so they decidedly preferred the addition of a hobby space in nature—for the approximate cost of a monthly car payment.

"We had a pretty fixed budget, which of course dictated what was available to us, but beyond that we were quite open to what form our property would take," he said.

"Private land-sellers often will act as lenders when banks can't provide a loan, but banks also often provide loans on rundown cabins," Jeff said. "Having a significant amount of per- sonal capital up front isn't necessary. I know a couple groups of friends who pooled their money and went in on properties together. It can be tough to wrangle a dozen people, but it can be done."

BOULDER CREEK

Jeff and Molly eventually came across a plot of 10 acres (4 hectares) on an overgrown hillside with very little flat space. Though it needed a lot of work, the parcel was canopied by magnificent redwoods, madrones, and twisting oaks, and its location just 5 miles (8 kilometers) from the Pacific Coast meant the mountainside lot was treated to beautiful views of fog rolling in off the ocean over the Santa Cruz Mountains.

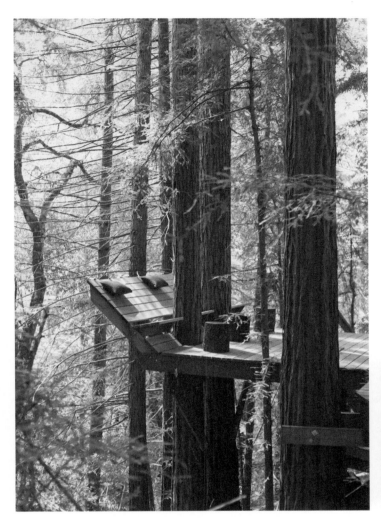

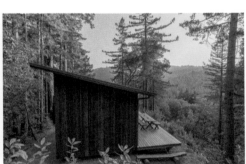

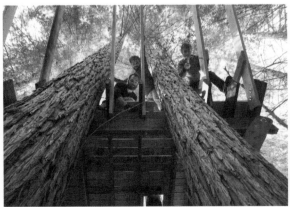

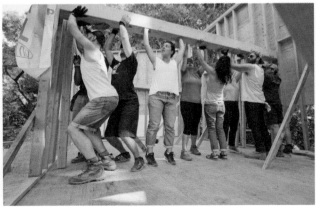

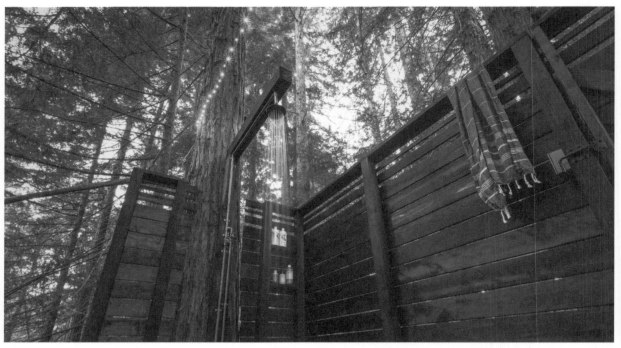

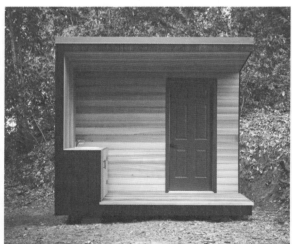

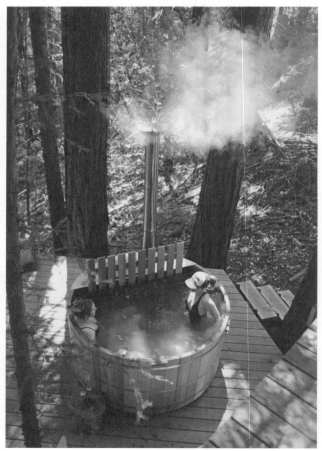

They fell in love with it. Jeff said, "You can watch the sun move over the mountains, lighting up trees, and listen to squirrels scampering over the duff. At dusk, the light shifts and different colors come out, then disappear as the coyotes, bobcats, skunks, and possums come out, scratching across the leaves on the forest floor."

"The nights here are pitch black," Molly said. "From the ridge we can see lots of stars and planets. We're surrounded by mountains and pretty much unaffected by light pollution, so headlamps are essential. The exception is on evenings with a full moon, which is one of the biggest treats. The ridge gets lit up, and we can walk around freely, no flashlight needed."

The setting was enough to make them sign on the dotted line.

THE BUILDS

The builds started small and simple. Some of the first structures that went up were the outhouse and shower. "The least we can do is offer our friends who come up here to help and collaborate with us a hot shower, cold beer, and a bathroom unlike any you'd expect to find," he said.

The outhouse is a 10-by-10-foot (3-by-3 meter) cube clad in cedar siding that's been treated with Scandinavian pine tar, which gives it a rich black finish and preserves the exterior in the damp coastal climate. The interior, with bear-themed wallpaper, was designed to feel like you've walked through a portal into a home.

The outdoor shower is constructed between two redwood trees, accessed by a 15-foot- (4.5-meter-) long bridge, heated by an off-the-grid propane water heater. The floor and walls are *shou sugi ban* (charred, brushed, and oiled) redwood. The shower platform opens on one side to overlook a private wooded area of the property (and it's a 15-foot (4.5-meter) fall, if you're careless).

The cabin is 14 by 20 feet (4.3 by 6 meters) with a large overhead loft and a 10-foot- (3-meter-) deep L-shaped porch. The interior features large exposed Douglas fir timber. There's a small kitchenette in the back with a sink, and a bed in the loft. "There are two giant glass doors, which frame the views of the opposing mountains," Jeff said. "We purchased the largest of the windows used, as well as half our other windows, in the year leading up to the cabin build and designed the cabin around them."

The heavy use of glass was designed to lean into the climate. "The small space of the cabin is meant to be only a part of the larger deck structure, blurring the line between indoor and out, with as much cooking, dining, and socializing happening outside the space as inside," he said.

And what to do for fun? "We've set up slacklines and zip lines, axe throwing, and archery. We have a wood-fired hot tub that sees a lot of use. We keep some tattoo supplies on the property, just in case someone finds themselves in the mood," he said.

A PLACE FOR FRIENDS, BY FRIENDS

"It can't be overstated how much we've learned by doing and how attainable that is for most people," Jeff said. "We've had no professional help or instruction, just a willingness to put in the work and try new things. Every tree we cut down safely happened because we cut down a smaller one first. Every skill is built upon previous ones."

"We've had so many visitors look at the land we've cleared, or the stuff we've built, and marvel that they 'could never do that.' Well no, they probably couldn't. But neither could we," Jeff said. "We built a dozen other things first, honing those design skills and learning improved techniques.

"We have some very talented and motivated friends who have lent a hand," Jeff said. "Most of the ones with any real building experience are out of town and have been a frequent source of knowledge, so most people have been as new to this as we are. It's been a learning experience for all involved. We've made it very clear that this place is theirs to use as their own, for recreation and as a space to exercise creativity. It's incredibly important our friends feel welcome here, a sense of comfort and ownership."

The romantic idea of cabin life has always appealed to Jeff: "There has always been an alluring quality to that rural lifestyle, and a deep respect and admiration for those who have gone into the woods. But I still enjoy the resources of cities too much."

Still, he said, "The retreats we organize, the workshops and butcherings and communal meals on a long farm table, it's all tapping into that evolution of why folks are leaving the cities in droves for the call of something more visceral. We're that intermediate step. Part of a new generation that recognizes the immense rewards that come from communing in nature and getting some dirt under our nails, but one that is still trying to work out how to make that gel with the resources we've come to lean on in the city. We're bridging that divide. Successfully, I think."

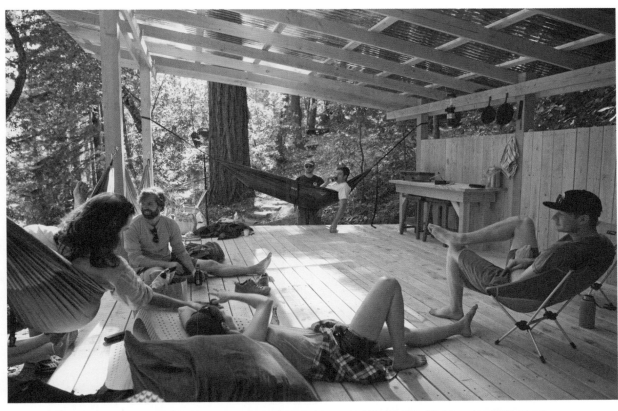

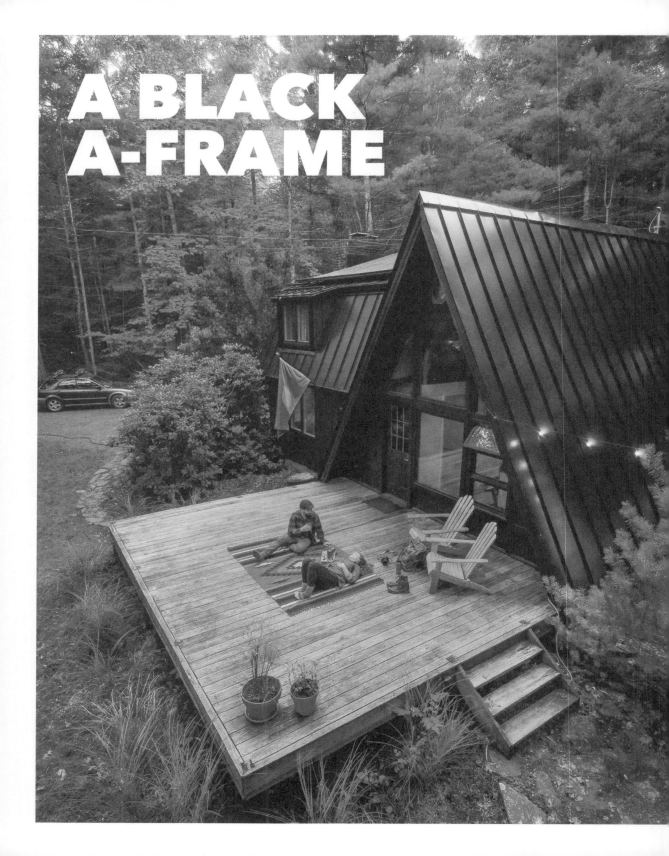

A BLACK A-FRAME

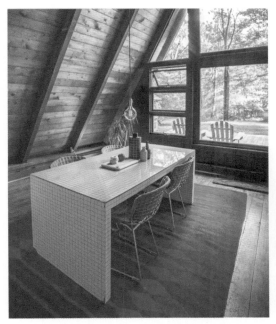

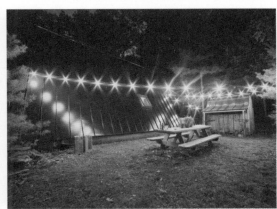

Kerhonkson,
New York

Plumes of smoke billow from the chimney of the starkly black A-frame cabin, set against a rooftop as dark as the sky overhead. Inside, angled walls and tasteful décor complemented by the sounds of Nina Simone spinning on vinyl create warm and fuzzy vibes, as friends pour wine before heading outside to share cheeses, fresh baked bread, and salumi by the firepit. Nestled in a region of forests, farms, and state parks, this escape is just a short drive from Manhattan. The Black A-Frame epitomizes the ultimate modern weekend getaway from the city with friends.

"We entertained the idea of getting out and seeing more nature," Jeremy Parker said. He and his partner, Carlos, live together in Manhattan's Chinatown, one of the city's most densely populated neighborhoods. The couple had a simple plan: to have a place to relax, away from the hustle and bustle of their daily lives.

Finally, one weekend, the two decided to take a drive upstate. They looked at some properties, one of which was that little A-frame structure in Kerhonkson, New York, just two hours north. "We'd never heard of the town, and it took us a year to learn how to say it properly." The A-frame's previous owners were elderly and hadn't done much upkeep to the property. "We felt like it was such an interesting structure with a lot of potential, so we said 'Fuck it' and put an offer in, which was accepted on our way back to the realtor's office.

"As a kid, I always wanted to be an architect," Jeremy said. The Black A-Frame became the perfect project to put those aspirations to work. The two took stock of all the property's structures: the house, doghouse, barn,

barn next to the barn, and years of knick-knacks left behind by the previous owners. "We basically gutted it and worked with a contractor to fix the plumbing, electrical, and all that stuff," he said.

However, keeping the energy, history, and character of the space was vital. "We kept all the wood elements in their original condition," Jeremy said. "We never refinished the floors, which draws attention to the original layout of the house. You can see where the old kitchen and bedrooms were." Even the mezuzah (a symbolic object in Judaism that is affixed to doorframes) that was left behind still sits on the ledge of the door. "We aren't Jewish, but we could never remove such a blessing," he said.

From the moment you step inside, the Black A-Frame envelops you in calm and coziness, with rustic yet modern décor, and atmospheric tunes always on deck. "We are furniture and design nerds. We also love music. We've been collecting various vintage furniture, contemporary art, vintage radios, and turntables. We finally have a place to showcase them all!" Jeremy said.

Weekend trips to the Black A-Frame followed, with friends coming along, hiking local trails, exploring the Minnewaska State Park ice caves, and swimming in the two large lakes nearby. "But our favorite thing is to wake up and just hear nothing in the morning," Jeremy said. "We take our time, make coffee, hang with the chipmunks, and watch the birds in the front yard."

The Black A-Frame became everything the two had hoped it could be. What they did not expect, however, was just how progressive the area had become. "We found ourselves

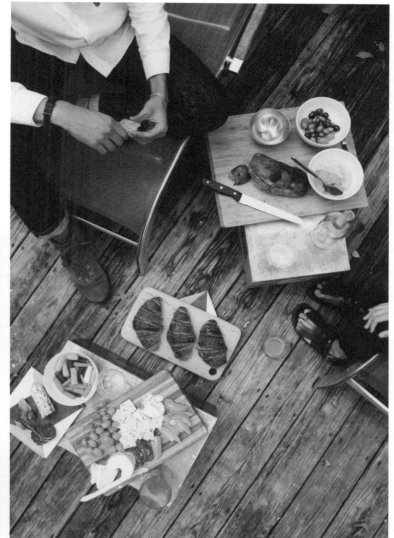

meeting more like-minded people upstate than down. Those who wanted to live somewhat off-grid, more sustainably, eating local, good, healthy foods. There are young creative types here," Jeremy said. "And for us, we're definitely not trust-fund kids, so we couldn't realistically buy a home in the city. There's opportunity here. We could afford this. Things are rapidly changing; it's a nice renegade energy."

The food culture of the upstate region also jibed with the couple's thoughts on food politics. "We aren't into monocultural farming, and there are many people here that share those sentiments," Jeremy said. They entertained the idea of farming and raising chickens on the property. "But we're on a very heavily wooded plot of land; we don't get a ton of sunlight, so our garden would be limited." Fortunately, the neighbors raise chickens,

and local farmers operate on a trust system, leaving produce and fresh eggs out for sale. "All you need to do is drop a few dollars in the bucket; some even accept Venmo. It's a pretty cool system," he said.

After three seasons with the Black A-Frame, Jeremy has been able to offset the cost of his mortgage by renting the cabin out, especially after the place hit social media fame. He said, "It just got really popular really fast. It was not our intention to have an Instagram for the house, but that's what happened." Jeremy and Carlos still keep the calendar open and block time for themselves throughout the seasons.

"We have the best of both worlds," Jeremy said of their weekend escape lifestyle. "The A-frame cabin, the rural New York outdoors, and the apartment in Chinatown. It doesn't get much better."

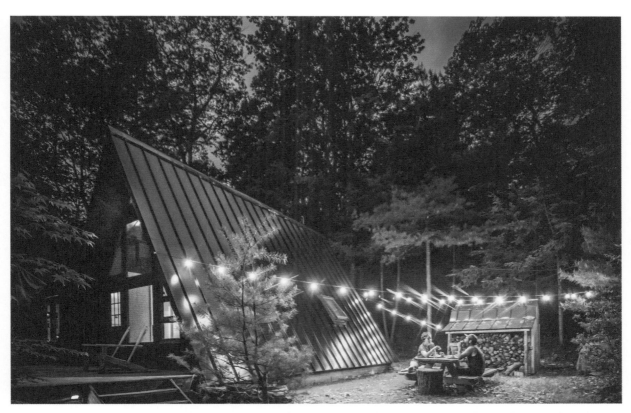

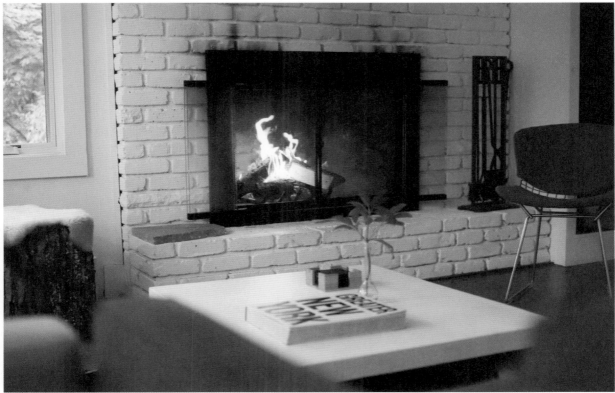

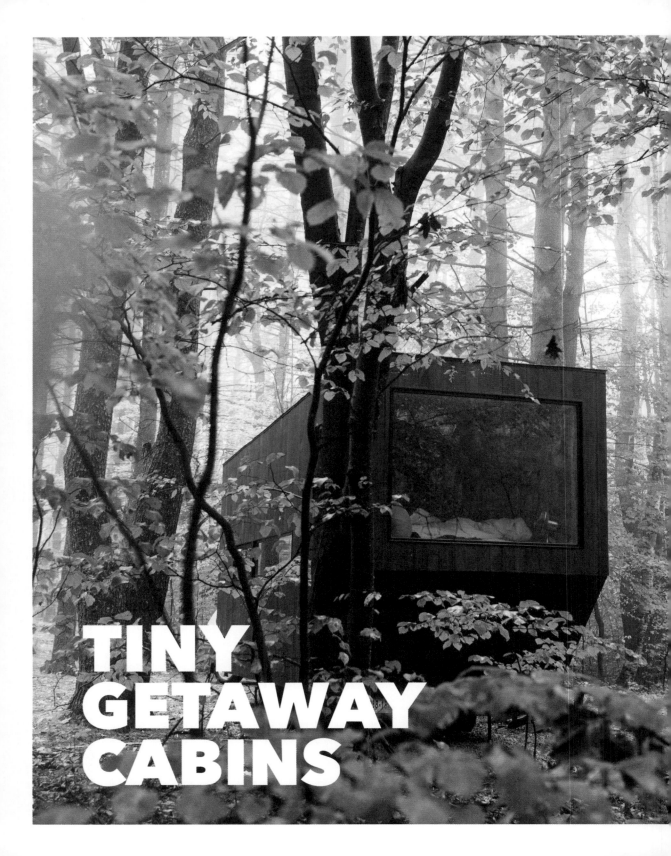

TINY
GETAWAY
CABINS

New York,
Washington, D.C.,
Massachusetts

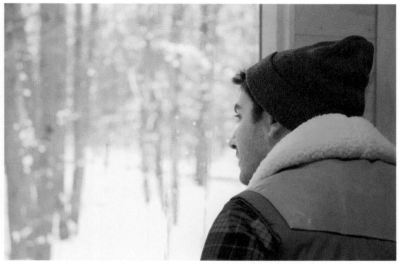

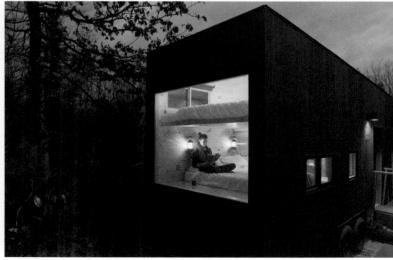

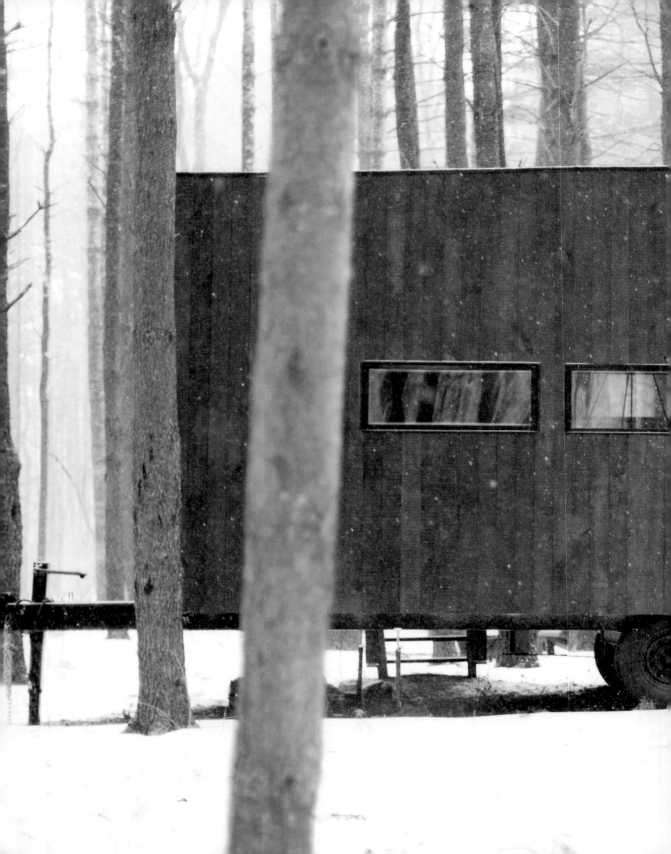

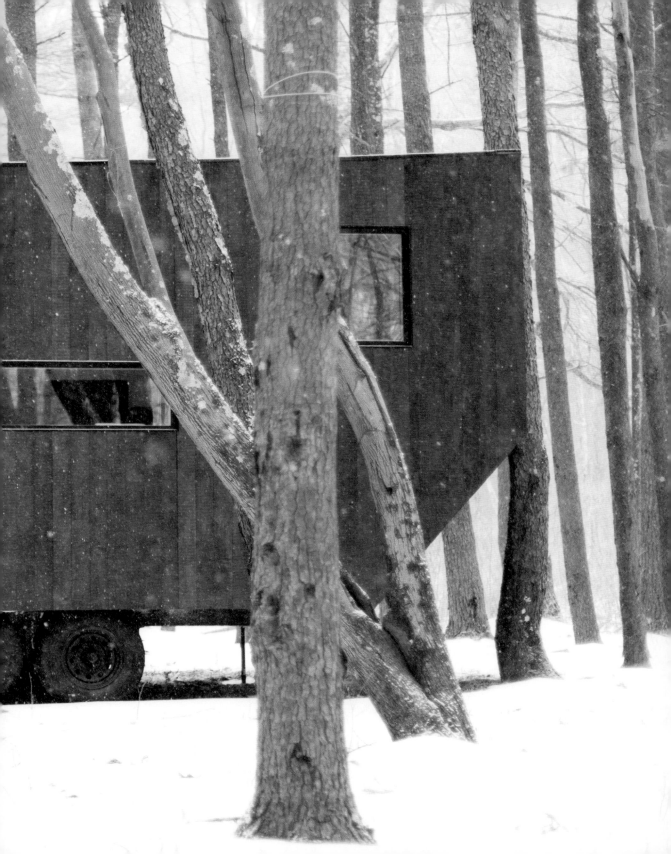

On Friday afternoon, the email comes in while you're finishing up a few things at work. In it, you discover a link to a Spotify playlist, a key code, and the location of a tiny home in the middle of a forest you've never been to before.

It's dusk when you arrive, turning down the music as your headlights catch a small wooden structure in a clearing with a few Adirondack chairs, a campfire ring, and picnic tables. You use the key code to enter, and discover a minimalist space with a kitchenette, bathroom, shower, and lofted bed: your home for the next two days.

"My entire childhood was being on the water, being in the woods, having campfires," said Jon Staff, founder of Getaway, a service pairing city people with tiny homes in the woods that are just an hour or two away. His inspiration for the company comes from his own background, growing up in a cabin outside a town of just fifty-four people. Jon didn't know life could be any different from his own— days spent exploring lakes and rivers and forests, evenings spent by a campfire.

Between college and business school, Jon spent five months in a borrowed Airstream trailer, working remotely and traveling out west. The trailer was on loan from a friend, who freely shared the trailer on the condition that Jon return it in time for Burning Man, a multiday event in the Nevada desert. Jon managed to log 8,000 miles (12,875 kilometers) on the trailer in the five months he had it.

It was around that time that Jon discovered tiny homes. He saw the small structures as affording people the opportunity to balance city and outdoor experiences.

"I got this idea of living life around experiences rather than stuff," he said.

Getaway serves city dwellers by situating tiny homes on plots of land within a two-hour drive from each metropolis. The cabins have a lockbox to stash your cell phone in, no Wi-Fi, and no distractions—what Jon referred to as "this idea of disconnecting and recharging. We want this to be a tool that allows you to be in nature."

The Getaway experience isn't about living in a tiny space; it's about being outside in nature. Jon wanted to make communing with the outdoors as easy as possible, and that ethos is reflected in the design of Getaway buildings: let nature into the space—even if the space is only 140 to 200 square feet (13 to 18.5 square meters) atop a flatbed trailer.

Central to the design of the simplistic, boxy cabins are oversized windows adjacent to sleeping nooks, raw knotty pine and plywood throughout the interiors, and industrial hardware like barn-style lanterns and library ladders that reach up into lofts. The results are clean lines and dramatic layouts, providing an airy sense of openness in what is actually a minimalist space—a cabin in the woods that encourages you to do nothing but simply embrace everything that crosses your path.

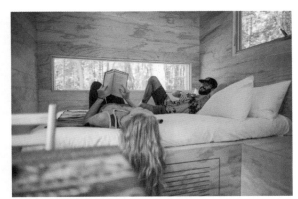

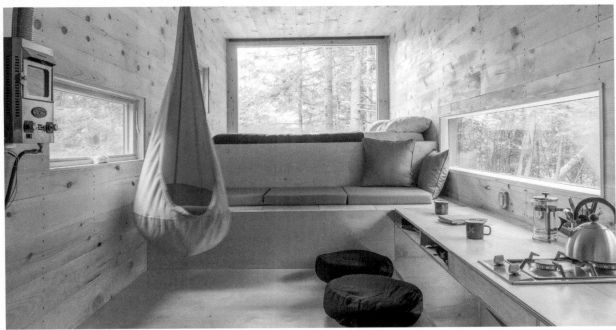

02
TREEHOUSE

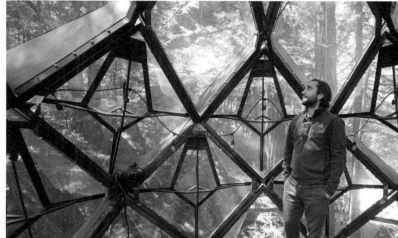

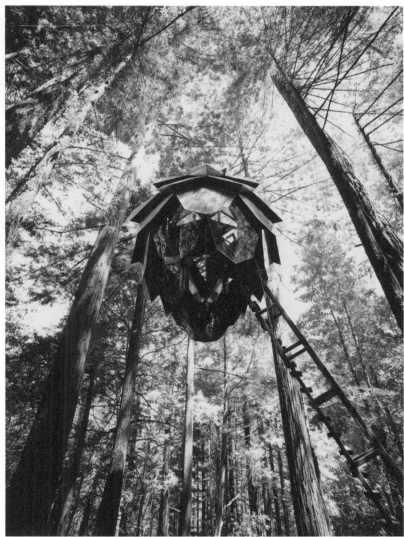

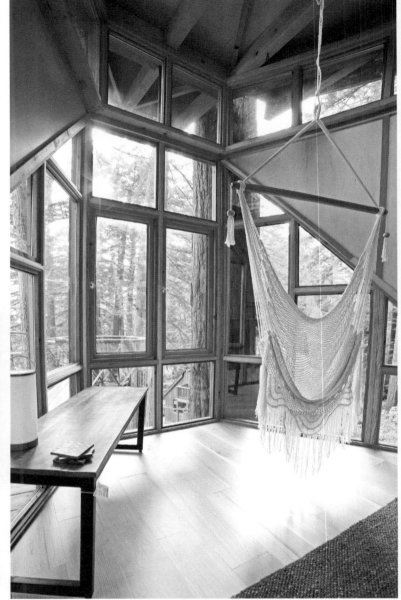

At first glance, Dustin Feider's tree houses appear terribly complicated: impossible angles of shiny glass and wood opposing each other high off the ground in a staggering feat of engineering. Traditional craftsmanship blends with sleek modern design to form otherworldly shapes that might seem better suited to a space lab than a forest canopy. Yet there's a perfect simplicity in the structure of these pods. Something soothing in their geometry and symmetry.

The designer tree houses—built under Dustin's firm, O2 Treehouse—are a study in ephemeralization, R. Buckminster Fuller's philosophy of using technological advancement to do "more and more with less and less until eventually you can do everything with nothing."

Dustin started building tree houses in 2005 and has since helped install dozens of his signature structures all over the world. Dustin promotes a simple philosophy: "To advance harmony with the natural world and foster stronger relationships through time spent at a new elevation."

Dustin grew up in Milwaukee's suburbs, and as a child he and his family built structures that brought him closer to nature. "I loved building forts—and my dad built us a tree house when we were kids," he said. "There was no ladder. You had to climb if you wanted to get in."

Eventually Dustin went to school in Minneapolis to study furniture design and pursue his interests in sustainable living. After he graduated from college, he and his dad set themselves a staggering new challenge: build a tree house made from lightweight, recyclable, and sustainable materials that could fit in any tree and be packed flat for shipping and assembled elsewhere. So was born a geodesic shape in which form meets function, within an ambitious set of parameters. Since then, Dustin has built and shipped dozens of the structures, which range in style and run from $10,000 to over $200,000.

Dustin's masterpiece creation is, without a doubt, the Pinecone Treehouse. Located in the Santa Cruz Mountains of California, the 11,000-pound (4,990-kilogram) structure is suspended by eight steel cables, floating 60 feet (18 meters) above the ground at its highest point. When you're inside, the pinecone-shaped geodesic behemoth immerses you in a 360-degree view of the redwood forest, with see-through floor panels that make you feel like you are flying through the upper canopy of the massive trees. The steep staircase with ascension safety system helps guests descend to the ground level and walk across a catwalk bridge to access the mini tree house bathroom, which includes a hot shower, composting toilet, and sink. This architectural feat was originally funded for a commercial project, which allowed Dustin to construct his dream and share it with others.

Building tree houses wasn't quite enough for Dustin. His passion for spending time in the outdoors and working on his craft inspired him to found Treewalkers, an educational program that brings builders and students together to create rentable tree houses, a model in which students learn the craft of building and then collectively own the project they help to create.

For Dustin, the work he does comes back to the simple desire to get people outdoors. A kid from the 'burbs, obsessed with the woods, pushing the limits of what can be done with his mind-blowing creations suspended in nature, he wants to pass on the knowledge to others and get more people outdoors.

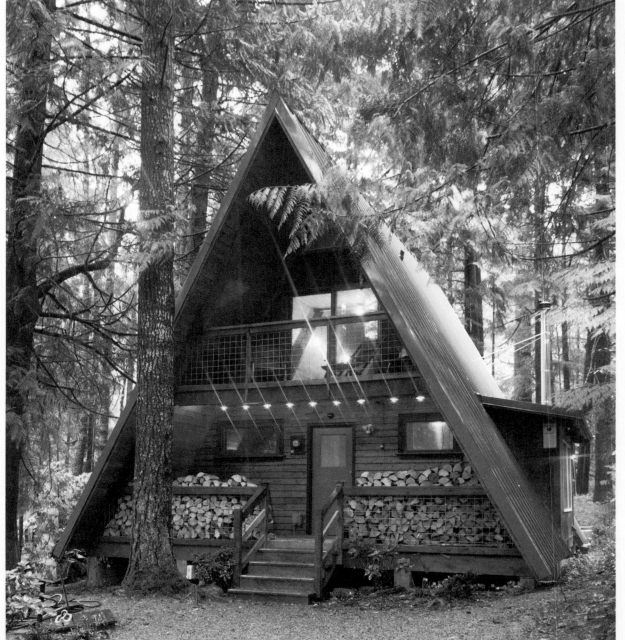

LITTLE OWL CABIN

Packwood,
Washington

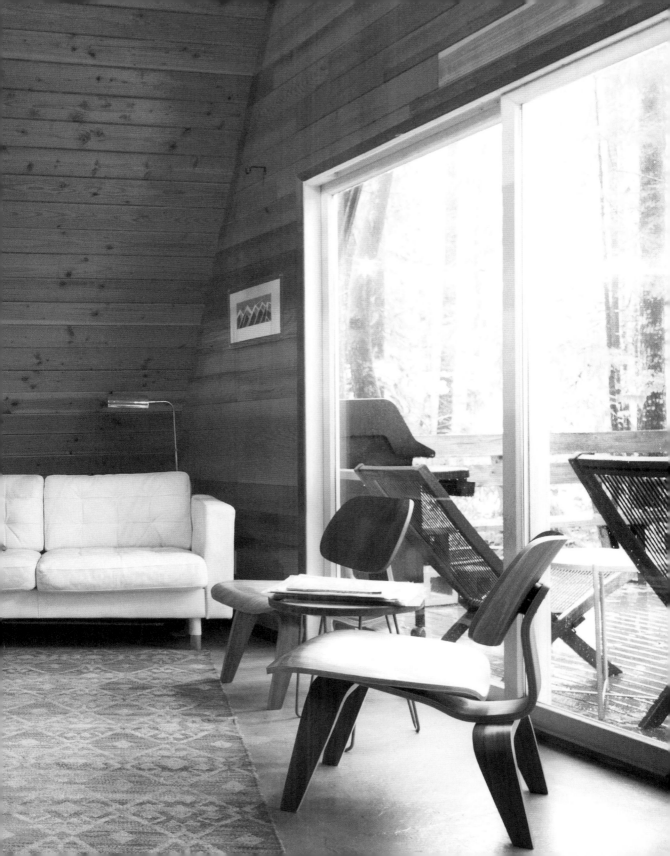

No structure looks more at home tucked in among the old-growth trees of Gifford Pinchot National Forest than an A-frame cabin.

There, just 5 miles (8 kilometers) from the main entrance to Mt. Rainier National Park in a tiny Washington town called Packwood, you'll find Little Owl Cabin. The 700-square-foot (65-square-meter) A-frame was built in 1976 with sleeping space for six, a wood stove, a covered front porch, a balcony, and a 200-square-foot (19-square-meter) deck with a cedar soaking tub.

Tiny triangular cabins were popularized in the 1950s when incomes in America ballooned and more people could afford second homes (or cabins in the woods). A-frame design is straightforward: an equilateral triangle, its peak comprising rafters bolted to the ground, with horizontal collar beams fortifying the walls and creating the cabin's signature "A" shape. The simple design means A-frames are affordable, quick to construct, and complementary to any natural setting.

Little Owl Cabin is a mid-century-modern A-frame, and its current incarnation—complete with high-end amenities and an elevated interior design—is the work of Ryan Southard. He and his wife, Val, are New York City transplants who moved to Seattle in 2013 when the hustle and bustle of East Coast urban life grew to be too much.

Ryan lived in New York for about twenty years, working as a public policy consultant. "It was the classic New York story of traveling and working," he said. "Seattle seemed like a nice step down without going totally off the urban grid. I took a job there with the city, and did that for about two years. It was just brain damage; every day felt like a tiny little lobotomy. I started getting this notion that there was something else."

On his flight home from a two-week trip to Japan, Ryan decided to quit his job. "I gave myself about a year to try out some new, potentially interesting things I might have talent for. One of the things I really enjoyed about New York, and that people told me I was really good at, was getting the best use out of tiny spaces. I lived in a lot of studios and one-bedrooms, and in thirty seconds I could figure out how to optimize a space. New York City is a boot camp for tiny living. My wife and I had always wanted a cabin. We were scouring listings out here, and on a Friday night before Memorial Day in 2015, I saw something pop up," he said.

Ryan told Val to pack a bag. First thing the following morning, they took a two-hour road trip to Packwood, Washington. He said, "We got there super early the next day, loved it, and made an offer right on the spot."

The space wasn't perfect, to be sure. "We looked around inside and could tell someone had put some lipstick on it. But it was the wrong color—like really bad lipstick. So I had to rip up all the carpet, rip out all the vanities. There was also some furniture in there that had to go," Ryan said.

Ryan spent a year renovating, and—because skilled workers turned out to be very, very hard to find—took it upon himself to do any renovations he could (and a few he figured he could learn).

"I just started looking for simple things I could start doing right away," he said. "Looking at YouTube all the time, watching home improvement videos, I just started taking it on and getting it done most of the time, and my

confidence started to snowball a bit. I certainly can't do it all, but I know what it takes to do it. I'm probably doing about half the work in this place now and using contractors for the rest. It just kind of evolved out of necessity."

Ryan is now renovating his third cabin. All three are a few miles apart in Packwood, allowing Ryan to move between cabins with ease and manage the rentals. For now, he splits his time between the cabins and Seattle, where Val still works. As for where he and Val see themselves in the future? "We're still figuring it out," he said. "I definitely enjoy being out here more than being in Seattle. I'm surrounded by trees and building things by hand. It's good out here."

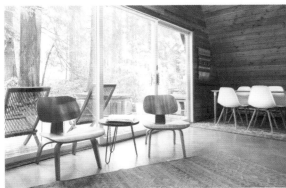

ROLLING HUTS

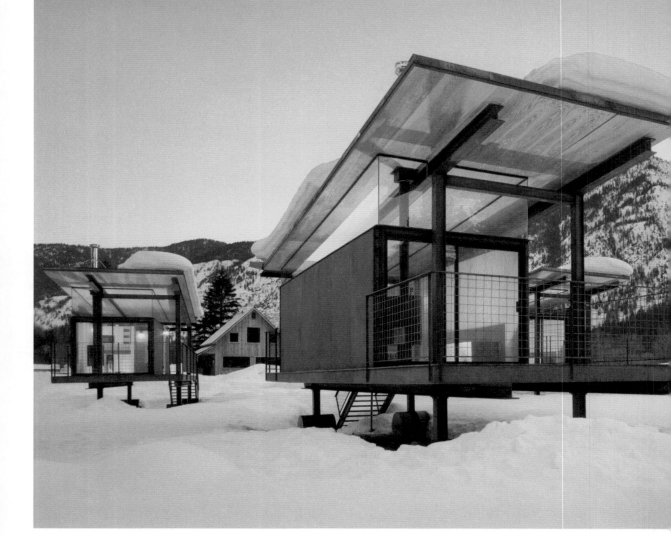

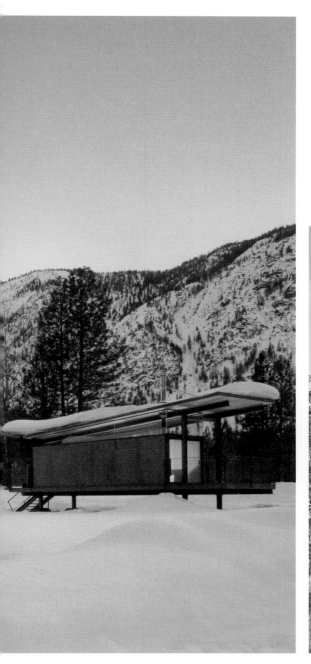

Methow Valley,
Washington

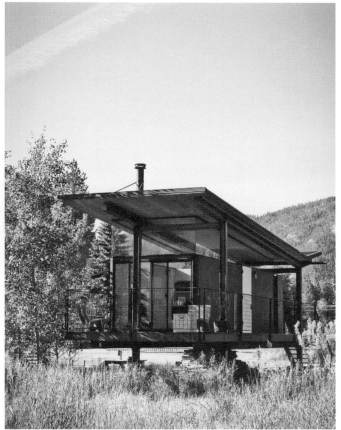

Across an open clearing in Washington State's Methow Valley, where mountains loom large as a backdrop along the Canadian border, a collection of trapezoidal steel trailers breaks up the natural landscape.

The industrial, geometric shapes—8,000 pounds (3,630 kilograms) each—are welded atop giant steel wheels and carefully designed so their highest windowed walls all overlook the meadow. Each 200-square-foot (18.5 square meter) "hut" has an interior finished with high-grade plywood and equipped with queen-size cots, a fridge, a microwave, a teapot, basic utensils, a deck, a wood stove, firewood, and an electric heater. Even the furniture is made of plywood and totally modular, allowing it to transform from bed or coffee table to benches or additional sleep space.

The rolling huts are part of the Wefola Polana ("Happy Meadow") property, bought in 2003 by Michal Friedrich. Michal was born in Gdańsk, Poland, near the famous Gdańsk Shipyard site where the Solidarity trade union movement was born amid the strikes of 1980.

Michal moved to the States in 1987 to practice dentistry in Seattle. He ended up buying a 50-acre (20-hectare) plot of land that had once been a turn-of-the-century homestead, but had been transformed into an RV park by the time Michal came upon it.

The house on the property was in serious need of an upgrade, so Michal set to work. But he was not content with rehabbing just one house—he wanted to create a "whimsical and fun" place for guests who didn't get out of the city much. So he partnered with Seattle architect Tom Kundig, who had made a name for himself creating mechanized homes featuring pulleys, cranks, and levers. Tom built what Michal fondly refers to as the "Delta Shelter," essentially a steel box on stilts with a hand-powered crank that opens and closes all four of the home's metal shutters at once.

The two men next worked to design platforms and cabins for visiting campers. Long-neglected property provided no shortage of projects. Drawing on Tom's background with industrial elements in architecture and Michal's childhood near the Gdańsk Shipyard, the two came up with simple shapes as utilitarian as they are beautiful. "My dream was to create something where families can come and be in nature together," Michal said.

The huts have electricity but no running water. Guests have access to their own composting toilet, as well as the nearby bunkhouse with showers. And those wheels? Michal installed them as a nod to the Soviet era, when the Polish people were prohibited from owning their own land and had to live in structures on wheels that would allow them to move their homes and villages when the Red Army encroached. Behind the huts are fifteen safari tents perfect for glamping; behind those are 200 miles (322 kilometers) of connected trails for hiking, biking, cross-country skiing, and running.

"You can leave and not come back for a long time," Michal said.

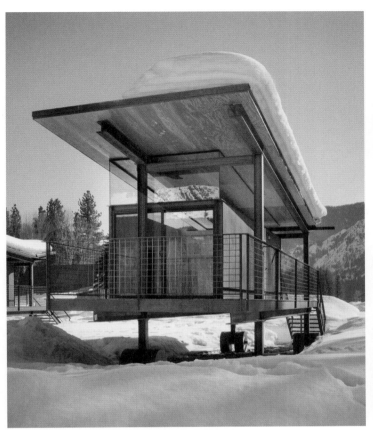

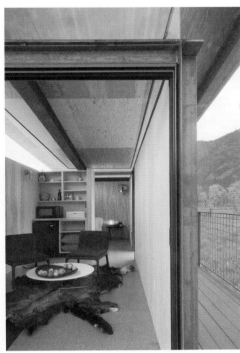

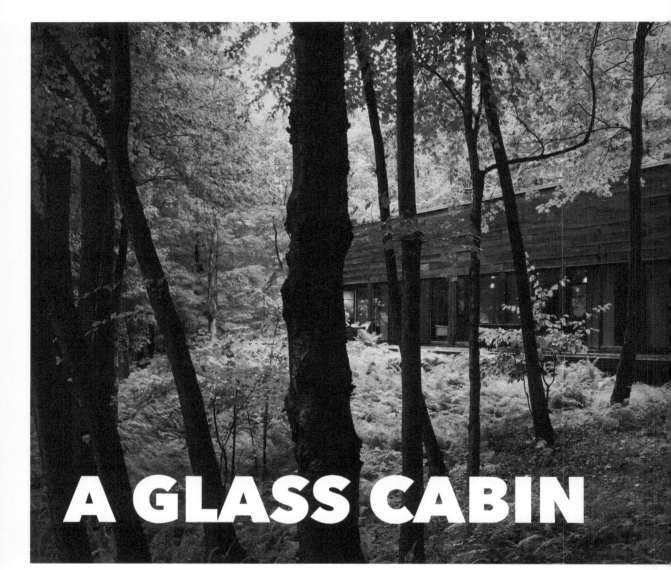

A GLASS CABIN

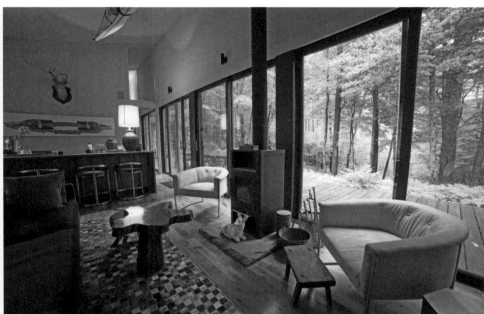

Hudson Valley,
New York

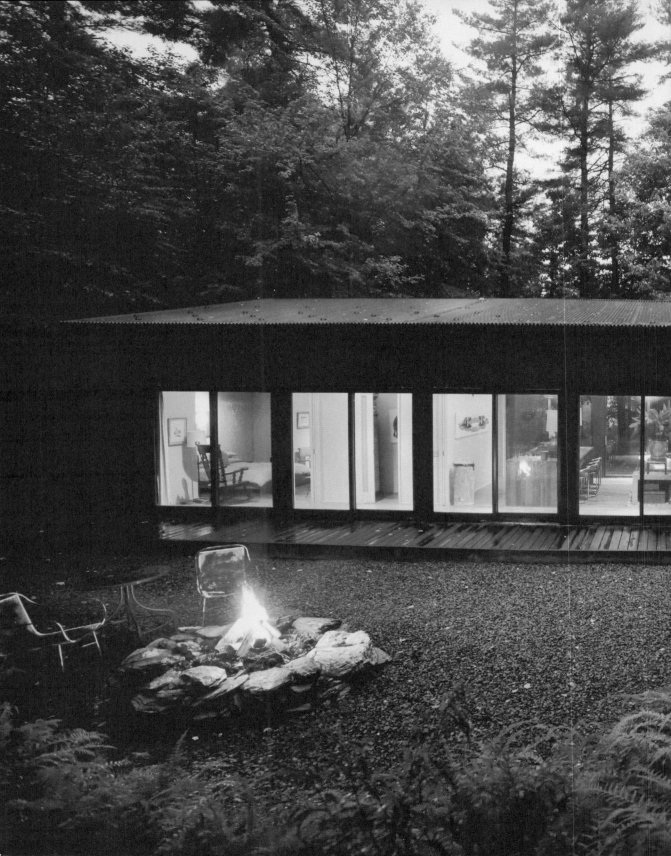

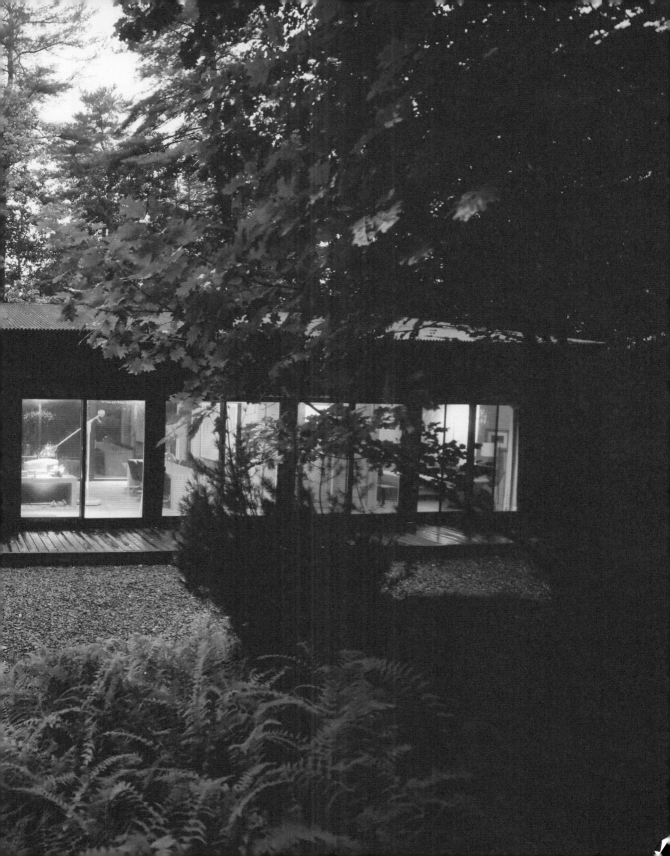

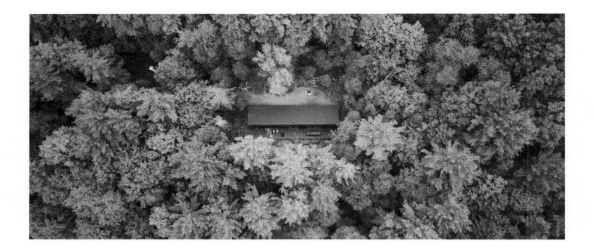

New York's Hudson Valley is known for its rolling hillsides, pick-your-own orchards, stone barns, and unparalleled autumn leaf-peeping opportunities that only the American Northeast can provide. The region's farms and artsy villages dot colonial landscapes between Westchester and Albany, towns populated by third-generation farmers and Big Apple transplants who've figured out the algorithm for escaping the hustle of city life.

One such person is architect Adam Rolston, a Los Angeles native who spent most of his adult life on the East Coast. Today, he and his partner, Martin McElhiney, are the owner-operators of the Glass Cabin, a two-bedroom, two-bath dwelling in the woods where they find refuge from the city every weekend. During the week they rent it out to urbanites seeking an escape from the bustle of Manhattan, less than three hours away.

The 1,350-square-foot (125-square-meter) cabin, tucked into a fern forest twenty minutes from the closest town, gets its name from the glass panels and windows flanking the structure along its two long sides. The open floor plan serves multiple functions: living, eating, lounging, cooking, and entertaining. The open concept also amplifies the building's communal feel: intimate, shared spaces that still feel roomy, with bedrooms on either side of the spacious living room. Actually, the entire space—all wood, which feels like a natural extension of the woods outside—feels spacious; with retractable windows and sixteen doors, it's a truly indoor-outdoor space; in the summertime you can barbecue right off the kitchen on the outdoor patio.

"Our eyeballs need to see the horizon," Adam said. "In urban life, you just don't get that. It was important for us to build a glass house to see the horizon. I can be sitting in the living room and feel like I'm camping."

Adam said the Glass Cabin has been a significant space of healing for him since its construction. "It's had an immediate emotional effect on my life."

You can witness the duality of city-meets-country living on any Friday night in the Glass Cabin: clear walls, friends communing around a table with Adam and Martin, and veggies from urban gardens cooked to perfection shared against a backdrop of crisp modern aesthetics that blends seamlessly with the natural beauty of a fern forest outdoors.

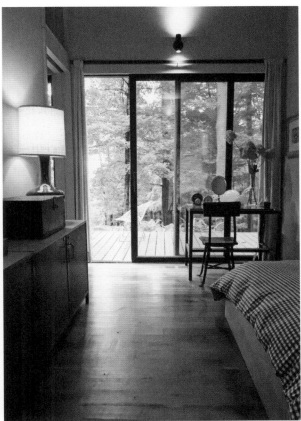

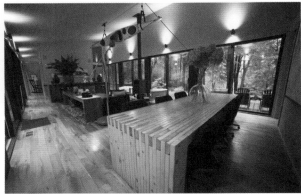

BUILD A CANVAS TENT CABIN

Canvas-walled tents can be easily erected and provide surprisingly sturdy protection against the elements. They're found on every continent and in every climate because of their efficiency, simple design, and portability—and they have been used by outdoors people, adventurers, and armies for centuries.

But while canvas tents are straightforward structures, fabricating one from scratch can be a hassle compared to purchasing a prefabricated frame to get started. A kit will ensure that you have all the important components that are easy to overlook when coming up with designs on your own. Here are some tips to get you started.

COMPARE THE COSTS OF VARIOUS CANVAS TENT BUILD-OUTS

Prices for tent cabin kits can vary wildly, depending on how much elbow grease you're willing to put into the project and where you're sourcing materials from. A full-wall tent cabin kit with canvas can range anywhere from $1,500 to $3,000 and up. A tent kit with a frame starts around $750 and climbs from there depending on size, options, and canvas treatments; a platform will run from $500 to $1,000 in materials. Add a tent stove, pantry station, and other essentials, and you're tacking on at least another $600. Material costs for a 16 by 20 ft (5 by 6 m) canvas tent that comfortably fits three or four adults will run approximately $2,200.

CHOOSE YOUR TENT KIT

A frame kit ensures you'll end up with a well-insulated structure that prevents exposure to the elements, including dust and debris. You can easily find prefab frame kits online, along with various pretreated canvases. Just keep in mind that the larger the tent, the less sturdy it will be in extreme weather (and the more complicated it will be to put up and take down). You'll want to choose the size and material of your canvas tent based on its intended purpose and location. Canvases can be treated for any kind of inclement weather condition and outfitted with any variety of doors, windows, and accessories. Flame-retardant material is a must if you're considering including a wood stove in your tent, and army duck

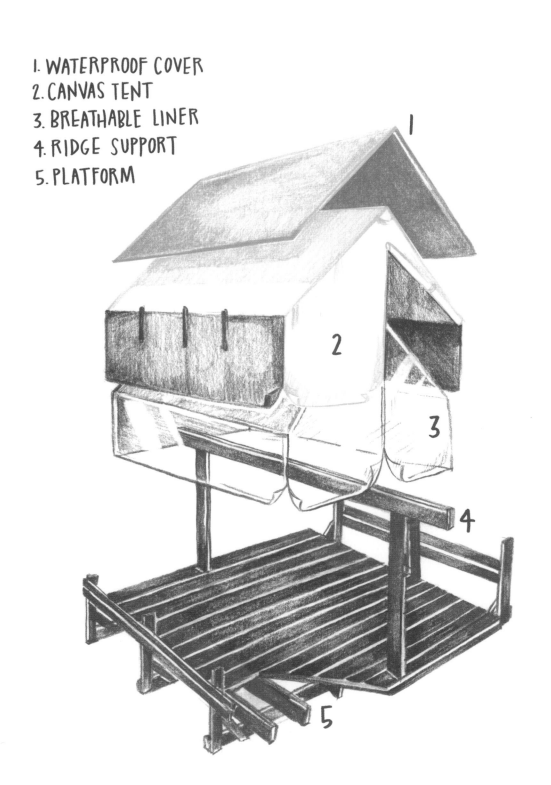

1. WATERPROOF COVER
2. CANVAS TENT
3. BREATHABLE LINER
4. RIDGE SUPPORT
5. PLATFORM

canvas treated with Sunforger will keep out all manner of wetness.

BUILD A PLATFORM

The platform will provide you with a sturdy foundation for the tent and porch area, as well as for amenity build-outs like heating, water filtration, and cooking appliances. Pro tip: Don't build your platform until the canvas tent has arrived! Fabric shifts, shrinks, and expands, and you'll save some major headaches if you take your own measurements first.

The platform should be built to the exact same dimensions as the tent. This keeps rainwater from pooling on the platform under the tent by allowing it to roll off the roof, down the sides of the tent, and away from the platform. A standard 12 by 16 ft (3.7 by 5 m) platform is the perfect size for a 10 by 12 ft (3 by 3.7 m) tent with a 4 ft (1.2 m) deck landing in front of the tent entrance. (We do recommend including a ½ in [12 mm] gap between platform and deck so that rainwater can escape through the crack instead of into or under the tent.) This size is big enough for a wood stove, two people, a queen bed (or two singles), and some basic furniture—but if you're looking to house more than this (or you're at all in doubt of the size you need), you should definitely consider going bigger. You should always assume you'll need 20 square ft (1.9 square m) per person for sleeping, and at least 50 square ft (4.6 square m) per person if you expect to cook, bathe, use a toilet, or work in the space (or all of the above). Consider 12 by 16 ft (3.7 by 5 m) the smallest you should go for two people.

Lumber and hardware for a platform utilizing 2x4s and ½ in (12 mm), exterior-grade plywood runs around $500. Built properly, the platform can be disassembled with a screwdriver and will fit in the back of a pickup. Also be sure to buy frame leg anchors to secure the tent to the platform. This will help prevent sliding during intense winds.

CONSTRUCT THE TENT

It is easiest to raise the tent with at least two people. Stake together the doors at the bottom, then your four corners (drive the stakes only halfway in to start). Remove the stakes holding the doors together and put the ridgepole into the tent along with an upright. After lifting the ridgepole and inserting the upright, work your way around the tent, inserting more uprights into the ridgepole and staking down the ropes.

SELECT A TENT STOVE AND ACCESSORIES

Once you have the platform, frame, and canvas tent assembled, it's time to accessorize the space with necessities like a tent stove, storage, and optional add-ons like a rain fly and French or double doors. A tent stove is a must-have, but also requires a protective stone fire mat, heat shield, and exhaust system. Adding a pantry and storage unit will help maximize space in the canvas tent.

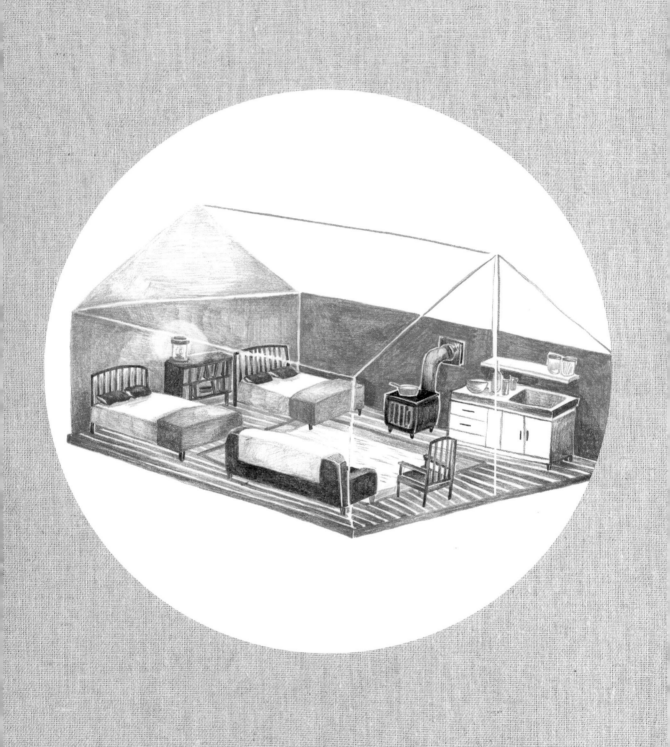

TAP A MAPLE TREE

There is a rhythm to the natural world. And one of the great joys of getting outside is being able to tap into nature's offerings. Sugaring—the act of tapping maple trees to extract sap that can be boiled down to syrup—is an exercise in following the natural order. Timing is everything as you wait for the pressure in the tree's trunk to be just right before you carefully siphon off some of its natural sugar water.

Sugaring isn't complicated, but it is a great test of patience. The ratio of sap to syrup is about 40 to 1, so you can see you'll need to do a lot of tapping and boiling to produce enough syrup to be worth the effort. Here's what you'll need and how to pull it off.

MATERIALS

- Maple trees with diameters of at least 1 ft (30.5 cm)
- Spiles (the tubular metal sleeves that you actually tap into the tree—they usually come in $^{7}/_{16}$ in (11 mm) or $^{5}/_{16}$ in (8 mm) sizes)
- Cordless drill
- Drill bit corresponding to the size of your spiles
- Hooks for sap buckets
- Buckets (metal or plastic is fine) with lids
- 5 gl (19 L) bucket (for transporting the sap)

- Heat source for hours of boiling (an outdoor kitchen is a must, unless you're into peeling the paint off your kitchen walls)
- 16 qt (15 L) pot(s) for boiling the sap
- Metal ladle
- Restaurant-grade filter paper, coffee filters, or clean felt for filtering out particulates

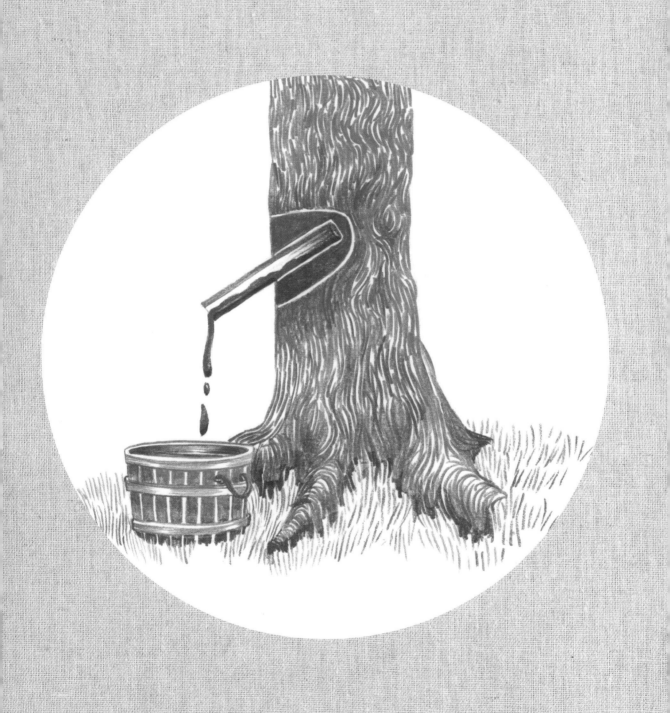

HOW TO PREP FOR TREE-TAPPING

The best time to plot your tree-tapping is in the autumn, when maple tree leaves turn from bright green to vibrant red and orange. To ensure a good sap run, you need trees that are at least 1 ft (30.5 cm) in diameter. Tie colorful ribbons on the maples that you're planning to tap so you can easily find them when it's time for tree-tapping (we recommend making a map too, so you can keep track of where everything is on the property you're tapping). Then watch and wait until overnight temperatures are consistently below freezing and day temperatures are above freezing. Sap flow is subject to pressure between tree trunks and roots, which is impacted by rising temperatures. When you tap a maple tree, you're severing the wood fibers that carry water throughout the tree, which causes the sap to drip out. Timing is everything!

HOW TO TAP YOUR MAPLE TREES

Grab your spiles, drill, drill bit, buckets, lids, and hooks, and head out to your trees. Again, tap only trees that are at least 1 ft (30.5 cm) in diameter. For every additional 8 in (20 cm) in diameter, you can add another tap to the tree.

1. Drill a hole for each tap about 3 ft (91 cm) up from the ground. Make the hole angle slightly upward to help the sap run down the spile.

2. Clear out any wood shavings from inside the hole as best you can.

3. Put your hook over the spile and use a hammer to carefully tap the spile into the tree—no need to overtap! Just get the spile to fit snugly in there so it won't fall out.

4. Hang your lidded bucket on the hook.

Check your trees every day to see how the sap is running. It's important that sap be kept below 50°F (10°C)—so if temperatures are fluctuating, pour your buckets into a 5 gl (19 L) bucket daily that you keep refrigerated (don't be shy if you want to sample your sap—we can never resist taking a swig right out of the bucket). Once you have a nice amount, you can get ready for boiling. That could be several buckets' worth or, if you're doing a small batch, whatever you're comfortable with. Just keep in mind that 40-to-1 sap-to-syrup ratio.

HOW TO MAKE THE SYRUP

When you're ready to boil, make sure you have all your equipment ready and a solid chunk of time (at least seven hours) to spend hanging around an open flame as you cook down your sap into syrup.

1. Sterilize all cooking utensils (metal ladle, large pot, and so on). Sugar is a breeding ground for bacteria, so this is not the time to get lax about keeping things clean!

2. Set up the pot(s) on an outdoor range, grill, or hotplate. Pour the sap into the pot(s) and bring it to a boil over medium heat (medium will allow for a gradual, all-over boil without scorching the sap at the bottom of the pot). Again, this is not something you want to do indoors.

3. The boiling time, depending on how much sap you have, could range from 7 to 12 hours. The peak temperature of the sap should be 7 degrees above the boiling point of 212°F (100°C).

4. The syrup is done when it coats the spoon of the metal ladle instead of running off like water.

5. Filter the syrup while it's still hot by running it through the filter material.

6. Pour the syrup into clean bottles and refrigerate.

7. Remove the spiles at the end of sugaring season, when overnight temperatures stay above freezing. To prevent insects from getting into the holes you bored, pack them with the shavings from when you drilled the holes or tree repair putty from a hardware store.

8. If you don't have enough trees to rotate their use every other year, be sure to drill new holes each season, at least 3 in (7.5 cm) away and 5 in (12 cm) or so above or below the previous tap hole.

How-to

NATURALLY CURE, SMOKE, AND PRESERVE WILD GAME

You can preserve meat using a slow-cooking method. Whether you're living off the grid and need to store food for the winter months or just looking for an excuse to get outside and play with knives and fire, the ancient art of preserving meat without refrigeration requires skill and plenty of time. Here's how to cure your own.

DRY PRESERVATION METHOD FOR PORK

Dry preservation is the most straightforward and commonly used method of curing, and the meat will keep for several months (the higher the fat content, the less time it should be stored). You'll have to practice and adjust the recipe to get the balance right. Not enough salt and the food will spoil prematurely; too much salt and your finished product may be way too salty for consumption.

WHAT YOU NEED

- 12 lb (5.4 kg) cleaned raw pork or other meat
- ½ lb (230 g) food-grade pickling salt with no additives
- ¼ cup (50 g) brown sugar
- Crocks or jars
- Cheesecloth
- Cold storage

SALTING PORK

1. Cut the pork into 4 to 6 in (10 to 15 cm) long slabs.

2. Combine the salt and brown sugar.

3. Thoroughly coat the slabs of pork with the salt-sugar mixture.

4. Put the meat into sterilized crocks or jars and cover with cheesecloth.

5. Store the meat in a cold shed or garage at temperatures between 33°F (1.7°C) and 38°F (3.3°C) for at least one month.

6. Wrap the cured meat in plastic wrap or moisture-proof paper and store in a cool, dark, and dry place.

HOT SMOKING METHOD

The goal with hot smoking is to cook and dry the meat while flavoring it with the smoke. Playing with different wood chips dramatically changes the flavor profile, depending on the wood's characteristics. Select a wood that will complement the type of meat you are smoking.

WOOD CHIP FLAVOR AND SMOKING PROFILES

APPLE: Smoky-sweet, mildly fruity flavor. Imparts the strongest flavor of all the fruit tree woods; works well for mixing with other wood types.

CHERRY: Sweet, mild, and very fruity. Gives light-colored meats a rosy appearance.

HICKORY: Very strong and pungent; imparts a bacon-like flavor. May cause bitterness if not used correctly. Hickory is the most commonly used wood for smoking and works especially well with pork and ribs.

MESQUITE: Creates a strong, earthy flavor and produces lots of smoke. Sweeter and lighter than hickory, but can also become overpowering if not used correctly.

WHAT YOU NEED

- A firebox and attached smoke box
- Hardwood or fruit wood chips
- Calibrated thermometer
- Pork

INSTRUCTIONS

1. Load the firebox with wood chips and light them.

2. Fire the chips until the thermometer in the smoke box registers 160°F (71°C).

3. Place the meat in the smoke box.

4. Check periodically and continue to add wood chips as needed to regulate the temperature.

5. The general rule is to cook about 90 minutes per pound (455 g) of meat. The meat is done when the internal temperature reaches 200°F (95°C).

6. Store in a cool, dark, and dry place. Smoked fish will keep for up to a week; most meats will keep for two weeks.

CUT, SPLIT, AND STACK FIREWOOD

It's true what they say: Firewood warms you twice—once when you cut it and once when you burn it. With the right wood and tools, you'll keep yourself snuggly warm in your cabin, tent, farmhouse, or yurt all winter long.

Timing is important when it comes to cutting, splitting, and stacking firewood. Ideally, wood should be cut at least six months before it gets burned (unless you're dealing with standing dead, dried-out trees). Cutting wood in late winter and early spring allows for maximum drying time before you need the wood for the next cold season.

For indoor burning in a furnace or wood stove, be sure to cut only hardwoods like oak, maple, or ash. Pine sap clogs stovepipes—and a chimney fire in the dead of winter is no fun for anyone.

SUPPLIES

- Work gloves
- Sturdy boots (ideally with metal toe caps)
- Splitting maul
- Safety goggles
- Chainsaw with a 16 in (40.5 cm) bar (minimum)

CUTTING THE WOOD

Once you've identified the trees or logs you're going to cut, suit up and start by using the chainsaw to limb the log, cutting off all the branches. Then cut the log up into 16 in (40.5 cm) sections (this is standard wood-stove size—but be sure to first check that this length fits into yours!). Before you cut, make small notches every 16 in (40.5 cm). (Tip: if you're using a 16 in [40.5 cm] chainsaw bar, you can use that as a guide instead of a tape measure.)

Cut the log up with the bar flat on the groove, taking your time as you bring the blade through the log in as straight a line as possible (this will make splitting significantly easier). Be careful to not let the wood pinch your chainsaw as you move it through the firewood. Often, wider logs will close in on your saw as they're cut, their weight "pinching" the blade and jamming the chainsaw. Cut only about three-quarters of the way through the log, then roll the log over

and cut the rest of the way from the other side. This will also keep the saw out of the dirt and gravel, which can dull a blade.

SPLITTING THE WOOD

Move your cut logs as close to where they're going to be stacked as you can (another firewood adage: move it as few times as humanly possible). To split the logs into

burnable pieces, you'll set each log on a chopping block—this can be another block of wood that's as wide as or slightly wider than the piece you're splitting.

Get into position: place your feet shoulder width apart and hold the handle of the maul with your less-dominant hand while your dominant hand grips the top of the handle near the chopping head. Take a few slow-motion practice swings: Bring the maul up over your head, and as you bring it down, make sure it's directly centered over the piece of wood. As the maul drops toward

the log, slide your dominant hand down to your other hand at the base of the handle.

DO NOT swing the maul like a pendulum! The tool should go down directly centered, straight, and vertical onto the piece of wood. You don't want the momentum of your swing to bring the maul back toward your body!

You may find that the wood does not split completely and the maul stops midway through it. If you can, lift the log with the maul handle, turn it over, and swing the reverse side of the maul into the chopping block. The weight will often finish the split.

STACKING THE WOOD

Stack the wood on ground that is level and dry, and keep the woodpile out of direct rainfall. There are several established types of stacking structures, but ultimately your storage space will determine which structure works best for you. The most basic structure is the simple stack: rows of wood pieces with a vertical stop at one

or both ends. This stop is most commonly made out of a column of wood pieces arranged in perpendicular rows.

BUILD A WOOD-FIRED HOT TUB

Baths, hot tubs, and natural springs have been used as places of communion, camaraderie, and transformation for millennia. The oldest hot tubs were hot springs in natural pools, or vessels heated by submerging piping-hot stones in the water. Ancient Egyptians were the first to bring tubs into their homes, where water was warmed and enhanced with essential oils and flowers to bring about physical and emotional healing.

Greeks built pools around natural volcanic springs; the Romans constructed aqueducts to funnel warm water to bathing tubs. Wooden soaking tubs have been utilized in Japan for more than a thousand years, and Native Americans used hot springs for healing long before any colonists arrived.

American troops returning from Japan after World War II brought back Japanese bathing culture—specifically heated wooden tubs. Discarded winery equipment like barrels became popular vessels for hot tubs in the mid-twentieth century. These containers offer the most straightforward designs, and many people who build their own hot tubs today continue to utilize old barrels, troughs, and tanks.

Whether you upcycle materials, buy a fully outfitted kit, or figure out your own methodology for installation, here's a basic guide for constructing your own wood-fired hot tub. What materials and supplies you'll need will vary depending on whether you buy a kit or source things yourself.

STANDARD MATERIALS

- Base
- Joists
- Hoops, bands, or cables
- Staves
- Rubber mallet
- Painter's tape
- Lugs or couplers
- Drain with piping
- Sandpaper
- Bolts
- Brackets

SELECT YOUR LOCATION

Though you may be tempted to set up a hot tub in a remote location, if you're going to keep a heater in the tub when not in use, utilize filtration, or include lights or sound, you'll need to be near a water source and power. Also remember that you'll need easy access to the tub's drain and a flat location that can hold significant weight (the ground is always more trustworthy than a deck).

To prevent the tub from sinking into the dirt below (when filled with water, most tubs weigh anywhere from 1 to 5 tons [.9 to 4.5 metric tons]!), first, construct a foundation made of beams, piers, posts, or—most reliably—cement slabs or blocks. It's essential to allow plenty of ventilation under and around a wood hot tub so moisture doesn't collect and rot the tub.

CHOOSE YOUR DESIGN

Wood-fired hot tubs can be heated internally, with what's called a snorkel stove, or externally, with a stove that sits a few feet from the tub. Snorkel stoves are the most efficient way to heat a hot tub, as all the heat produced goes directly to the water. These stoves have an opening at the top for feeding the fire and a chimney for smoke to escape. Exterior heating units warm water that is piped from the tub by convection to the heating unit and back into the vessel. For first-timers, a kit ensures the best seal on tub walls, the most efficient heating, and the security of knowing the parts will all fit together properly. Many components of a wood-fired hot tub require planing, welding, and metal work; it's best to leave those jobs to the professionals.

Reasonably priced cedar kits for a tub that can accommodate four people run around $4,500. You can build your own from scratch for less, but tracking down clear runs (knot-free boards) of cedar, making sure the parts fit correctly, and building the stove can become time-consuming and a logistical nightmare—convincing most people to cough up the extra cash for a kit.

CONSTRUCTING THE TUB

1. **SET THE TUB BASE.** With a cement pad or other base in place, lay evenly spaced beams in a row on the base. The spacing between them will allow for air flow underneath the hot tub and prevent mold and rot. Assemble the tub bottom on top of these joists, making sure the wood is perpendicular to the beams so everything is evenly supported. Check the base with a level—an uneven tub is prone to malfunctions.

2. **INSTALL THE DRAIN.** Whether you have a drain kit or are assembling it yourself, it's easiest to install it in the tub floor before the walls have gone up. Bathtub drains work fine for this, but you may

want to consider a ball valve as backup in case the drain leaks.

3. **ASSEMBLE THE HOOPS AND BANDS.** Put together the hoops, bands, or vinyl-coated cable that you'll use to hold the tub's walls in place. Slide one hoop down over the base—this will be the first hoop and closest to the bottom, so it's helpful to have it in place, ready to be slid up around the staves, as they will add several feet to the tub's height.

4. **STAND THE STAVES.** Tap the staves into the tub's grooves with a rubber mallet. You'll tighten things up later, but for now you need to just gently get everything in place. If a stave doesn't quite fit into the groove, sand or shave it. There should be a slight gap between the staves—this will allow you to make them uniformly tight later. If you have trouble keeping the staves standing as you move around the tub, you can use blue painter's tape to hold them in place.

5. **ASSEMBLE AND SLIDE THE HOOPS OR BANDS OVER THE SIDES.** Assemble the bottom hoop at the base (if you haven't already staged it) and slide it up. The rest of the hoops can be assembled and slid down from the top of the tub. Slide the hoops before you add any lugs, couplers, or other hardware so they don't damage the wood while you slide the hoops. If the tub is 3 ft (91 cm) high, you'll need hoops at the following heights, from the bottom up: 4 in (10 cm), 14 in (35.5 cm), and 32 in (81 cm). For a 4 ft (1.2 m) high tub, hoops can go at 4, 14, 28, and 44 in (10, 35.5, 71, and 112 cm). If you're having trouble keeping the staves in place, use

ratchet straps to hold them together. Once all the hoops are in place, they can be tightened up. Do not overtighten! Lugs should span the seam between two staves, rather than being located squarely over an individual stave.

6. **MIND THE GAP!** Walk around the tub and make sure there are no gaps larger than 1/8 in (4 mm) between staves. If there are, loosen the hoops or bands and make necessary adjustments, then tighten again.

7. **ROUND THE TUB.** To round the hot tub, use the mallet to tap the staves toward the center of the tub, tightening the hoops or bands gradually as you make your way around the tub. If you have a willing helper, have them do the tightening while you swing the mallet. Start with light taps, then gradually increase the strength of the blows. Be careful not to overtighten the tops of the staves—when done, the tub should have straight sides (not conical).

8. **SMOOTH THE STAVES.** Walk around the tub and sand the top of any staves that feel rough to the touch. No one likes a splinter while climbing in or out of a hot tub!

9. **INSTALL THE STOVE AND FENCE.** Even a heavy stove can become buoyant when immersed in water, so be sure to properly secure it with carriage bolts and mounting brackets. Be sure to put down a base for the stove to rest on. Once the stove is in, add at least 6 ft (1.8 m) of stovepipe and a fence that will function as a divider from the heating and seating areas. If you're installing an external

stove, be sure the placement works with where you want the benches and where the drain is, and that it provides easy access for loading wood.

10. **BUILD THE BENCHES INSIDE THE TUB.** Be sure to build benches at different levels so the tub can accommodate people of different heights, and so you can have a spot higher up for cooling off or deeper for being more submerged. Make sure any hardware you use is corrosion proof.

11. **GET READY TO SOAK!** Fill the tub with water and fire up the stove! Most owners of wood-fired hot tubs refill the tub weekly so that no chemicals are necessary (some people do add hydrogen peroxide to lengthen the life of the water in the tub). If you don't add any chemicals, you can use the old water for garden irrigation.

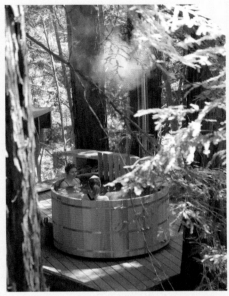

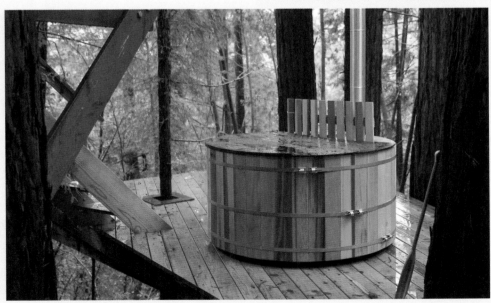

Part II
COUNTRYS

Inspiration

Dwellings

Provisions

Essentials

More and more I find I want to be living in a Big Here and a Long Now.
—Brian Eno

When you spend more time in nature, you notice how wild things react and adjust to the seasons. You learn to count time with natural cycles: when chickens lay eggs, or what inspires bulbs to reach up through the soil. You learn how to move around a beehive without getting stung. The countryside gets us in tune with the cycle of nature and reconnects us with the essentials of growing food for ourselves.

Across America, thousands of people are leaving cities and buying plots of land like those their great-grandparents farmed generations ago. They seek out country landscapes that offer unobstructed views of rolling farmland, hills, barns, and meadows; their homesteads feature big front porches and vegetable gardens. These former urbanites are learning how to work with their hands, grow their own food, and fix what they have instead of buying new replacements. They are discovering a slower pace of life, rewarding daily work, and the satisfaction of truly carving out their own place in the world.

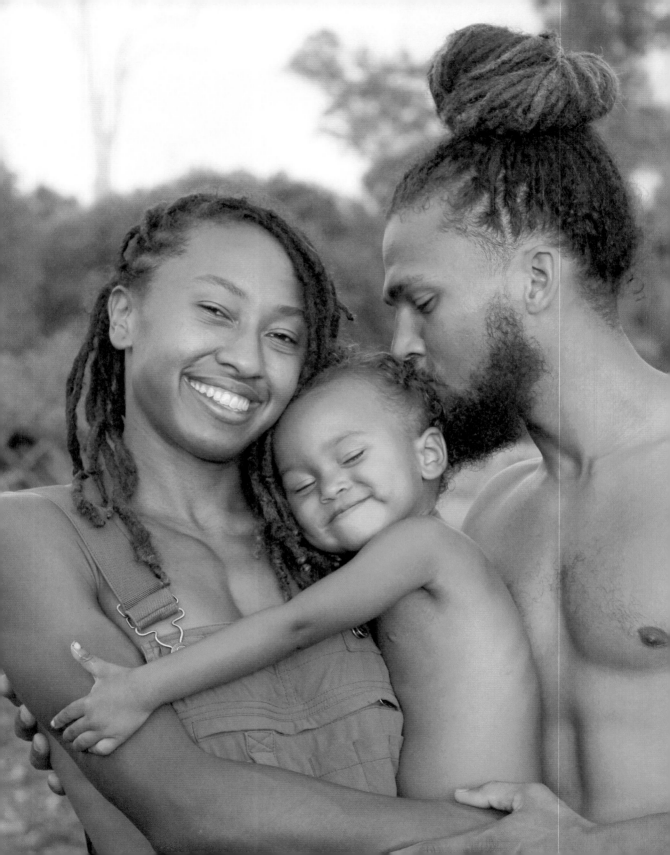

A FARMER'S PARADISE: AINA & CO

The Big Island, Hawaii

Detroit might seem like an unlikely place for an organic farmer to grow up. The lush lettuce farm Adonis Ward runs in Hawaii with his wife, Asia, is a world away from the sprawling industrial city where he was raised. And Adonis might have resigned himself to an urban existence had it not been for several formative experiences early in his life, along with a fortuitous stroke of luck.

Adonis got his first taste of what life might be like beyond Detroit's borders through conversations with his grandfather—conversations that left him inspired and hungry for new experiences. "My grandfather came from an agricultural background and would share stories with me. I developed a connection to nature through him," he said.

And Adonis's interest in the natural world grew as he experienced the world beyond Detroit as an adult. He and Asia both worked for airline companies, and their occupations allowed for frequent and affordable travel. As they discovered the world outside their hometown, the two quickly developed an affinity for more temperate locations. "I felt more at home in tropical climates. I felt I was a tropical being," Adonis says. They were tired of the harsh and lingering Detroit winters that seemed to last an eternity, and the allure of a lifestyle that would allow them to spend more time in nature—especially in a place that was warm—intrigued them.

They were also eager to embrace a more natural way of life, one that provided a chance to explore their interests in health and wellness, which went beyond just shopping at a health food store or watching what they ate. "I considered myself healthy, but as I searched deeper, I realized it went beyond eating healthy. It was about reconnecting to nature and how natural elements are part of our well-being."

Together they adopted as much of a healthy, natural lifestyle as they could in Detroit by following a mostly raw vegan diet and composting their food scraps. "Clean air, clean water, clean food, undoubtable," became their mantra. And they started to focus on how they might build the life they dreamed of, what Adonis calls "paying dues back to the dirt."

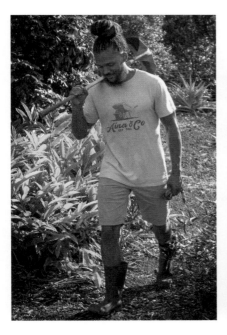
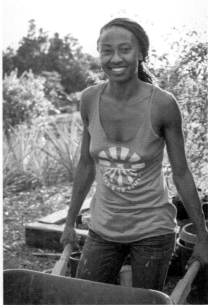

"I wanted to take on that responsibility for myself and my family," he said. "I dropped any fear of giving it a try. I decided I would put all of my energy into being a naturalist, a man that interacted with the elements of the earth." They were ready to make a drastic, but necessary, change.

A LEAP OF FAITH

As Adonis and Asia planned their next move, the couple considered places they'd visited in the past that could provide the lifestyle they were hoping for and immediately settled on the Big Island of Hawaii. They had reservations about making such a huge move without much of a safety net, but they both believed they could make it work, so they took a leap of faith. Adonis got a job transfer, and they made the big move from Michigan to Hawaii in 2014. "We didn't have a place to live in Hawaii, didn't know anyone when we arrived there, came with no savings. But I knew the pressure would make me figure it out," Adonis said.

Their dream was to start their own farm where they could grow food, despite a lack of prior farming experience. That dream quickly began to feel like an impossibility when they learned Hawaiian land was some of the most expensive real estate in the world. But they were determined, so to make their dreams a reality, they got creative. "I told Asia, 'I believe there must be someone in Hawaii with land who has their hands full and is willing to help us out; we just need to find them,'" Adonis said. They posted an ad on Craigslist, and several days later they received a life changing message from Lindy Lou Pounds: "I have 16 acres (6.5 hectares) of land that I don't use, and I think it's yours."

The land had belonged to Lindy's late husband, a lettuce farmer, and she had planned to sell it until Adonis and Asia came along. They fell in love with the property on their first visit. "It was the most beautiful piece of land; it just needed some love," Adonis said. Two weeks later, the couple was living on Lindy's land.

With all the puzzle pieces falling into place, Adonis resigned from his full-time job so that he could finally lead the life he'd sought for so many years. "We gave everything we had to revive that land right away," he said of those early days on the farm. "We worked from sunup to sundown, happy as can be. It wasn't a business yet, but we enjoyed waking up to the land every day and working our butts off."

Lindy became an invaluable source of information and support for the Wards. She taught Adonis and Asia everything she knew about farming and taking care of the property. Lindy was impressed by their tenacity and aptitude for agriculture, and convinced them to start a business. She helped them build a list of customers, and allowed them to carry on her husband's legacy through his brand, Sam's Organic, a well-known purveyor of quality lettuce. Their first victory came when they received an order from a small vegetable stand; three heads of lettuce signified the start of something major.

Adonis began making weekly lettuce deliveries and seeking out new vendors for their product, and eventually orders started to pour in. Within a couple of years, they had grown into the largest supplier of local organic lettuce to the west side of the Big Island. And as they grew, they remained loyal to their naturalist philosophy, using oil derived from neem trees as a natural pesticide and fertilizer—it's the only thing sprayed on Adonis's lettuce crops. "We're living the dream," Adonis said. "Growing food, eating healthy, providing healthy produce throughout the island."

In 2016, their family grew with the arrival of their daughter, Aina, whose name means "the land that feeds us" in Hawaiian. And that same year, they finally accomplished their biggest goal when they purchased their own land, just ten minutes away from Lindy's property. Aina, now three years old, is Adonis and Asia's biggest inspiration and a constant reminder of the values that brought them to Hawaii in the first place. She became the namesake of their farm, which they rebranded as Aina & Co, and has quickly become a little farmer in her own right.

It's been five years since Adonis and Asia left Detroit. Today, thanks to an ambitious Craigslist ad and tons of hard work, they now oversee more than 20 acres (8 hectares) of land in Hawaii. Through it all—growing a business, starting a family, and expanding their land holdings—they have managed to remain true to their original values: connecting with nature, providing healthy food, and paying their dues to the dirt.

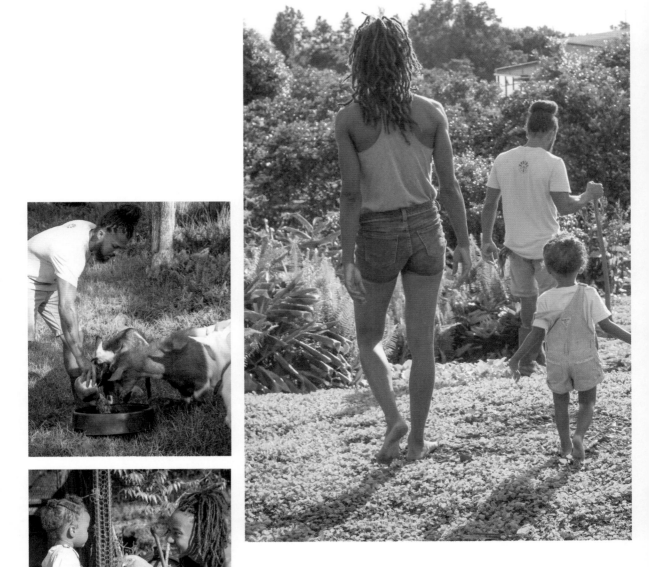

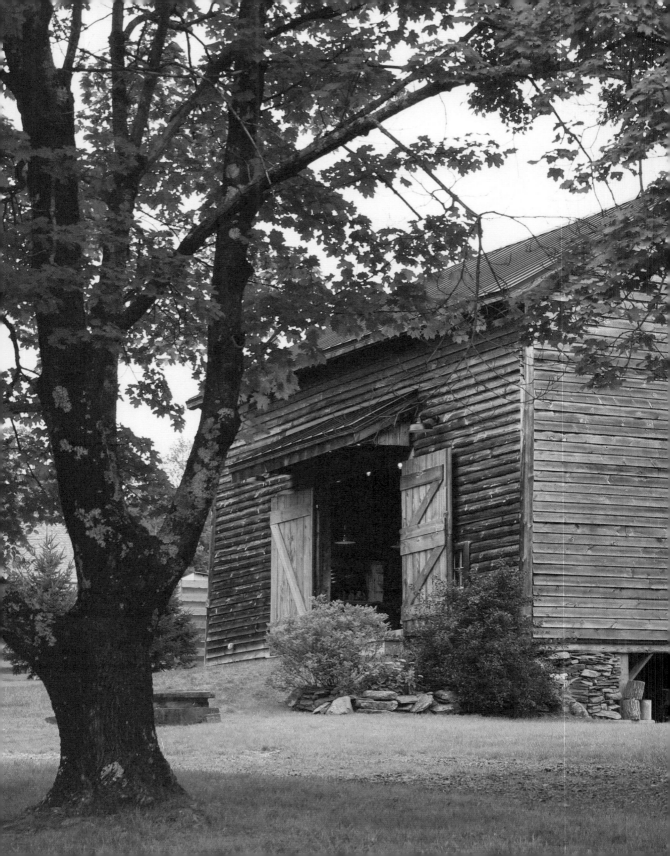

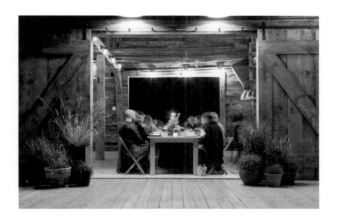

FARM, FOOD, AND DESIGN: RAVENWOOD

Kerhonkson, New York

For Dana McClure and her husband, Chris Lanier, the transition from city living to farm life has been less of a leap and more of what Dana calls a "slow-growing experiment."

That's because the couple didn't uproot all at once to forsake the charm of Brooklyn life for the rolling hills of New York's Hudson Valley. Their transition was gradual, and at times so subtle as to not seem like much of a change at all. What started out as days or weekends away grew, over the years, into a desire to live off the land, create in new ways, and gradually wean themselves off of full-time jobs in favor of starting something new of their own.

After years pursuing various options, in 2010 the couple found a house and 4-acre (1.5-hectare) lot on Ravenwood Road in Olivebridge, New York. They set about amending the soil there to support growing food, and they slowly settled into the 1977 farmhouse.

Now they're using their property to explore the intersection of food, agriculture, and local artisans with an on-site farm stand and a monthly dinner series featuring food grown just steps away.

CITY PURSUITS FOUND A HOME IN THE COUNTRY

Dana was born and raised in New Jersey, moved to Syracuse for college, and then lived in New York City to attend the prestigious Parsons School of Design. Chris grew up in Yoakam, Texas, and pursued the culinary arts early on, living and working as a chef in Austin, Chicago, and Aspen before settling in New York in 2003. Despite spending his adult life hopping between major American cities, Chris always longed for the open space and quiet he'd grown up with.

During the years they lived in Brooklyn, Chris was an accomplished chef and food stylist, while Dana's successful design career included teaching for a decade at Parsons and New York University.

"Chris was doing all kinds of restaurant work and private cheffing, while I was doing film and design," Dana said. "I was probably perfectly happy to stay in Brooklyn forever, but the city was kind of getting to Chris." The couple had worked to bring elements of the natural world into their home even then, with a rooftop garden that was growing at capacity.

Dana and Chris decided to give country living a try for the summer, and they stumbled onto an opportunity to live on a farm in East Hampton on the South Fork of Long Island with a third-generation potato farmer who was growing a variety of vegetables. Chris got a job working at the farm during the week and as a private chef on weekends.

"I was living in the farmhouse close to the beach, picking vegetables and cooking in this little cottage," Dana said. "And we were like, 'Oh, this is country living!' That was silly.

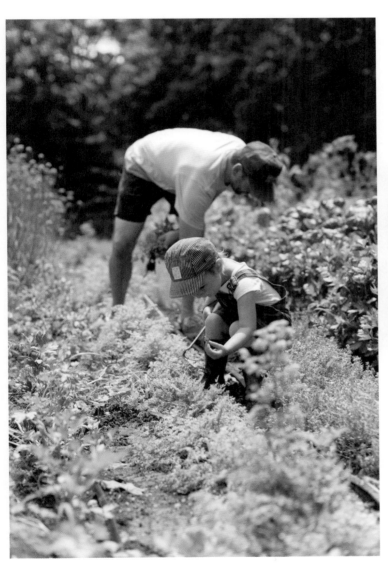

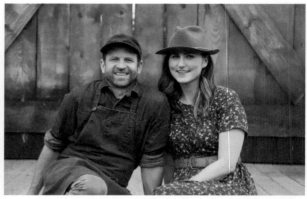

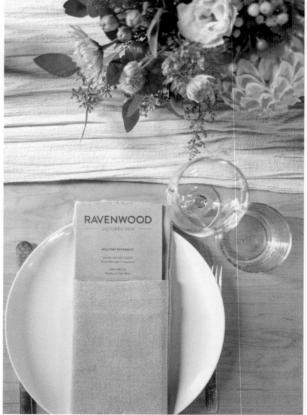

RAVENWOOD

OCTOBER 2018

WELCOME BEVERAGES

But that was still our test of living outside the city and what it would be like. We did that for two summers, and it was our impetus for our upstate adventures and mini-vacations."

Chris caught the food-growing bug, and so the two began looking for a small farm property where Chris could grow his own food to cook. They didn't care about the number of rooms or the house so much as they were looking for the land to make their vision a reality.

When they bought Ravenwood in 2010, they started growing produce right away. But the soil was unforgiving, so they took to the "lasagna method," in which you essentially make your own soil with layers of compost and other biodegradable materials like leaves. They spent several years getting the soil to where it needed to be. "We made a ton of mistakes, but we had so much more energy," Dana said.

With that energy, they hosted friends for their first dinner made from produce grown at the farm, at the loft space they still rented in Brooklyn.

They hosted a number of these parties at a variety of locations. But the trick, they figured, was to get people upstate for these events so they could interact with where the food was grown and be in a space meticulously designed for the experience.

"The dinners are our opportunity to pull together people who are doing really incredible things—whether New York State winemakers, bread makers, the person who made the linen on the table, or the flower arranger," Dana said. "The menu is designed to give props to all these incredible people and celebrate the time and place. The idea

was to have them once a month, at the end of every month. So at the end of June, you're getting a sense of what the Hudson Valley region smells like, tastes like, and looks like at that time of year. We even stopped bringing in outside wine."

MAKING RAVENWOOD HOME

Dana and Chris acquired an 1850s barn on an adjoining property, which they renovated to become a shop and event space. This new setup allowed them to cut ties with their Brooklyn loft once and for all, and in 2015 they transitioned to living full time at Ravenwood.

> *"So what we're offering isn't so much buying a bunch of kale but a conversation about how to piece together a life even though we don't have all the answers."*

"People in the barn are all people who are looking at how to come up and live up here. They're in some sort of trajectory toward that," Dana said. "So what we're offering isn't so much buying a bunch of kale but a conversation about how to piece together a life even though we don't have all the answers."

The dinner parties—held on a 26-foot- (8-meter-) long table in the center of the barn, with doors wide open in the summertime—are frequented by clients, friends, and strangers. Attendees buy tickets ahead of time, and there's a thirty-person limit. The farm stand

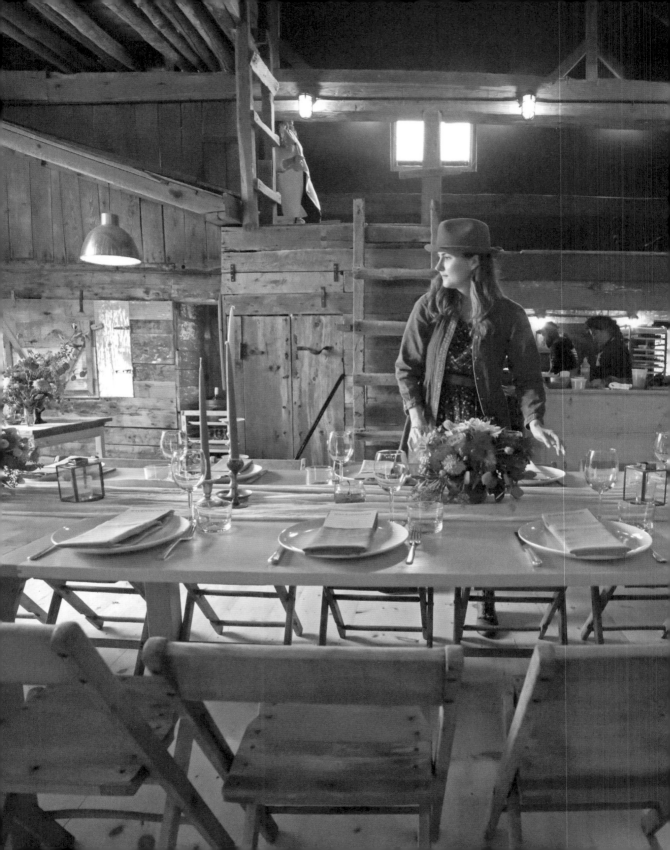

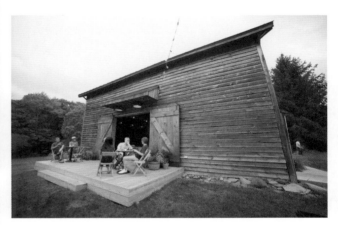

was designed to feel more inclusive, which has been a great bridge to the local community. "One impetus was to make sure that some of the locals, who haven't joined us for dinners, might come to the farm stand on the weekends and buy a pastry or hang out," Dana said. "This space is so much about agriculture and art. People come in to really enjoy the space and start to mingle. Even when they don't know each other, we've noticed people will sit around, have a cup of coffee, and realize there's one degree of separation."

Dinners feature 100 percent local food.

"I only work with what's growing here in this area at the particular time we're doing the dinners," Chris said. Though Chris started out working only with produce grown exclusively on their own farm, they've expanded to working with different growers in the area, which takes some pressure off.

Chris also does all his cooking over open fires outside. "We've got a bunch of grills and have had things custom-made." It's a bit limiting, but Chris said it "forces me to come up with something new and gives our guests more of the experience of this particular place."

CONNECTING WORLDS

"For a while I felt very invigorated whenever I would get back to the city," Dana said. "But it wasn't until I had kids that I met other mothers who are really badass at running their own businesses up here. I was like, OK, I can get that kind of stimulation up here.

"I still do design work, but I've whittled it down to like one longtime client. And I do personal artwork, which is also integrated into Ravenwood," she said. "And for Chris, it's food styling. He's preparing food for magazines, as well as traveling for gigs all over the country."

The couple have found a way to bridge the two communities: rural and urban, local and transplant, artist and agricultural, chef and consumer. With collaborative events, a collaborative shop, and collaborative space, Dana and Chris are acting as connectors for various worlds that, when brought together, are a remarkable synthesis of creative energy. The couple agrees: there is no finer place to bring folks together than around a table over a nice meal.

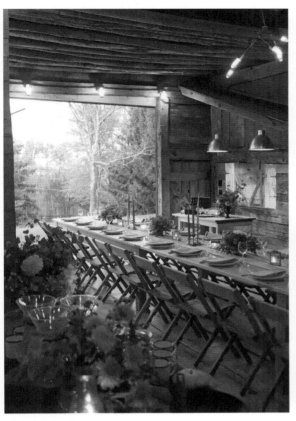
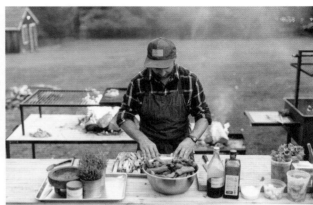
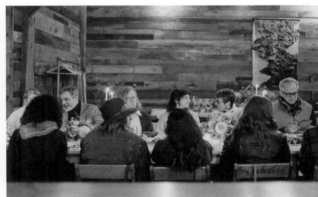

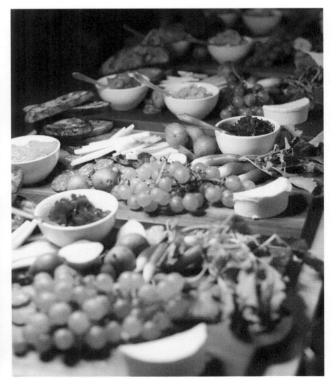

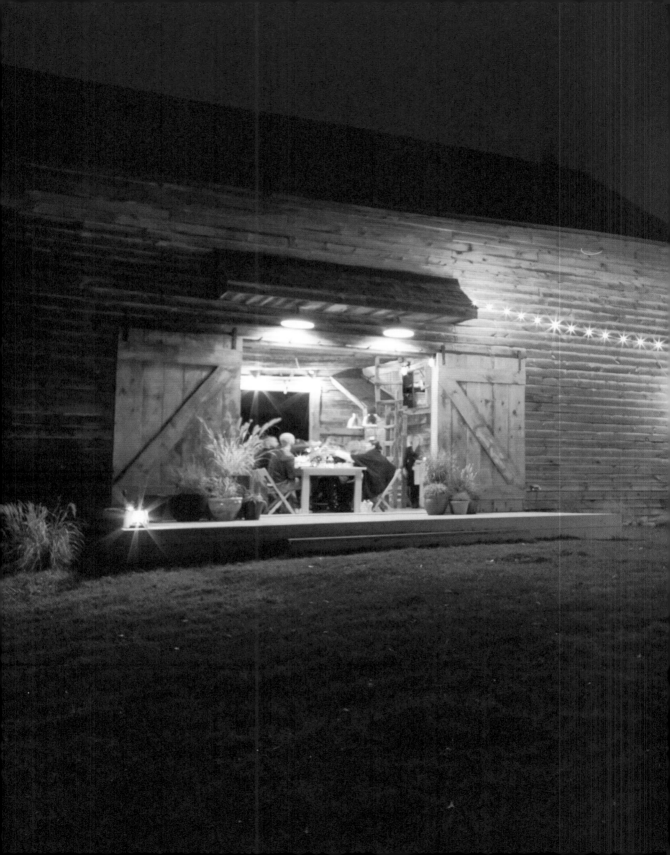

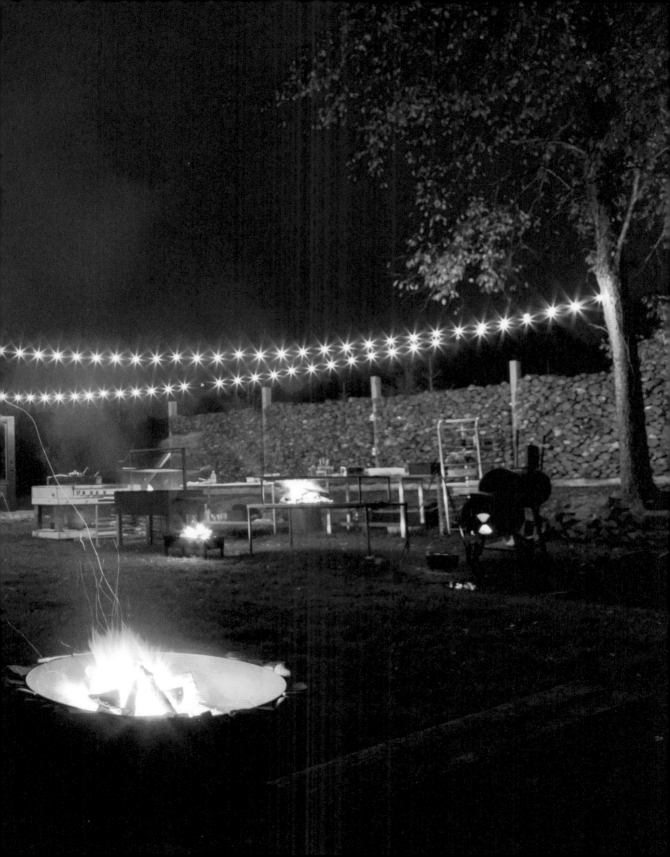

AN OFF-THE-GRID WONDERLAND: OZ FARM

Point Arena, California

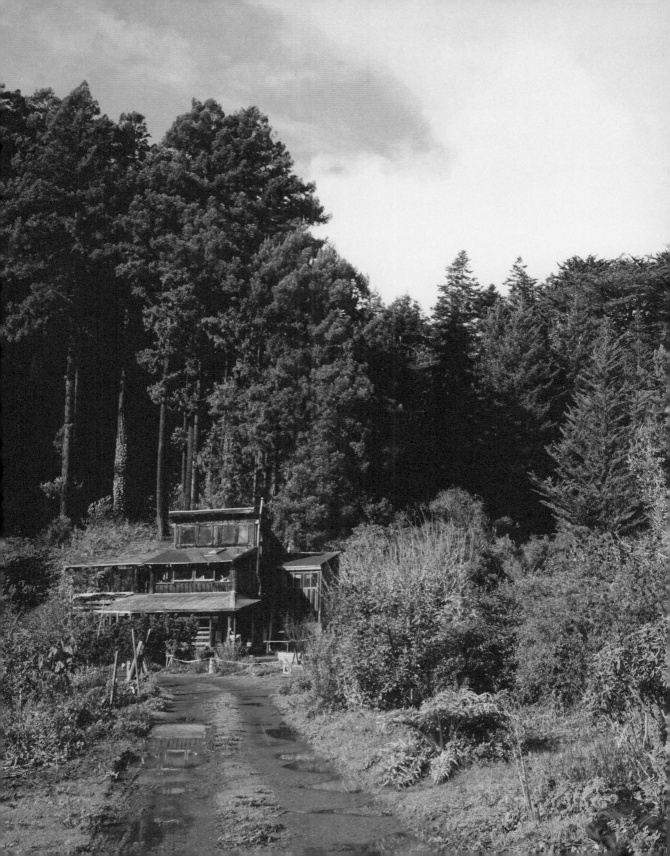

One hundred and thirty miles (209 kilometers) north of San Francisco and 2 miles (3 kilometers) inland from the craggy Pacific coastline, lush Mendocino County's towering redwood trees and stunning rock faces give way to a fertile private valley complete with a bubbling river coursing through its 240 acres (97 hectares).

There is life everywhere here. Rows of asparagus, artichokes, and other vegetables thrive in rich, dark soil. The nearby forest teems with all kinds of wildlife. Pear and apple trees fill an orchard landscape, while off-grid cabins—from yurts and domes to a springhouse and tower—house visitors, wedding parties, apprentices, and staff throughout the year.

This is Oz Farm. And at its helm is a thirty-one-year-old from the suburbs who has reinvented himself as a full-time, off-grid farmer and landowner.

NATURE-DEFICIT DISORDER

Dean Fernandez grew up in a sleepy suburban surf town outside San Diego with his little sister, mother, and father. His dad was from the countryside of Spain, and he took great pleasure in raising his son to be steeped in a similar culture of fishing and farming. "We used to go fishing for tuna on Point Loma, and occasionally down in Mexico for marlin and dorado," Dean said. "When we were older, we visited the farm where he grew up in Spain. His mom still lives there in the summertime, and there are still a lot of subsistence farmers out there."

People in the community had "a few sheep," Dean said, "one or two cows, and a patch of mixed fruits and vegetables. There's a special kind of potato from the region, and Spanish-style peppers that you fry up, and they're real nice. As a kid I just kind of showed up, and all these things were going on that my grandmother spearheaded."

But in spite of the fishing trips and visits to the Spanish countryside, Dean said he grew up with nature-deficit disorder—a phenomenon first described by author and journalist Richard Louv. "In the San Diego suburbs, you don't have a good sense of connection to the earth—I think a lot of people suffer from this in the modern world. I think the experiences I had as a kid planted the seed in me that eventually turned

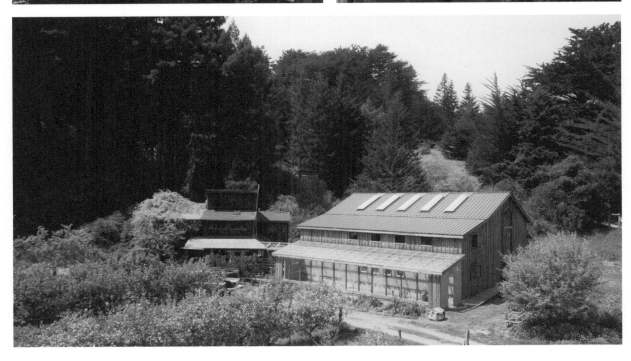

into going to farming school. While most of my classmates had families that were like, 'What are you doing with your life? How are you going to make a living?' I had family on both sides that were like, 'Hell yeah,' and we'd get to trade stories about working the land."

After high school, Dean went to Notre Dame in Indiana to study business and ecological horticulture, eventually returning to California. But he still wasn't sure what industry he could apply his learning to. "So I became obsessed with what I could apply this skill set to. Even through college, we had little makeshift gardens in the back. And back home, we always had plants in back of the house," he said. "But I think people just like me are around these things and just don't see them as a viable business."

But Dean knew he wanted to work with his hands—outside, if he could. He decided to volunteer on a few different farms to see if that life was really for him. That led to his spending a winter in Northern California, picking apples for a farmer named John Hooper. The

property—called simply "Oz"—had been a hippie commune back in the '60s. Hooper still had some dilapidated old cabins on the property, as well as some gardens and a fruit orchard.

"But I think people just like me are around these things and just don't see them as a viable business."

"This place is pretty special," Dean said. "It was three years of doing the winter pruning here that gave me a sense of this place and the land here. So it was that the next year I was living in a similar community called the Occidental Arts & Ecology Center. I got a lot more training on living in a community with people, facilitation, and all those skills."

And then he found out that Oz was for sale. "John was in his sixties and wanted to give it to his kids. But they didn't want it, so he held out.

John had other offers, but they wanted to turn it in a different direction. He was really waiting for someone who would bring it forward," Dean said.

Dean's interest was piqued. And though the property was in an advanced state of neglect, he couldn't look away. In 2014, Dean put in a proposal to buy the property. Hooper accepted.

OZ IS A PLACE UNLIKE ANY OTHER

"People are overwhelmed by the natural beauty here," Dean said of Oz's visitors. It's not hard to see why: Many of the weathered buildings, constructed a half-century ago, have been restored. The rolling hills, sounds of the river, and lush redwood forest are enough to make you forget you've got no cell service. Because the location is so remote, it's naturally off-grid. Wind turbines and solar panels provide just about all the energy, save for weekends when larger groups visit and generators must be used to meet the increased demand. Tesla car batteries store the power that Oz creates.

"It's a pretty wild place," Dean said, "being on a fault line in a floodplain on the westernmost point of California, closest to Hawaii."

"The first thing people notice when driving in is the big barn," Dean said. "You see a bunch of apple trees. There's a river." Guests almost always spend some time by the water and hiking through the hundreds of secluded acres of forest comprising most of the property. The land heals that pesky nature-deficit disorder Dean was so weary of.

"There are a lot of people who, now that they're in their mid-thirties, don't know what they're going to do with their life. They don't have a good purpose to hold on to. There's nothing else I can think of that's more impactful that I could possibly do. My purpose isn't a super important question in my life anymore. It just always bummed me out that I wanted to give something my all and didn't know what that was, until this project came along. My buddy loves Jesus, and always said my whole life Jesus put me on the path to this one thing.

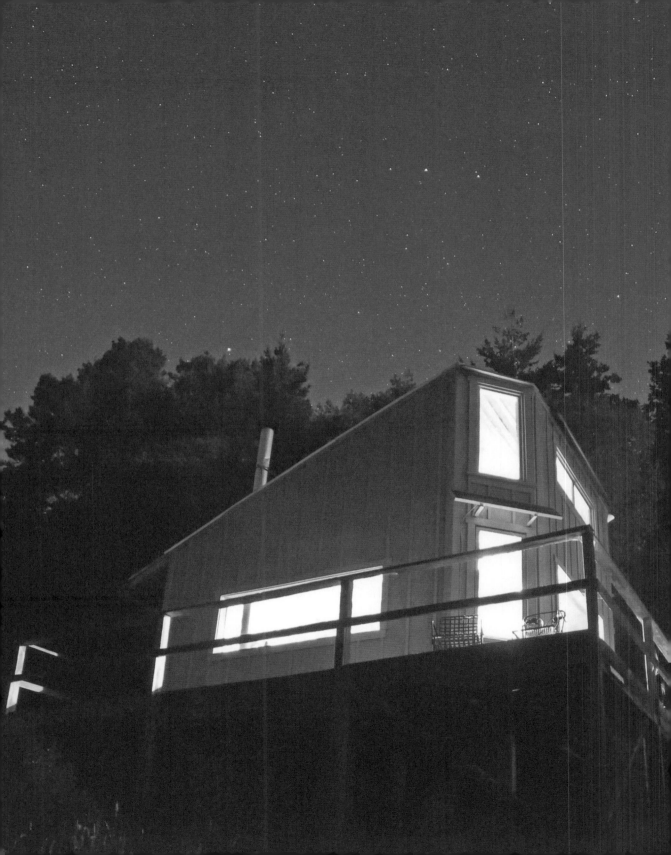

I was raised by two atheists, but I see what he means—it's the right place at the right time. I did the business management, ecological horticulture, and entrepreneurship to find other revenue streams to support the farm and all the things we do here. Plus, there are great waves nearby and not that many people," Dean said.

Word of Oz inevitably spread, and soon Dean was fielding requests for retreats and weddings. He was also getting to work: renovating cabins, installing gardens and fruit trees, designing a Community Supported Agriculture (CSA) program, and encouraging young farmers to join the fun as apprentices. To make short order of getting the outbuildings rented, Dean turned to HipCamp (an online platform for renting outdoor space). Dean was able to list his buildings and land there and attract guests who would pay to visit the pristine adult playground.

A WORLD UNTO ITSELF

Every cabin at Oz is a mini homestead, complete with solar array, running water, and a wood-burning stove. All visitors have access to an outhouse at their cabin, as well as a community house with flush toilets and hot showers. The unusual architecture of the buildings would be nearly impossible to pull off with today's zoning laws, making them historic and impossible to duplicate.

"Everyone's favorite building here was obviously the old barn, but it burned down the year before I got here. That barn was the oldest thing here when the hippies came in the late '60s. They lived in the barn while they built the other structures. That place showed the history of what a hundred years will do to

a building. It had all the relics of their trying to go off-grid: experimentation with the solar panels, wind turbines, batteries, all the knobs and dials and triggers. But today, my favorite buildings are the domes across the river, which were built by the original founder of Oz," Dean said. "R. Buckminster Fuller invented that shape and spent a lot of time in this area giving talks. So somehow that shape ended up over there. It's leaky, but it's OK because we've got a lot of houseplants. It used to have a really cool swinging bridge that was washed out in the '90s."

The Domes, a double-dome geodesic house situated on the Garcia River's south bank, was built in the '60s and is accessible only by a seasonal footbridge between June and October. The Domes has its own complete living space, flush toilet, hot water bathtub and outdoor shower, and fully equipped kitchen.

Canvas tents house visiting apprentices each year; they work at Oz in exchange for monthly stipends, all the fresh produce they can eat, and a crash course in small-scale farming. Rounding out the structures are a tower, community house, and staff lodging.

As you wander through the property, it feels more like a scaled-up hobbit village than a modern-day compound.

FEELING THE RHYTHM OF THE LAND

Oz sells produce at area farmers' markets and to local restaurants. The farm also has a growing CSA program. Apples function as Oz's main crop and account for the majority of its revenue. Those apples that don't sell get made into cider in Oz's micro-cidery (which is made available for weddings and retreats). Dean has

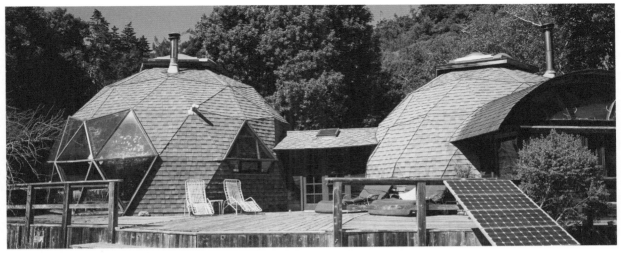

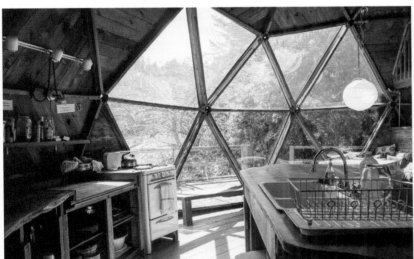

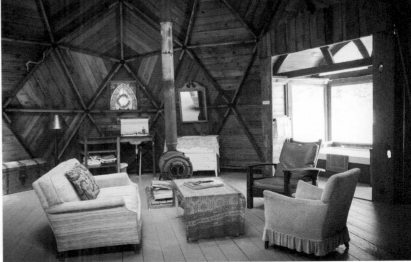

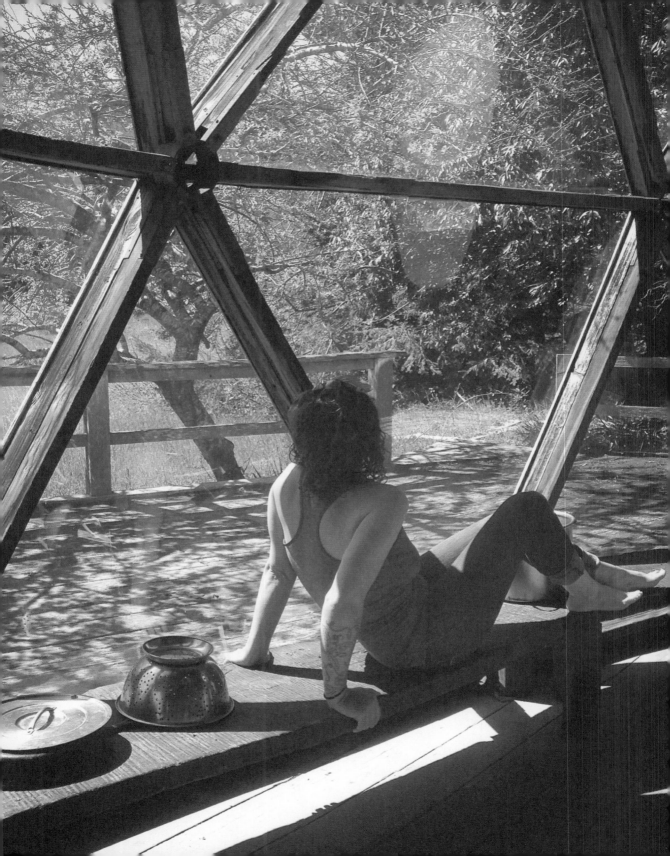

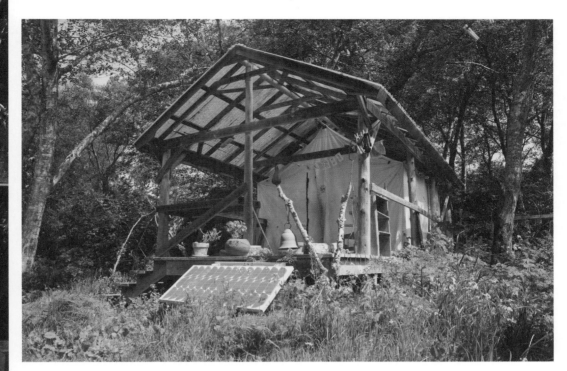

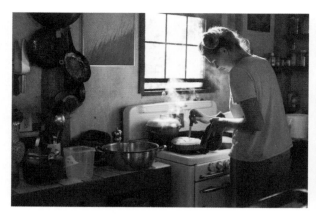

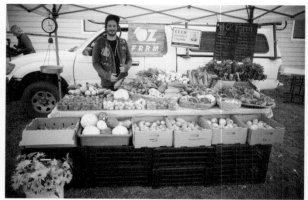

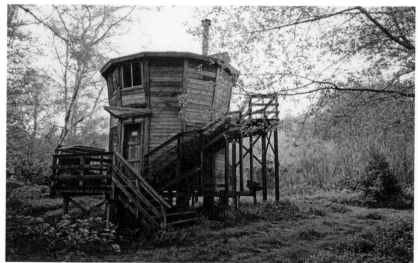

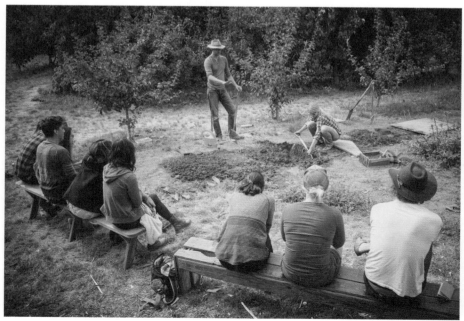

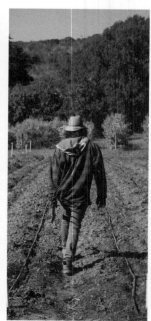

dabbled in having different animals on the farm, but the goats kept jumping on guests' cars, so these days he just has some chickens around for fresh eggs. "Nature is a beast," he said, "but it's rewarding and addicting."

To tend the produce and run the business, Dean needed help. So he initiated an apprenticeship program that each year welcomes four young farmers to Oz from March through November. The workers live in private canvas tent cabins on the property and work thirty-five hours a week, Monday through Friday. Apprentices earn a monthly stipend for farm work, which ranges from planting and harvesting to rotational field maintenance and weeding or pruning. Workers also help with sustainability education, cabin prep for visitors, landscaping, and community upkeep.

On any given day, there are around ten people working on the farm. "You can spend your whole life here and learn something new," Dean said. "It's supremely rewarding. You start to feel the rhythm of the land and place. Instead of being responsive, you become more proactive. There's always been people that have done all this before. You rely on the people to learn how to be respectful to the land."

Oz is constantly changing. For now, Dean is focused on transitioning into doing more education work, and changing the retreat model to include fewer weddings, which had funded repairs, remodels, and new construction. "We want to do more of our own programming, education, and workshops so we can invite people to come out and learn everything about the human potential movement," he said.

John Hooper and his wife still visit their old property. "They were so stoked on the progress we've made here. That was one of my biggest fears—not being accepted by them and the community where this place is such a mainstay. Most people in the area have come through here at one point or another. But that fear went away real quick. And eventually someone else will be able to carry this place forward, too," Dean said.

"Nature is a beast, but it's rewarding and addicting."

Dean sees himself as one cog in the wheel that makes things happen at Oz. "The team here gets as small as four in the winter and up to ten in the summertime to pull off this project. That's always changing, and a great reason to keep doing this work is the apprenticeship program," he said.

"We can only grow so much food here—but if we can grow farmers, they can go out and make an impact that is endless," Dean said.

Dean's neighbor recently stopped by Oz with a question for the young farmer: "If I gave you $10 million, would you sell this place?"

Dean didn't hesitate. "I told him, if I had $10 million, I would be looking for a place like this."

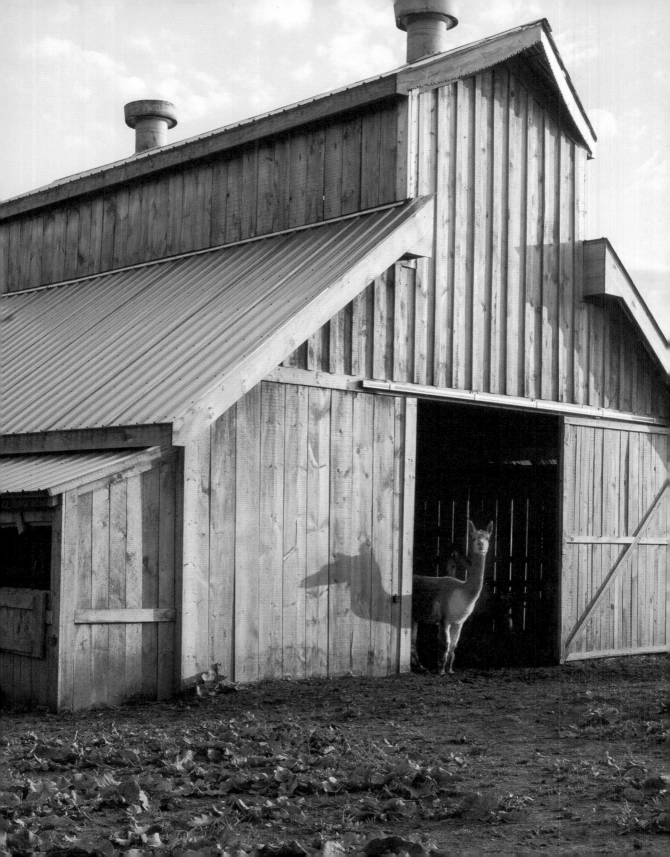

SUSTAINABLE LIVING: BETTER FARM

Redwood, New York

Many people who trade cities for homesteads have long imagined pursuing a simpler life: a thriving garden, backyard chickens, sun-warmed sheets fresh from the clothesline, and toasty wood stoves.

Nicole Caldwell was not one of those people. Manhattan suited her. The Big Apple has the most of everything, and she took giant bites from it every chance she could. "I was a regular at museums of natural history and modern art, frequented operas and plays, and loved wandering city sidewalks at all hours," she said. "I volunteered at community gardens, attended underground parties featuring burlesque dancers and acrobats, went to pop-up art galleries, and saw live music several nights a week."

She was also a nature lover. The most memorable family vacations of her childhood were to national parks and farms. "When I was a kid, my favorite thing to do was spend hours out in the woods behind our house, building forts with my sister," she said. Nicole rescued and rehabilitated injured animals like birds and mice, and at age nine she went vegetarian. She loved the ocean, the woods, and the mountains. But she completely and unabashedly also loved New York City. So she made it home.

Nicole moved to Harlem in 2005 for grad school, then picked up a job downtown as editor of a magazine. She steadily acquired debt while paying rent on and furnishing apartments she couldn't afford, and living the life of a young career woman and social

butterfly. Everything in New York City sparkled in Nicole's twenty-four-year-old eyes. She'd escaped the Jersey suburbs of her upbringing and was living independently in the center of the universe.

"I honestly thought I would stay in Manhattan forever," Nicole said. "I figured I'd send my kids to a public school, and host tiny-apartment dinner parties."

Manhattan supported her lifestyle. As a vegan, Nicole could eat well at any restaurant. She participated in political groups, jogged through neighborhoods that never got boring, and met people from all over the world every day. But as Nicole's time in New York City lengthened, she was disproportionately feeding one part of herself while starving another.

To compensate, Nicole began leaving Manhattan more and more to be surrounded by nature.

"I used to skip town unannounced just to go hiking," she said, "or spend an entire Saturday in December riding trains to Coney Island to sit on the cold beach with no one around. I would take subways from Brooklyn to the Bronx just to dig my hands in the dirt at a community garden, and lose a full afternoon on my rooftop tending to salad greens and sunflowers growing in raised planters."

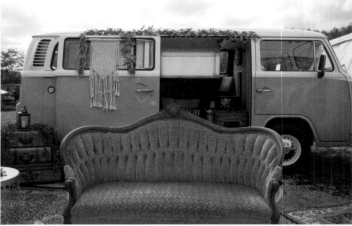

Nicole used weekends to jump in the car and drive 350 miles (563 kilometers) upstate to a tiny speck of a town along the Canadian border. There, on a sprawling farm property, sat her Uncle Steve's commune, Better Farm.

BUILDING BETTER

Uncle Steve had bought a farmhouse in 1970 to create a stomping ground for members of the peaking anti-war and counterculture movement. But Better Farm was much more than a commune.

"People in town, who had never seen hippies before, drove by the farm on the weekends to catch sight of the topless gardeners, pot plants, and multicolored house."

It was a place of refuge for Steve, who just three months after graduating college in 1963 was in a car accident that crushed his spinal cord. Instead of pursuing his professional dreams of becoming a journalist like his mother, father, and uncle, now Steve was a quadriplegic, living in his parents' house in New Jersey with his youngest sibling. He was a prisoner in his twenty-one-year-old body.

The insurance money from Steve's accident took seven years to arrive. When it did, Steve spent it on a homestead almost 400 miles (644 kilometers) away in Redwood, New York, where he could get the daily care he needed and live less burdened by his disability.

Steve's friends and family renovated the farmhouse to include wheelchair ramps, indoor plumbing, electricity, and a dozen small bedrooms befitting its commune classification. "People in town, who had never seen hippies before, drove by the farm on the weekends to catch sight of the topless gardeners, pot plants, and multicolored house," Nicole said.

Steve called it Better Farm because of the "Better Theory," his philosophy that every

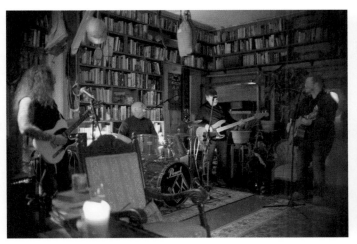

moment is an opportunity to make things better. Steve was the theory's poster child, transforming his injury into an opportunity to bring people together at a community space for the disenchanted, mystical, wild children of the hippie generation.

For half a century, Better Farm welcomed anyone who showed up. And show up they did, getting there by thumb, bus, and car. Babies were born there, weddings held, gardens tended. The house's collection of books and records grew until the family room's walls were filled with floor-to-ceiling shelves overflowing with reading material and records. Conversations around the kitchen table continued late into the night. And the cast of characters kept revolving, ebbing, and flowing.

A RESPITE FROM THE "REAL WORLD"

Nicole's experience growing up in suburban New Jersey was in stark contrast to the frequent trips her family took to Better Farm. There, she could sit on the back deck and listen to birds, or perch in the house's library and pull any of the thousands of dusty books off the shelves and read uninterrupted for hours and hours. "The curtains were made of old pillowcases stitched together," she said of the house's interior. "Bedroom doorknobs didn't match and were painted with little flowers. It was like the polar opposite of the perfectly manicured lawns and professionally decorated homes back in Jersey. I was in love."

Nicole clung to her farm pilgrimages over the years as a respite from the concrete jungle downstate. As the crowds at Better Farm dwindled, Steve asked Nicole if she'd like to move in and help him keep the place going. The two talked about establishing an artist residency program, using gardens as classrooms where people could learn to grow their own food. They talked about hosting music festivals on the 65 acres (26 hectares) of land.

"It was so, so tempting," she said. "But I always felt like I'd be giving up so much to move so far from the academia and culture of Manhattan. People who grew up like me weren't supposed to do things like that.

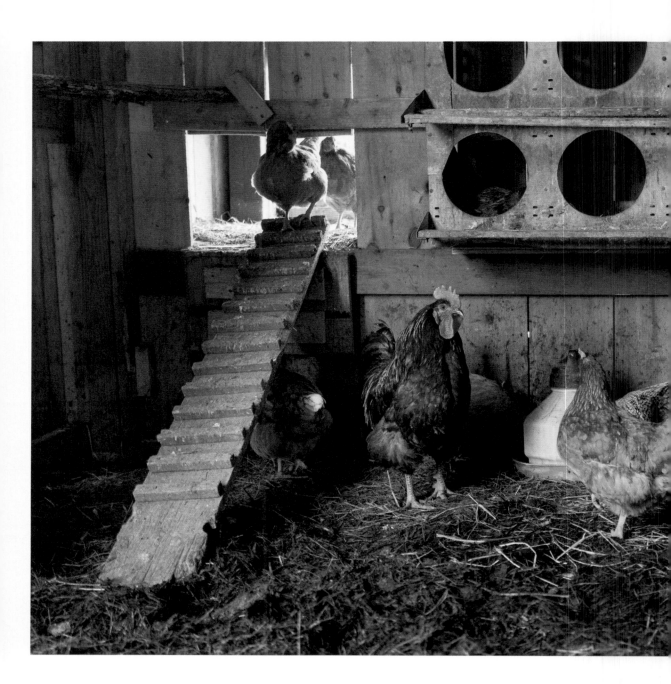

"I was supposed to work in an office, buy an apartment or house, get married, and stay on that hamster wheel my whole life," Nicole said.

"Steve and I talked a lot about all of this stuff. But at the end of the day, I'd get in my car and drive the six hours back to New York City." By the time the traffic closed in around her, Redwood would already feel so far away—not the "real world" at all.

In 2008 Nicole took a high-paying journalism job covering Manhattan's Diamond District and traded her shoebox apartment in the West Village for a large third-floor walkup in Brooklyn that doubled her commute and raised her rent. It turned out she hated her new job, and she was neck-deep in a tense relationship with a man she was supporting financially and emotionally. Every day, the pressure built inside her.

The hours at work destroyed her energy to keep up with any of her hobbies. The spinach and sunflower plants on her rooftop wilted, and her beautiful apartment felt increasingly like a cage. The city Nicole loved so well became an impossible burden.

"That winter, Uncle Steve called me from a hospital to tell me he had pneumonia," Nicole said. "Hours after we hung up, he stopped breathing and was hooked up to a ventilator." For the next two months he survived like that until his stubborn, hurt body let go and died.

Nicole went into a tailspin. She threw her boyfriend out of her apartment, and two weeks later she was laid off from her job. "All of a sudden I was left wondering what I'd been working so hard for," she said. "A job I didn't like, money I couldn't save, crap I didn't need, and a boyfriend I couldn't get along with?"

She felt helpless, frantically applying for job after job, knowing whatever gig she got wouldn't be fulfilling. What was the point of working forty hours a week for something that meant nothing to her?

A DAUNTING OPPORTUNITY

"It's an absurd reality that we're unwilling to take chances while we're comfortable," Nicole said. "What-ifs and buts keep us from doing so much. And while I don't wish anything bad on anyone, it's often the bad that pushes us to take the chances that end up fulfilling us."

Nicole started composting in her apartment kitchen. She volunteered in gardens and wandered through city parks. She rented out her apartment on Craigslist and stayed with friends to make rent money. And she took a good long look at a big, daunting opportunity: Uncle Steve had left Better Farm to her in his will.

With a handful of ideas and the support of her community, she discovered a fearless urge to take a chance with no preparation, parachute, or idea what awaited.

Taking on the responsibility and legacy of Better Farm felt like another unmanageable stress point. If Nicole couldn't even cover her monthly rent, how was she going to manage this, too?

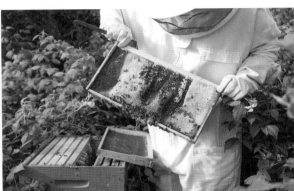

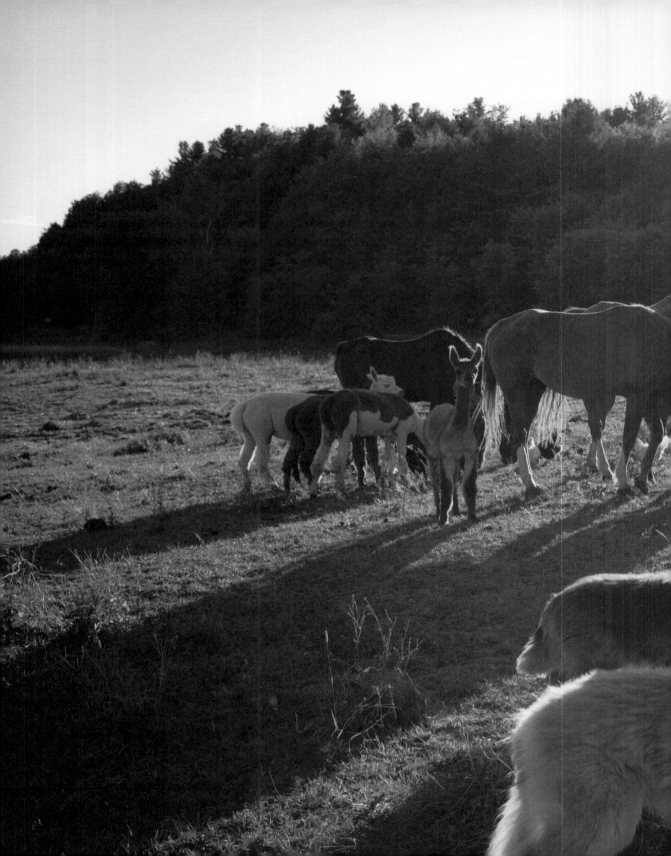

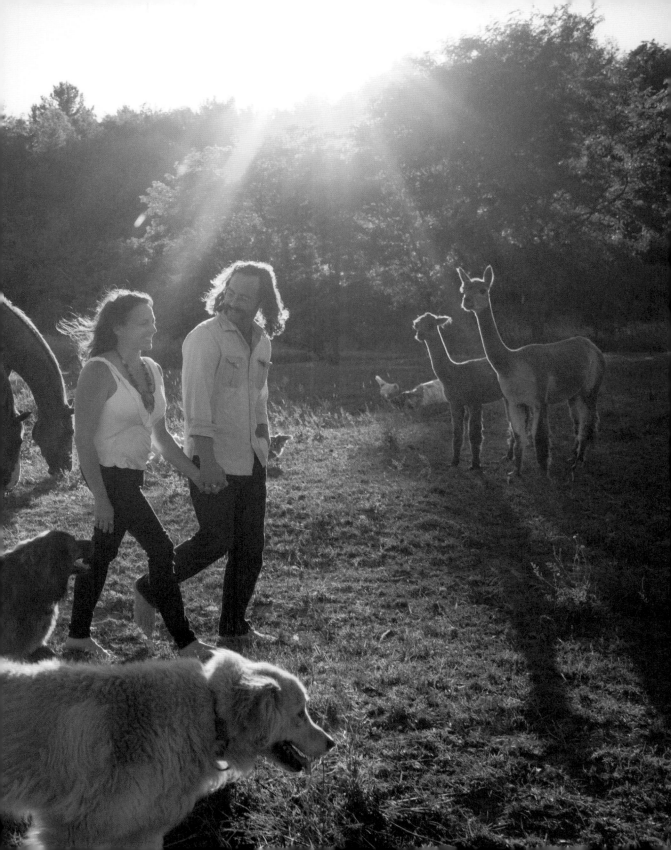

But as time passed without promising job prospects, Nicole let herself imagine what life at Better Farm might look like—taking the interests she'd marginalized as hobbies and turning them into her central focus.

"There was a lot of cool stuff happening in New York City," she said. "Urban farming, rooftop and community gardens, and a hyper-awareness of the politics of food systems. Food co-ops were springing up in every neighborhood. But it occurred to me that none of this had to be fringe, temporary, or infrequent. If I wanted, these things I had so much interest in could be my whole life."

So one afternoon in April, Nicole squeezed her sister and twenty of her closest friends into her Brooklyn apartment and hosted a roundtable in which the group brainstormed ideas for what Better Farm could become. Common themes came up: artist residencies, gardens, alternative housing, shop space, recording studios, galleries, events and festivals. "If my friends were a cross-section of any urban area, I reasoned, there was a fair chance of there being a market for these things," Nicole said. With a handful of ideas and the support of her community, she discovered a fearless urge to take a chance with no preparation, parachute, or idea what awaited.

In June of 2009 Nicole filled her Mini Cooper with personal possessions and a new puppy, and steered north to Better Farm. She didn't have a business plan, a job, a partner, or any background in homesteading, farming, or carpentry. In fact, the greatest advantage she had was a sense that she had nothing to lose.

Nicole got to Better Farm, smelled all those familiar smells, curled up on the couch in the library with her puppy, and lay there holding on to so many memories. Then she grabbed a notebook and started writing down ideas.

A HIPPIE COMMUNE BECOMES A LIVING LAB

That first summer, Nicole staked out a large plot, laid down hay and compost, and created a mulch garden—a permaculture design she'd learned about from secondhand books. "I started writing emails to colleges with environmental programs, asking if there were any students interested in spending a month or two learning about organic gardening here with me," she said. "Then I designed an application process for visiting artists who might want to stay at the farm while working on their book, a series of paintings, an album of original music, or sculptures." She set up her worm bin in an enormous farmhouse kitchen, installed a wood stove, and swapped out inefficient light bulbs for CFLs.

Rooms in the main house that had been vacant for decades suddenly housed overnight guests, students, volunteer farmers, artists, and long-term renters.

As she peeled old wallpaper and rented dumpsters to fill with long-forgotten items left behind by previous generations, folks began to show up. Painters set up easels in the fields. People in the area—soldiers from nearby Fort Drum, a missionary, local professionals, and

various friends from New York City—traded help for rent, put on impromptu concerts, held art classes, and generally eased Nicole's transition. Better Farm was fast becoming a "living lab" reminiscent of its former incarnations, but with a purpose of teaching skills, making a difference, and practicing eco-conscious living. Instead of a place for checking out from the world, it was a focused space in which to become better, then return to communities all over the world to make a difference.

Each year brought more change: gardens taking root and expanding to sell produce to local restaurants, the establishment of a CSA program, a farm stand, and enough bounty to feed the house for half the year. Buildings went up to house people in cottages and tiny homes, a sauna and greenhouse were made from recycled materials, and more barns were built. The artist residency program grew until a separate entity had to be formed—a nonprofit called betterArts, complete with board and monthly meetings—that handled arts-related workshops, concerts, and eventually a low-power FM radio station broadcast out of a barn on the property, renovated to

also encompass a gallery, studio spaces, and recording studio. Rooms in the main house that had been vacant for decades suddenly housed overnight guests, students, volunteer farmers, artists, and long-term renters.

People began bringing animals to Better Farm, too—horses, alpacas, pigs, chickens, ducks, and goats that had been neglected or were unwanted. Nicole took them all in, establishing an animal sanctuary. Her writing career began mirroring her farming work, with free time spent documenting her progress in blogs, magazines, and, eventually, books.

The road to Better Farm winds past rock faces, lakes, creeks, and valleys dotted with modest homes and barns tucked into a tangle of trees. The first view from a hilltop is of a series of paddocks outlining wide-open grazing fields for large animals who've found refuge. To the left is an old hay barn, now home to radio equipment and DJs, its walls covered with art. A huge garden is visible in the distance, just past a vintage avocado-green school bus. And in the midst of it all sits a farmhouse, no longer multicolored and no longer vacant, now brimming with life.

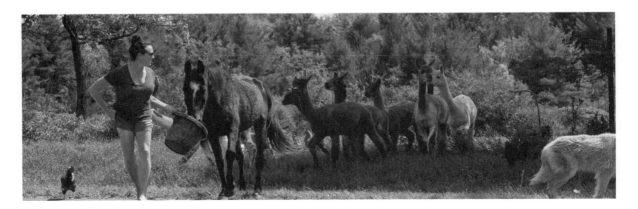

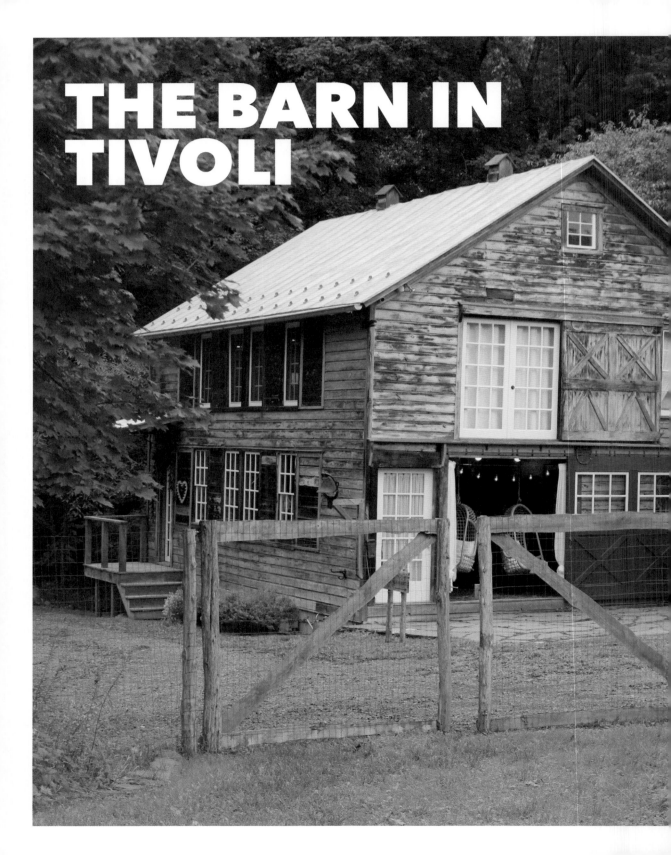

THE BARN IN TIVOLI

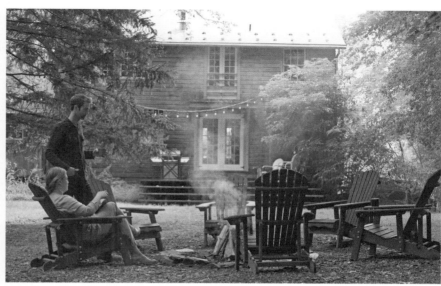

Tivoli,
New York

No one knows what year the Barn in Tivoli was
built. Aerial photographs from 1935 show it
from a distance, and some of the stones from
the old foundation were put there sometime
in the nineteenth century. The barn served
its original purpose housing farm animals and
hay. Later it was used as a wood shop, then a
performance space, and, eventually a bed and
breakfast.

That's when Bruna De Araujo and Andrew
Personette discovered the Barn.

"We were some of the first guests to stay
here, back in 2005," Bruna said. The couple
and three close friends rented it as a getaway.
When they married in 2007 and then had a
child, they increasingly sought more open land
away from New York City. So when the barn
went up for sale in 2012, Bruna and Andrew
seized the chance to own it. Since then,
they've hosted hundreds of guests hungry for
an experience outside the city limits.

Bruna and Andrew met in New York City
through mutual friends. They were both with
other people at the time, but nevertheless
connected and began collaborating on live
video performances. They performed all
over New York City at well-known clubs like
CBGB, The Cooler, Joe's Pub, and Symphony
Space. "Every Monday, video artists, musi-
cians, and dancers would convene at the loft
where Andrew lived with his girlfriend in
Williamsburg, Brooklyn," Bruna said. "Every
practice session would end with a dance
party. This one night, he vetoed dancing and
sent us all home. We sensed something was
going on. He and his girlfriend broke up. She
moved out. I had also recently broken up with
my boyfriend. Soon after, Andrew asked me
on a date."

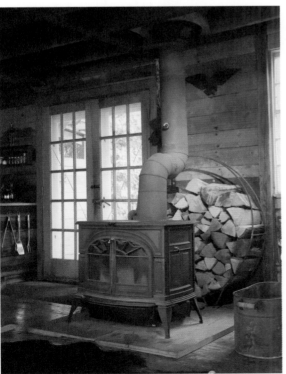

Bruna was born and raised in Brasilia, Brazil's capital city. Her father passed away when she was just five years old. "In the '60s, my father spent time as a teenager in New York City and absolutely loved it," she said. "On his deathbed, he told his father he wanted me to learn English and travel the world. So my family put me in the American School of Brasilia, where I mingled with diplomats and learned to read English before Portuguese. I started traveling internationally at eight years old: the United States, Europe, Japan. Once I finished high school, I had a complete American education. The natural choice was to attend a university in the United States. But I did a little rebelling, wanted to experience other things, started getting interested in art and design and working in film. After some family pressure to finish my studies, I agreed to do it, but only if I could do it in New York City."

Bruna moved to the city in 1998 to study film at the School of Visual Arts. "I loved every minute of it," she said. After graduating, Bruna started her own production company with a classmate. "We first got into the world of music videos, then developed an entertainment brand for kids. We immersed ourselves to the point of burnout, and eventually decided to take a break."

That was around the time Bruna and Andrew found out she was pregnant. "I was away from my family, no siblings, no friends with kids," Bruna said. "I had to learn everything about mothering by myself. After our son was born, city life quickly reached its expiration date. It began to feel very unnatural to raise a kid in a concrete jungle. I got pretty depressed because I couldn't see a way out."

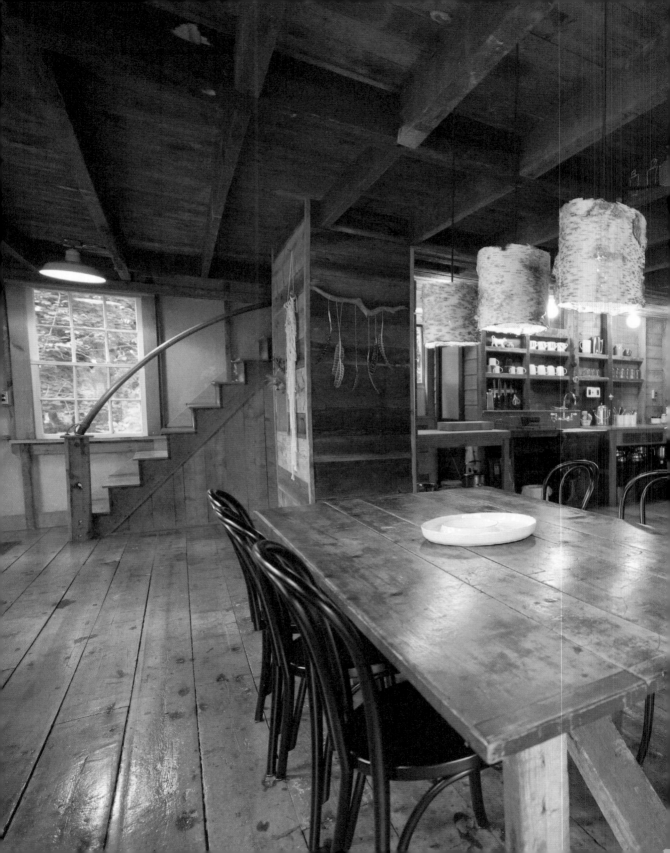

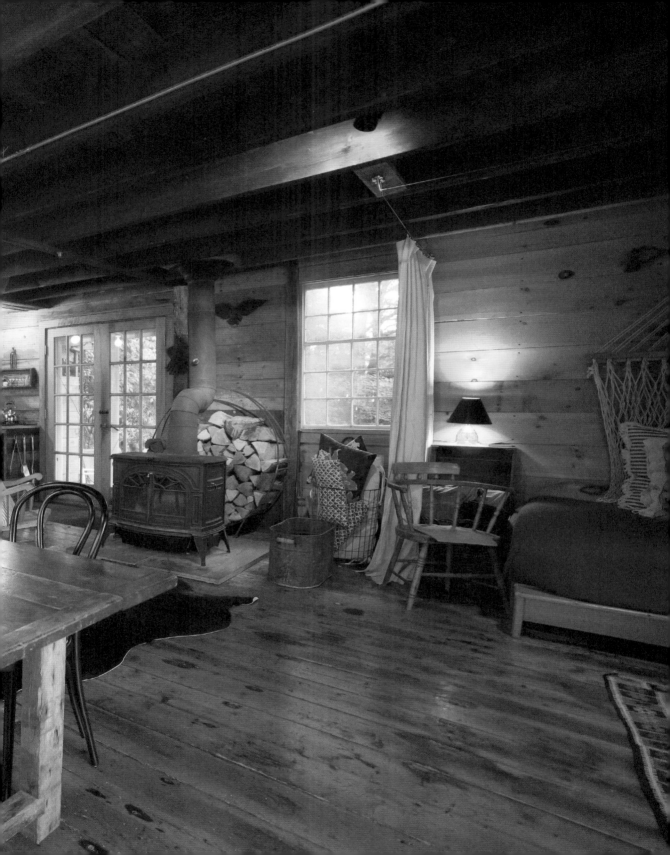

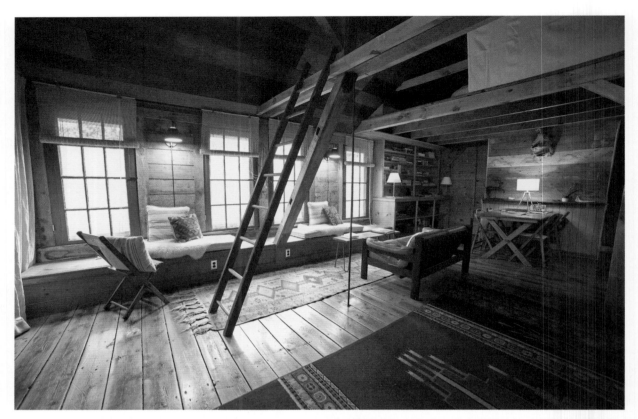

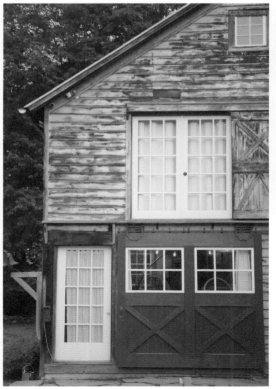

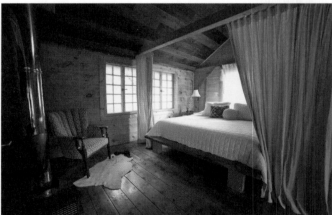

It was 2012 when Andrew got the email—in the little town of Tivoli in the Hudson River Valley, a barn that Bruna and Andrew had seen and loved was for sale. "Our lives changed quickly in just six months," Bruna said.

"The barn just has that perfect, very pleasant home shape. The kind you draw as a child when you're asked to draw a home," she said. Situated on 4 acres (1.5 hectares) with a stream, the barn's loft-like space is heated by a wood stove and can sleep up to six people on three levels.

"The previous owners had done an incredible job remodeling the interior ceiling. They laid out all the pieces of wood outside and randomly stained them different shades of pink and wine. The woodworkers installed them randomly, and the result was this beautiful patchwork on the ceiling," Bruna said.

Nonetheless, it took extensive renovations and design changes to bring the Barn in Tivoli up to snuff for Bruna and Andrew.

Andrew is a designer and builder, and together the couple totally reconstructed a bathroom and kitchen, added a new deck with an outdoor shower, and unboarded the front door, creating new stairs and an awning. Most importantly, the big rolling barn door was repaired and outfitted with two hanging birdcage chairs on the inside to twirl around on and enjoy views of the adjacent garden and cottage.

Decluttering the property also allowed all its natural beauty to show. An edible forest would nourish inhabitants, and a state-of-the-art solar array would provide power.

Everywhere you look, there are artifacts. "It seems like every time I stick a shovel in the ground, I find something interesting," Bruna said. While renovating the property, they found Civil War–era cannonballs, saw blades, historic pottery pieces in the stream, and a small ceramic doll—treasures galore. "We used to display many of these artifacts inside the barn, until we had a shaman come perform a blessing ceremony. We were instructed to remove all those artifacts, which reflected industrialized times and the colonizers who decimated the natives. We were told to build an altar instead, honoring the native Mohicans who lived on the land and off the creek. So that's what we did."

Today, Bruna and Andrew rent the barn out, enjoying their own time in the cottage next door.

"We love, love, love living here," Bruna said. "We feel so lucky. There's an amazing community of artists, makers, chefs, and entrepreneurs all around us. It's culturally rich. Most surprising is how we never really miss the city."

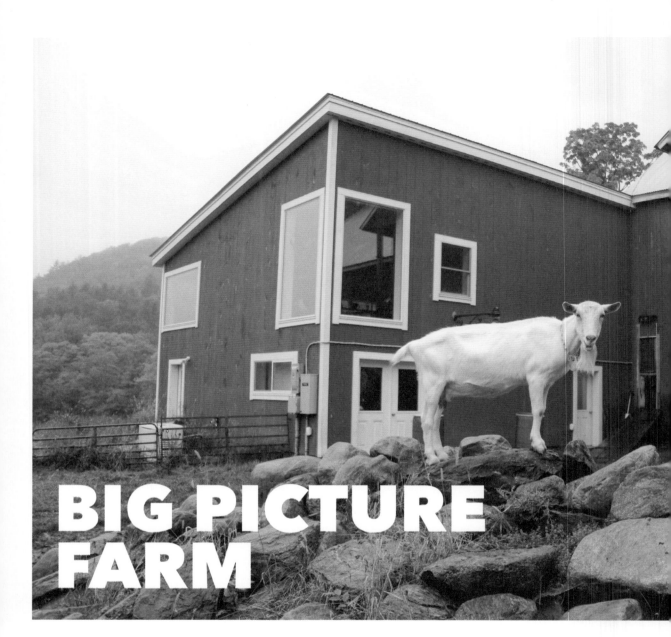

BIG PICTURE
FARM

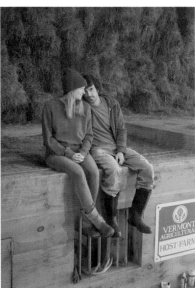

Townshend,
Vermont

Perhaps the most iconic symbol of country living is the American farmhouse. Whether built from fieldstone, wood, or brick, the structure stands as a beacon of cohesion and order against a backdrop of open fields and rolling hillsides. A farmhouse plants a flag in the ground of civility: a staked-out plot of garden, pasture, and organized growing fields that makes human sense of the untouched wilds in the distance.

In Townshend, Vermont, the farmhouse at Big Picture Farm embodies all these qualities. The stately eighteenth-century building, which has been lovingly renovated, stands in a glen, flanked by red barns and outbuildings, a picturesque pond, and stately old trees.

Big Picture Farm is part goat farm, part milk caramel confectionery, and part high-end accommodation for families and business groups. The property is owned by Louisa Conrad, a Manhattan native, and her husband, Lucas Farrell, originally from Maine. The two met at college in Vermont and moved to New York City following graduation, but eventually found themselves missing the landscape and quality of life Vermont offered.

As artists and professors—Louisa is a photographer and visual artist, and Luke is a writer and poet—they were able to find teaching jobs in Vermont that allowed them to move back to the land they loved so well. But they wanted more than day jobs: they wanted to farm.

"We realized that the community that felt the richest in Vermont was the agricultural community, and we wanted to get our farming toes wet," Louisa said. "Honestly, if I hadn't grown up in New York City, I probably would have gotten involved earlier, but I felt it wasn't something that I was familiar with. It took a little longer to get there because I didn't feel secure or sure of my abilities to make that initial leap. What we knew was that we wanted to live here, we wanted to put down roots, and we wanted to have a garden and chickens—and it was like, OK, how do you afford to do all those things?"

They discovered the way was by doing—and getting creative. Louisa and Lucas apprenticed at Blue Ledge Farm and learned to make cheese, then learned the art of aging raw-milk cheeses by working with Peaked Mountain Farm. The couple who owned Peaked Mountain Farm were approaching the end of their farming careers, and Louisa and Lucas moved in as winter caretakers. Eventually they struck a deal with the owners so they could open a small business on the property.

"We got housing and could keep three goats," Louisa said. "They incubated us, and it made it much easier to get going. Especially with a dairy, it's so hard and expensive to get off the ground." Louisa and Lucas suddenly had at their disposal equipment, facilities, and space. In time they would buy the woodlot on the property, and then, finally, the farmhouse.

Finding the goat's milk market oversaturated, Louisa and Lucas spent close to a year perfecting a recipe for caramels. Their product is so good (and well designed, with Louisa creating the artwork), the couple has sold confections through Anthropologie, Crate & Barrel, and several other high-end and specialty stores throughout the United States.

The original farmhouse was built in 1797, and its upgraded, expanded 7,000-square-foot (650-square-meter) incarnation features details like four fireplaces, state-of-the-art

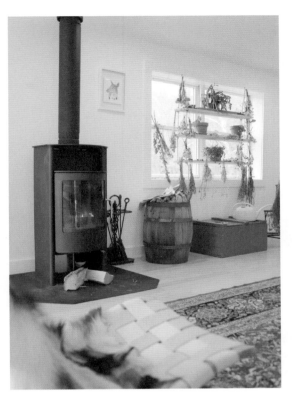

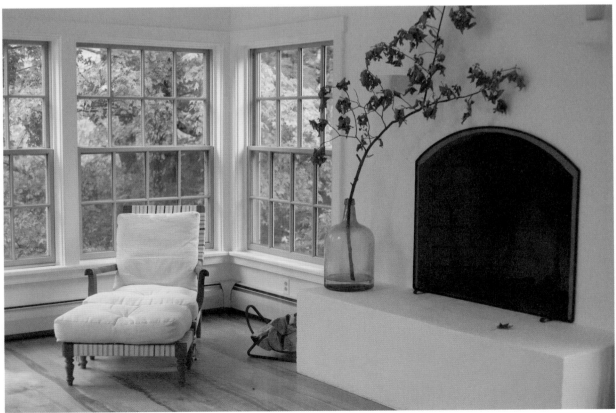

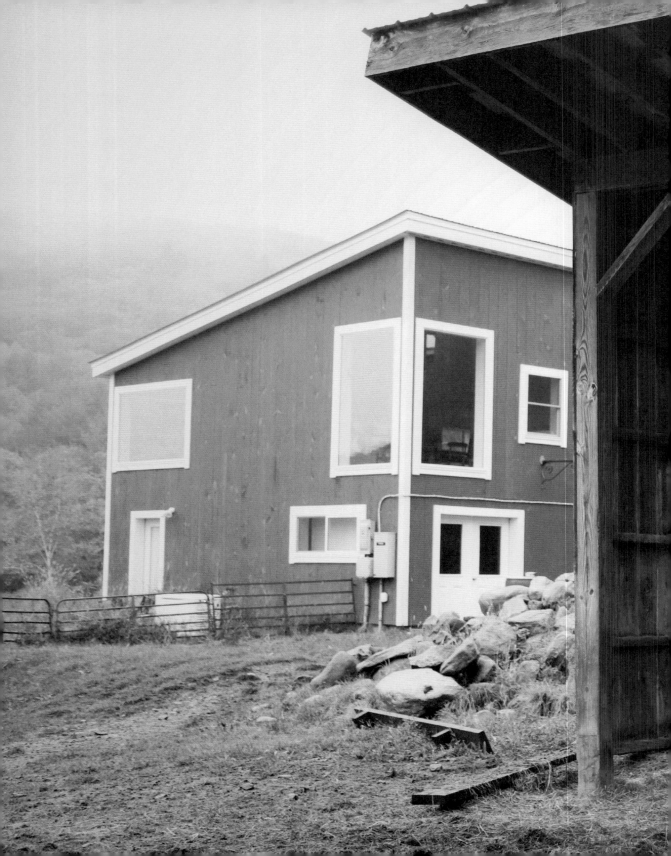

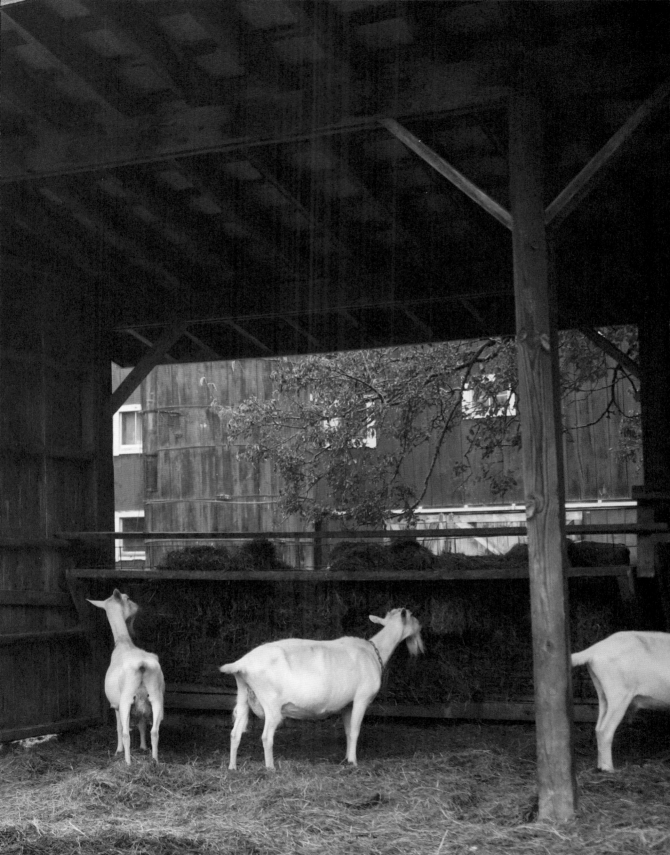

appliances, a giant dining table and spacious outdoor deck, and an enormous master bedroom suite complete with whirlpool tub, steam shower, and stunning country views in every direction. The oversized house has 8.5 bedrooms and 5.5 baths, and can house groups of up to twenty people.

Fifty feet (15 meters) from the house is Big Picture Farm's barn and creamery, where Louisa, Lucas, and their growing staff produce cheese and confections. The couple and their young daughter, Maisie, live in a separate house across the street from the farmhouse.

"I think it's not so random that I ended up here," Louisa said. "I never minded being dirty and gritty, and when I first experienced the seasons in a truer way, it made my heart beat in a way that was really important. I was a pretty stressed-out kid; it's wonderful to have found this rhythm, and at the end of the day to be able to go on a nice walk and be calm. When we had our careers, and in that particular economy, it just felt so out of our control whether hard work would allow us to be successful or not. Hard work isn't an indicator of whether you will be successful. We needed to take things into our own hands."

Lucas said the key to having a farm is being open. "You have to be creative in the country," he said. "Most people who live rurally, whether they move from the city or have lived here for generations, wear multiple hats. They might be your plumber, but they are also the rock star in the local band. People have all these different outlets that they use to express themselves fully. It is refreshing, and you realize that that is what you have to do as well. There are going to be times when you do this, do that, to sort of piece together a life and a living in the country."

"A question I get asked all the time is, 'Do you have time to make art anymore?'" Louisa said. "And I understand why people ask me that, but I feel so—like 500 percent—creatively satisfied. I consider this whole thing an art project, and I don't need it to be curated or validated. It's the coolest conceptual art project you could ever have. You have these animals that provide you with this amazing milk, and then you package it, and you get to send it back into the world."

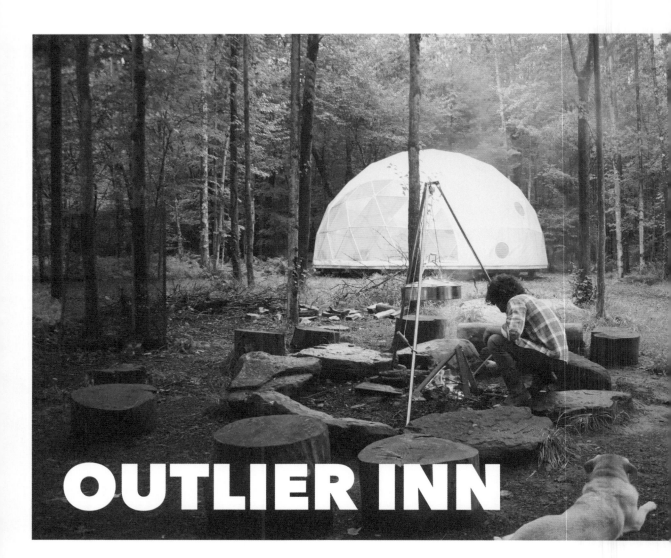

OUTLIER INN

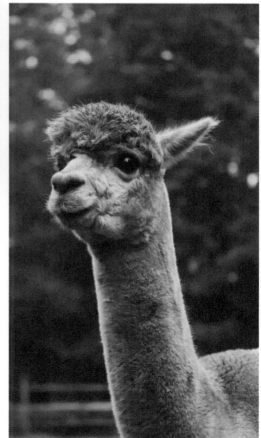

Southern Catskill
Mountains,
New York

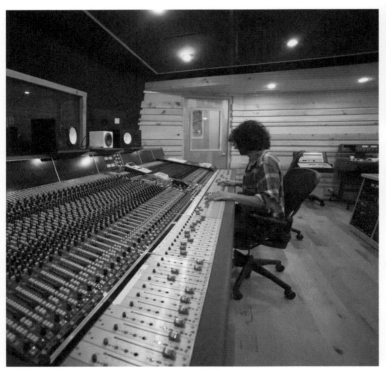

A professional recording studio might seem like a strange thing to find on a property with alpacas, merino sheep, a wood-fired hot tub, and a geodesic dome. But to Joshua Druckman, it all makes perfect sense.

After wrapping up a graduate degree in music and economics in 1997 at Columbia University, Joshua spent a couple of years slogging through work on Wall Street in order to raise enough capital to open his own recording studio.

"I hated Wall Street from the second I started," he recalled from a decidedly different setting in Sullivan County, New York. "But I managed to last for almost two years, and then quit and opened my own recording studio in the city." Joshua loved the studio and certainly had the know-how to run it. But running the space in the city came with high costs that could be covered only by saying yes to everyone who walked through the front door.

"I was working on all kinds of stuff that I really hated," he said.

In 2001, two years after opening, Joshua closed the doors of his beloved studio. His next move was to pack a bag, book a flight, and take off on a "little soul-searching travel mission" overseas for close to a year. Upon his return to the states, Joshua's grandmother, Esther, rang him up to ask a favor.

His grandparents had owned a summer camp upstate, which they sold when Joshua was just two years old. They still owned some of the property, however, and they asked if Joshua would come up to help them sell what was left.

Joshua had grown up in South Florida but spent his summers in upstate New York with family. "I lived in the city for eight years—I would come up to the Catskills often. It just always felt like home to me. The smells, the memories—it felt like a homecoming," he said.

While helping his grandmother sell off the parcel of land, Joshua started to think about purchasing a plot of his own. Though his grandmother offered to give him hers, at the time Joshua considered it too undeveloped for his capabilities.

"I didn't know the difference between a flathead and a Phillips head screwdriver at that point," he said. "I passed on her offer, and she sold the land, but I was up here for a week looking around." He soon found a property that felt more manageable, with better road access and a house that he still lives in today. "I was twenty-six, and I didn't know anyone up here, but I found myself all of a sudden living through a winter season alone."

Today, the property is known as the Outlier Inn: 12 acres (5 hectares) of structural treasures, including a campground, teepee, tiny houses, vintage trailers, koi pond, farm, garden, a communal outdoor kitchen and shower, and firepits throughout. The property serves as a retreat center, event space, and farm. Oh—and a popular recording studio.

"I wasn't going to do another commercial studio," Joshua said. "It started out as a recording studio just for me. I still don't consider it commercial, although it has gone way further over to the commercial zone than I had intended. I was just so inspired being up here and creating here, and I wanted to share it. I needed guinea pigs—I liked electronica but also played guitar and wanted to record acoustic—so I was looking for guinea pig bands I could learn how to record."

Joshua raises chickens for organic eggs, and two alpacas, Angora goats, and merino sheep

for wool. There are koi in the pond and two cats and a dog. "We grow veggies for ourselves and to sell to our guests. One of the things I'm most proud of is that we were able to turn a relatively small, stagnant piece of wetland into a functioning farm and get the property added to the agricultural zoning, protecting it from any future development threats," he said.

Raising animals is one of the joys of Joshua's life. "To love and care for creatures that are happy and producing something for the planet is very gratifying and fun," he said. "I never thought about where my food came from when I was living in New York City. I just didn't. Moving upstate, being in a community of conscious and sustainably minded people, having the opportunity to grow my own food

has really opened my eyes (and stomach) to the benefits of eating locally."

Waking up at the Outlier is peaceful and serene. You take your time, rise with the nature that surrounds you. Stroll over to the outdoor kitchen and put on a pot of coffee, crack a few fresh eggs out of the nest box, cook up some bacon that comes from the farm down the road. Mallard ducks fly in and land on the pond. You can take a dip in the pond or chill in the hammock and read.

"I often get asked, 'So what do you do here all day? Aren't you bored out in the country?'" Joshua said. "After living in New York for eight years, I assure them I'm busier now than I ever was, but on my own terms, which is way more gratifying."

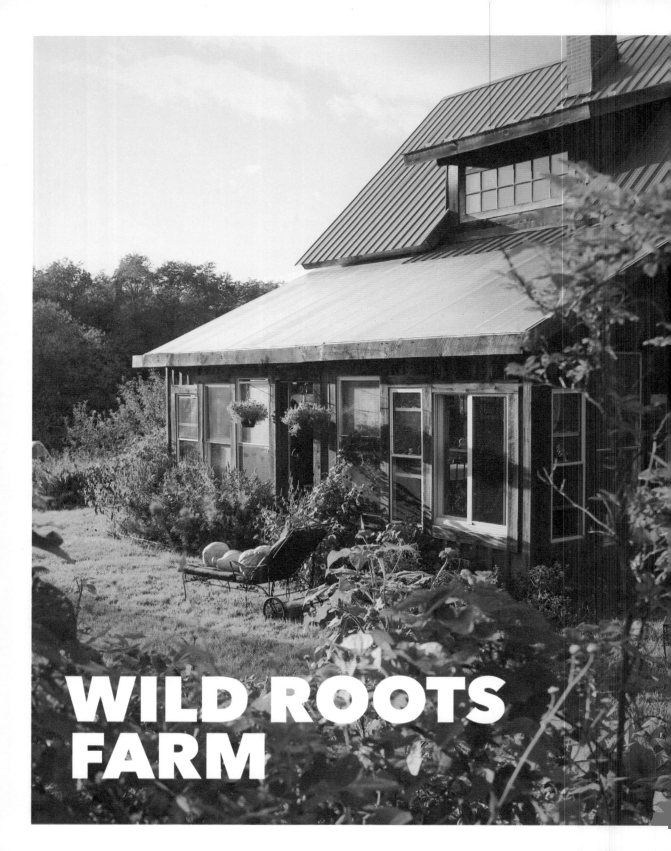

WILD ROOTS FARM

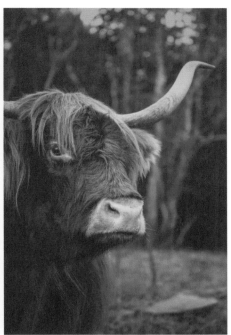

Roscoe,

New York

"If I was to write a book about my life, it would have to be called *A Half Mile from the Road*," Amy Gillingham said. That's because her property—an immense expanse of 100 acres (40 hectares) of rolling hills, farmland, and swaths of forest—is hidden down a small, unmarked dirt driveway, a half mile from the road.

Wild Roots Farm is stewarded by Amy; her husband, Wes; and their children, Iris and Roan. The property is filled with berry patches, gardens, and orchards. A dozen sheep of hardy island breeds—including Icelandic, Shetland, and Scottish Blackface— produce a variety of wool for Amy to shear and dye using wildflowers she forages from the fields. The wool is later spun into yarn.

A pair of Shorthorn Cross and Scottish Highland cows also graze the land. The Highland's long, pointy horns may look intimidating, but Amy promises, "She could walk through a china shop without knocking a single thing over. She's such a softy."

The centerpiece of the property, situated between the towns of Liberty and Roscoe at the edge of the Catskills in upstate New York, is a solar-powered, hand-hewn log home built by the family and a team of interns, volunteers, and friends.

When Wes was growing up, his family visited the Wild Roots property often. At that time, in the 1950s, the only shelter on the property was a single, uninsulated hunting shack. "Wes was a little naturalist," Amy said. "He and his Alaskan Malamute, Stormy, would just always be out here learning amazing skills and knowledge of the land."

In his twenties, Wes was traveling and teaching when he met Amy on an expedition. After college, the couple started to look at farmland to purchase. Amy recalled, "I realized Wes would have to get to know another piece of land for thirty-two years to have the same relationship he's had with this one. I didn't have that relationship—I grew up in Kansas City, Missouri, and couldn't wait

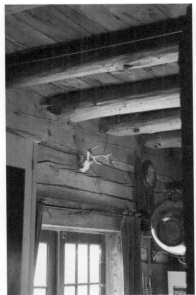

to leave. Wes is fifty-eight now, been here thirty-eight years. This place was a real gift to obtain.

"Wes is not really a carpenter," Amy confessed. "But the half-dovetail log homes don't rot, because of how they're notched." Considering the property is situated in an area with plenty of rain and moisture, "Wes picked the hardest type of home to build. Of course."

Wes and Amy's goal was to avoid buying materials from big chain retailers, and to instead buy purely local and have only friends and neighbors work on the house with them. The couple started a little piece at a time. Wes picked out all the trees himself. Certain pieces—like the A-frame pulley system Wes devised, and the farm tractor—proved to be necessities. "We mostly did it all with a chainsaw, farm tractor, broad axe, and chisel." Amy helped with chinking all the logs, as well as feeding the crew of helpers.

The entire structure was built using just logs and pegs, like a toy cabin building set; you won't find a single nail or screw holding the structure together. "It took about eight years to do it all," Amy said.

"There are a lot of little things that have stories here. It's kind of like a tree museum," she said. She proudly points out the flaws and errors throughout the walls and ceilings. There is a story to tell behind each one of them.

"It was really important for us to have good energy going into building our home, and knowing how every detail got here. A lot of our friends put their hands into it at one point in their life, and they love coming to visit. That's the connection we've made with our farm as well," she said.

From the slate sink to the solar greenhouse built with recycled windows, Amy and Wes can tell you something about every single detail of their home. "I just want to feel connected to the resources that went into making it," Amy said. "You can't get that when you buy out of a catalog."

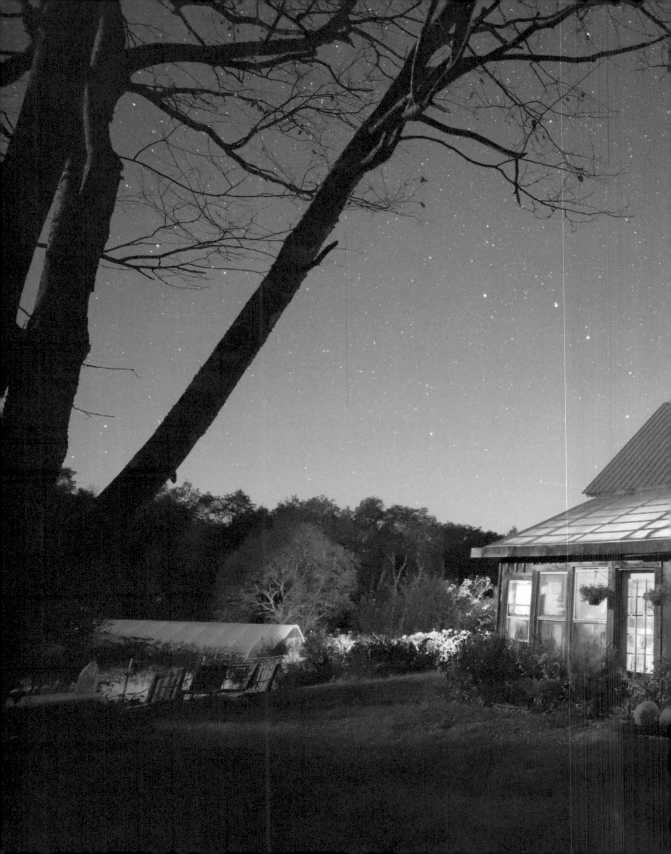

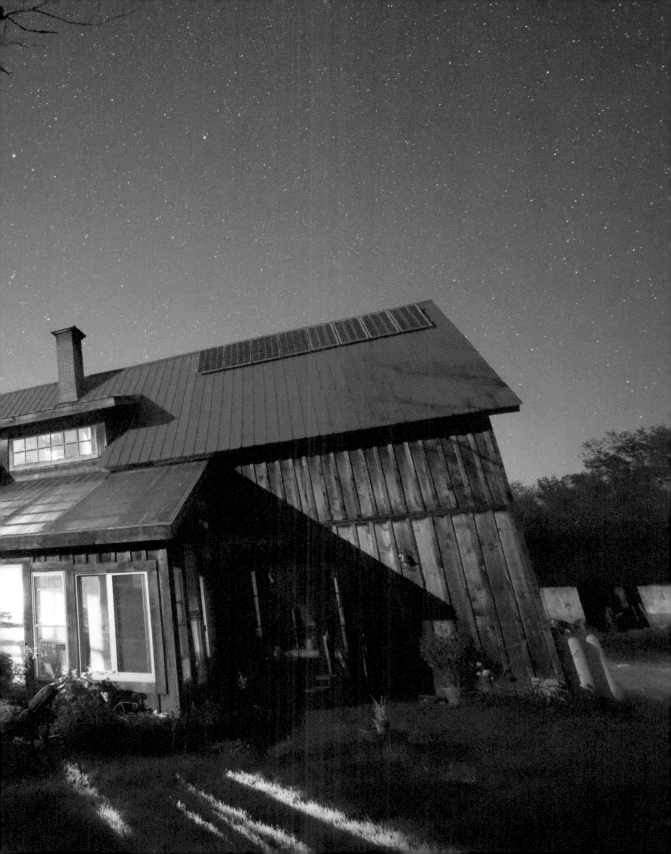

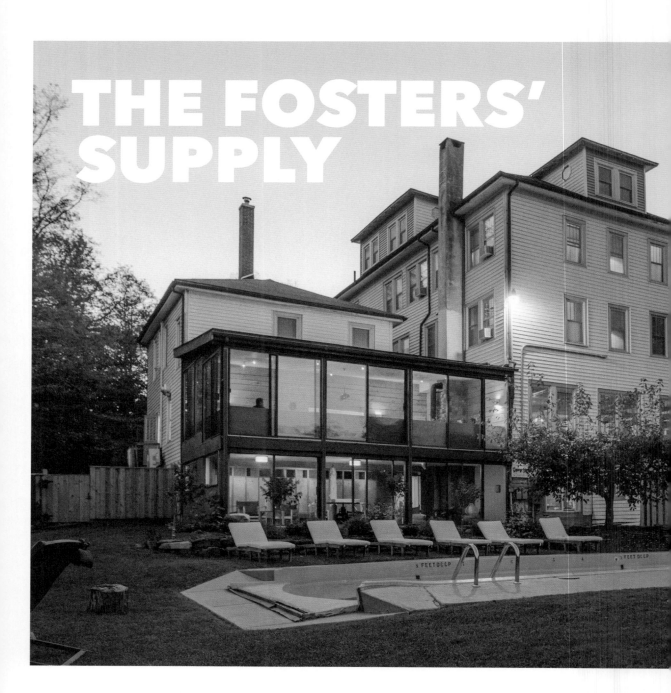

THE FOSTERS' SUPPLY

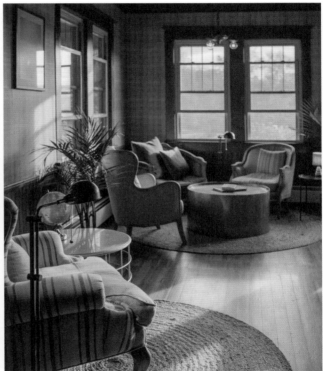

Catskills,
New York

In its heyday, from the 1920s to the 1970s, the Catskills region was one of the most famous vacation destinations in the country. It was called the "Borscht Belt" because it attracted many Jewish Eastern Europeans who came for a reprieve from hot, humid New York City summers. Lavish golf courses and resorts were constructed, and some of the world's biggest entertainers came to perform there—names like Tony Bennett, Mel Brooks, George Burns, and Jerry Lewis.

Then, in the 1970s, international air travel became more affordable and families ditched the Borscht Belt for the Eiffel Tower and the canals of Venice. Resorts, hotels, and boardinghouses were all left abandoned—nearly twenty of them in the Willowemoc Valley alone.

Today, a renaissance is underway in the Catskills region, with a generation focusing on getting back to nature and forming deeper connections with their neighbors and local communities.

Sims and Kirsten Foster are deeply involved in this revival, reconnecting with the history of the Borscht Belt through a thoughtful, organic design process that is bringing an atmosphere of days past to modern times. The Fosters provide this experience with four Catskills-based boutique hotels that can be better described as quaint yet refined bed and breakfasts in the countryside: The Arnold House, North Branch Inn, Nine River Road, and The DeBruce. Each has its own history, rejuvenation story, and promising future.

Sims and Kirsten met on a weekend trip to a cabin in the Catskills through Kirsten's brother Oliver. She explained: "I was meant to go fly-fishing with Oliver when he got a last-minute call from his friend Sims, who invited my brother up to his cabin for the weekend. Oliver asked if it was OK for his 'little sister' to tag along." Sims reluctantly agreed. "I guess he was picturing pigtails and braces!" she said. The two hit it off immediately and started spending almost every weekend upstate together. "I really fell in love with this area and the people," Kirsten said.

Sims was no stranger to the region. His family had lived there for over a hundred years, spanning five generations. In the meantime, he was busy carving out a path of his own, leading hospitality groups and opening restaurants, bars, and hotels throughout Manhattan. Kirsten, with a master's degree in economics and international policy, was working in the financial sector.

Eventually, a time came when "neither of us felt right about raising a family in the city—we felt strongly that our kids should grow up with grass stains, splinters, and a strong sense of community," Kirsten explained. "The conversation quickly turned to how do we get up here full time, as opposed to 'should we?'"

Kirsten, feeling stressed by years in a corporate job that required constant traveling, was ready for a new challenge, and Sims's experience in the hospitality world turned to a passion for reviving the history of a region his family had roots in for over a century.

The couple began working together on their first property upstate: The Arnold House, a thirteen-room countryside retreat on 7 acres (3 hectares) with a tavern and garden house. "Neither of us had any idea how it would go. I think we both had it in the back of our heads that this could be the start of our way up here full time. We held on to our day jobs and

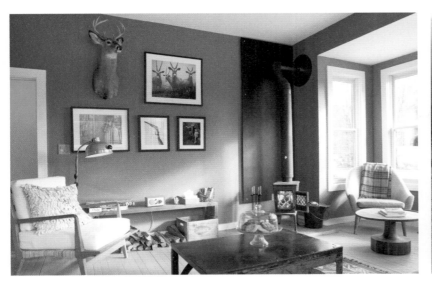

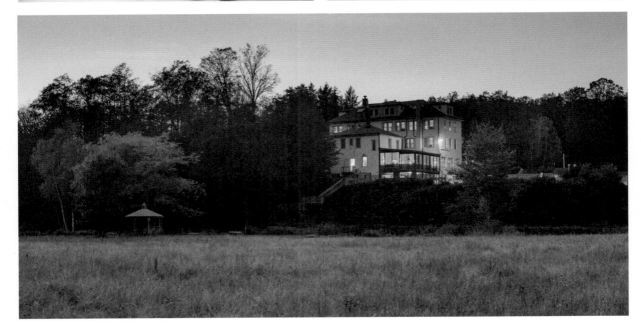

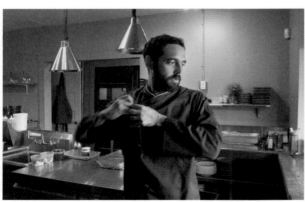

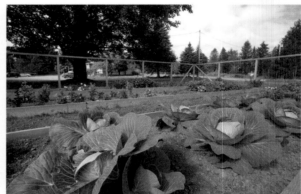

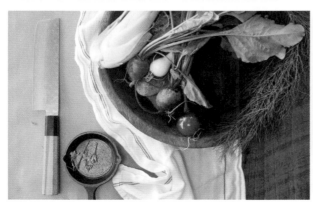

worked weekends and nights on The Arnold," she said.

Once opened, the Fosters' Arnold House was a hit. "We were truly humbled by the great coverage and momentum we received; it encouraged us to explore further properties," she said. "We both became so passionate about it, and it finally allowed us to ditch the apartment in the city for good and jump upstate. We never looked back!"

The DeBruce could be considered the crown jewel of the Fosters' properties. With access to hundreds of acres of private land spanning two mountains, a river, and several ponds, with a private pool, there is a wonderful sense of solitude and isolation here. It is a place where you can in one moment feel surrounded by the warmth of friendship and in the next luxuriate in completely private intimacy.

Built in the late 1800s, The DeBruce is one of the last remaining Catskills hotels that has stood the test of time. "We discovered an 1872 atlas book of the county in an antique shop. We use The DeBruce as a way to showcase these maps, framing them throughout the 'Great Room.'"

The Dining Room at The DeBruce is also a nod to local history, with multiple design elements using reclaimed woods from local hotels that were eventually torn down. Which leads to the Fosters' dining program, not to be overlooked.

The Fosters work directly with local farmers and foragers in the region to help bring their culinary vision to life, providing a well-thought-out and perfectly executed seasonal farm-to-table menu. Access to people who grow their own product provides a constant source of creativity for Executive Chef Aksel Theilkuhl. Outside the kitchen door are private woodlands, where Aksel and his team gather ingredients and find daily inspiration.

"Whether it's for a meal, a weekend, or a special celebration, we take the responsibility of taking care of our guests extremely seriously," Kirsten said. "It is an enormous responsibility for us—but also the greatest reward, and it's what continues to drive us. We're grateful to be able to create this in our little part of the world. The journey has been truly inspiring and humbling."

How-to
BUILD A GEODESIC DOME

Twentieth-century inventor R. Buckminster Fuller first popularized geodesic domes in 1922 as part of his extensive work to solve world problems related to housing, education, transportation, and shelter. Fuller's design offered a dwelling that was transportable; economically feasible; notably strong against elements such as ice, snow, and wind; and had exceptional airflow and insulation potential.

Today, geodesic domes have become a practical option for overnight shelters, greenhouses, and even permanent dwellings. Here are some tips to get you started on making your own geodesic dome.

CHOOSE YOUR STYLE AND SIZE

For those starting out, we suggest scouring online marketplaces and decently priced kits. Kits typically start around $1,000 and go (way) up. Sourcing your own materials can bring that cost down to a few hundred bucks—but you risk making some wrong cuts, which could result in the structure not coming together properly.

PICK YOUR LOCATION

Domes require a flat surface, and you'll save yourself a ton of stress by keeping it away from soggy sections of lawn or errant stumps and roots that can interfere with your structure or interior layout. So find a flat, dry, hard surface and clear it of all brush, tree stumps, and large roots.

LAY OUT YOUR MATERIALS

Geodesic domes are most commonly made of struts (individual lengths of pipe, either galvanized metal or PVC) and hubs (strut connectors) or screws drilled through flattened and slightly bent end pieces of metal pipe (electrical metallic tubing is commonly used). Do a count to make sure you've either cut all the pieces to the proper length or accounted for all the parts in your kit.

You can lay greenhouse plastic over the top of struts and hubs. For more sturdy construction, the plastic can be replaced with glass or Plexiglas panels, and the plastic or metal struts made with wood. Heavy canvas can be used to cover the dome on sunny days or for privacy, or to strategically cover most panels while leaving some open for windows or skylights.

START FROM THE BOTTOM UP

If you're going to put your dome on a plat-form, build the platform first. Then begin at the bottom of the structure. The foundation ring for most domes comes first (but not always—check your guide!). To create it, you'll fit together the largest cut lengths of strut, connecting them with hubs until they form a circle. Make any adjustments nec-essary so the circle is as even as possible. Then work your way up the circle, tier by tier, alternating struts as you go.

VENTILATE!

Do not underestimate the importance of ventilation in your dome, regardless of your location. Ventilation is easy to achieve with a simple air vent at the very top of the dome—this will also help prevent mold and mildew from forming inside. An alternative or additional way to achieve this is to pur-chase an energy or heat recovery ventilator (depending on your climate), and, if you've built a permanent structure where water could otherwise be trapped, to ensure an air gap between the inner and outer skins of the dome.

ADD YOUR DOOR AND ANCHORS

The next step is to add a door, doorframe, and side and top supports. If you're not using a kit, you'll have to build the door on specs for width and height as it fits with the dome. Don't forget the side and top supports! Anchors work just like tent stakes to hold the dome snug to the ground. You can bend rebar for this or drive spikes into the ground.

ATTACH YOUR COVER

You can cover the dome with canvas, green-house plastic, or tarp cut to size—or simply work with the cover that came with the kit. Attach the cover by using grommets and tie-down rope with stakes. If you're using multiple tarps, make sure each overlaps by at least 2 to 3 ft (60 to 91 cm).

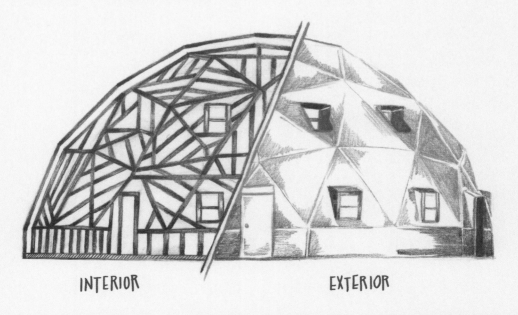

INTERIOR EXTERIOR

RAISE CHICKENS

Chickens are among the easiest farm animals to raise, and they offer a host of benefits, from nutritious eggs to tick and mosquito control. The most essential part of chicken care is providing the birds with sufficient housing to protect them from predators and the elements. Chicken housing should be easy to clean and constructed of at least ½ in (12 mm) plywood. We recommend keeping the coops at least 3 ft (91 cm) off the ground, to make them harder for predators to reach; just set a ramp against the opening for the birds to use to get in and out. Provide secure door latches. Inside the coop, birds should have access to roosting bars (they prefer perching to standing on flat ground) and nesting boxes for egg-laying (at least one for every three or four birds). Provide a minimum of 4 square ft (.4 square m) per chicken. The coop should be vented to allow for airflow, but located out of the wind to protect from winter chills. Do not heat the coops—sudden, extreme temperature shifts can kill the birds.

It's essential that chickens get the calories and sunlight they need every day in order to thrive, along with a bottomless supply of fresh, clean water. Give your chickens free-range access during the day. Chickens love to forage for greens and bugs, so if you need to contain your birds in a protected run during the day, consider making it movable. That will help prevent both boredom and the illnesses to which confined birds are vulnerable. Here you'll find a breakdown of regular chicken chores, organized by frequency.

DAILY

Each morning (the closer to sunrise the better), let the chickens out of their coop, feed them, and offer fresh water. Make sure the waterer is kept clean—keeping a stiff-bristled brush next to the hose is an easy way to remember to give the waterer a good scrubbing every day.

Collect eggs every day to keep predators at bay (ravens, black snakes, raccoons, and opossums love chicken eggs) and prevent breakage.

It's important to spend some time every day with the flock to observe them and check for any illnesses, injuries, unusual behavior, or signs of predators. Chickens are very good at hiding illnesses and injuries until it's too late to treat them. An observant chicken steward will be able to catch and correct problems before they escalate.

Close and securely latch the coop doors each day after sunset to protect the birds from overnight predators.

WEEKLY

To keep your flock healthy, add 1 Tbsp of apple cider vinegar for every gallon (3.8 L) of water once a week. Apple cider vinegar is an excellent all-over immunity booster and great for digestive health; it eradicates germs that can cause respiratory illness (a common problem for chickens) and increases calcium absorption.

Check the coop weekly to see if it needs cleaning. If you're using a deep-litter method, you can just add bedding as needed to keep smells and messes at bay. Or use cardboard as a coop liner and distribute sawdust, dry hay, or even shredded paper as bedding over the cardboard and in the nesting boxes. This is an easy way to reuse junk mail (just shred it and toss it in), and you can remove it each week and add it to the compost pile. After a year of decomposition, chicken manure is a great source of nitrogen for the garden. Keeping nesting boxes fresh and filled with bedding will encourage hens to continue laying in them instead of all over the yard.

SEMI-YEARLY

Deep-clean the chicken coop twice a year with a sanitizing cleaner and stiff-bristled brush.

If you live in an area that experiences significant winter cold, make sure your flock is prepared. Adding cracked corn to the birds' feed will help keep their caloric intake and weight up, while water heaters can ensure fresh water 24/7. In cold weather, chickens also need a windbreak and nice dry bedding so they can get out of the weather and keep themselves warm.

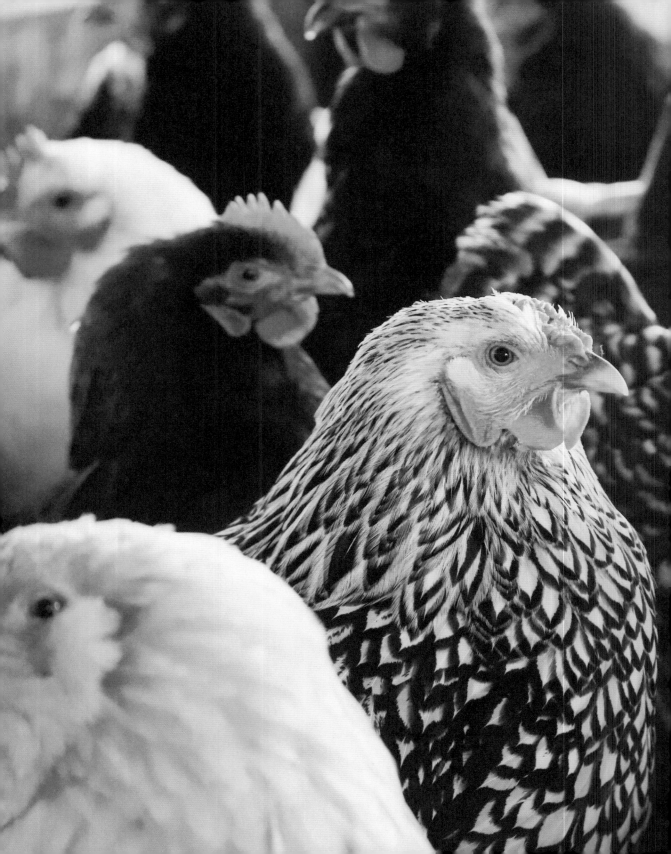

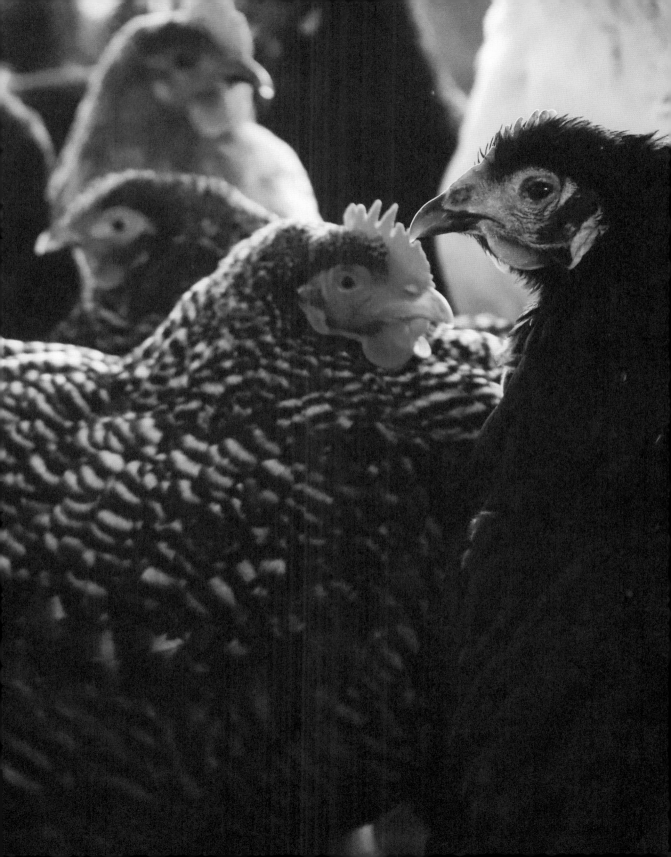

RAISE HONEYBEES

There is nothing quite like the feeling of being completely in tune with a beehive. Understanding the behavior of a hive, handling the frames, extracting honey—beekeeping brings you face-to-face with nature. You come to understand how pollination works and how bees make their honey, and you bear witness to one of the most fundamental examples of how the plant and insect worlds interact. Here's how to keep your own beehive.

MATERIALS

- Bee suit, including veil
- Beekeeping gloves
- Smoker
- Beehive: outer and inner cover, shallow and deep supers, bottom board and hive stand
- Hive boxes: deeps and shallows, frames
- Metal hive tool

SELECT THE BEST SPOT FOR THE HIVE

Bees need four things for their hive: sun, fresh water, wind protection (always point hive openings away from prevailing winds if possible), and privacy (at least 50 ft [15 m] from areas where people or pets congregate). Keeping the hive elevated by even just 1 to 2 ft (30 to 60 cm) will help keep out moisture and pests. You can use any sort of stable platform for this, from a sturdy wooden box to poured cement.

GET YOUR TIMING RIGHT

Always add bees to a hive during spring, when there are flowers blooming that can offer food to the bees.

INSTALL THE BEES

Bees can be purchased online, although if you're able to find a local beekeeper, you're more likely to end up with bees suited for your climate. Your bees will most likely come in a brood box. You'll have to suit up and move the frames into a super, or box (see photos of farmer Dana DiPrima in her bee suit on the following pages). Supers come in different sizes: deep (the largest), holds 60 to 70 lb (27 to 31 kg) of honey; medium holds 35 to 40 lb (16 to 18 kg) of honey; and shallow holds 25 to 30 lb (11 to 14 kg) of honey. Check with your bee source for their recommendations on moving the frames into your super—often this is as simple as smoking the hive; transferring the frames, one by one; then covering with the lid. For the base of your hive, always start with a deep super to optimize the amount of honey left for the bees to consume.

CHECK ON THE BEES WEEKLY, AT LEAST AT FIRST

When you're just starting out with beekeeping, the general rule is to check on your bees once a week. More than once a week may become disruptive for the bees, but weekly checks have the added bonus that the bees grow acclimated to your scent. In time, many beekeepers are able to work on the hive without having to wear a bee suit, because the bees have become accustomed to their presence. It's best to check on the hive during a still, sunny, and warm day, when most of the bees are out foraging.

There are a few things to look for when checking on your bees. Make sure the hive opening is clear, there is evidence of the queen, bees are coming in and out, honey is being produced, and no pests (like mites, wax moths, or hive beetles) are present. When one super is just about full with honey (at least seven frames will be filled), you'll add another super on top and replace the lid.

COLLECT HONEY AT THE END OF THE SEASON

In the fall, at the end of your first beekeeping season (or the following spring, if you want to give the bees their best chance of survival), you'll be able to extract honey from the top of the beehive, leaving behind the bottom super or two for the bees to survive on. Always be sure to check the supers at the bottom to ensure they're full before you take from the other boxes up top—sometimes bees will only partially fill a box before moving into the one above.

To collect the honey, smoke the hive, then take the frames out of the supers, gently sweep away the bees, and put the frames into a large pail (a sterilized garbage pail or giant Tupperware container works fine—the frames just need to be in a container where the honey dripping off them will be caught). When you get them away from the hive, you can scrape the honey and wax from each side of the individual frames into a 5 gl (19 L) pail with a double layer of cheesecloth or honey strainer stretched across the top. The warmer the space where you do this, the faster the honey will strain through the filter (generally between 12 and 24 hours).

You can use the beeswax collected in the filtering material to make soap or candles; the filtered honey collected in the bucket can be poured into jars for storage or sale.

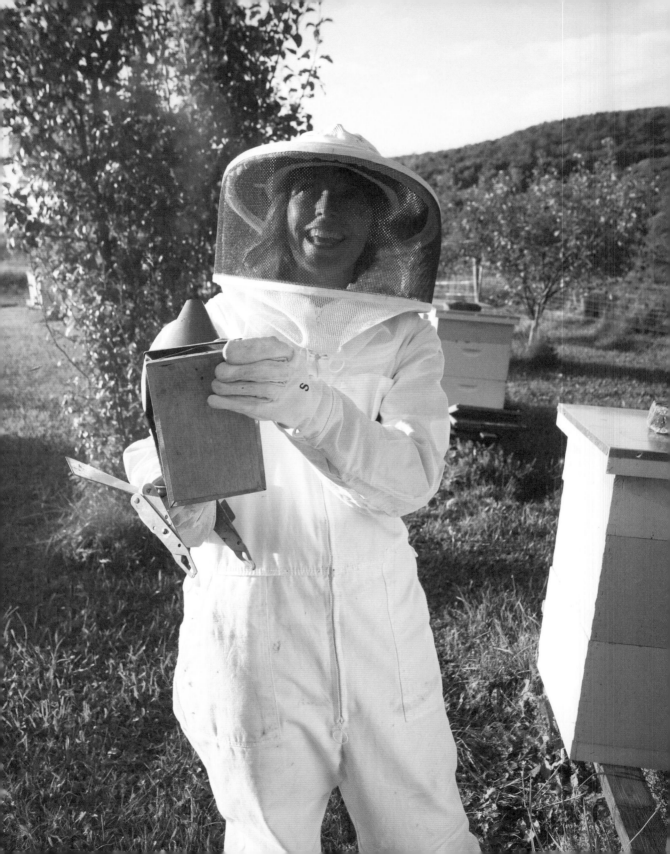

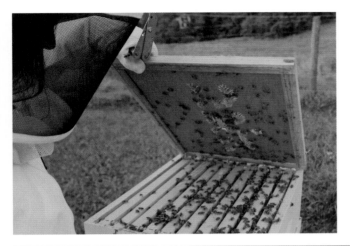

Dana DiPrima, founder of the *XoXo Farm Girl* blog and Catskill Mountain Honey, a community of beekeepers working to protect and repopulate bee colonies.

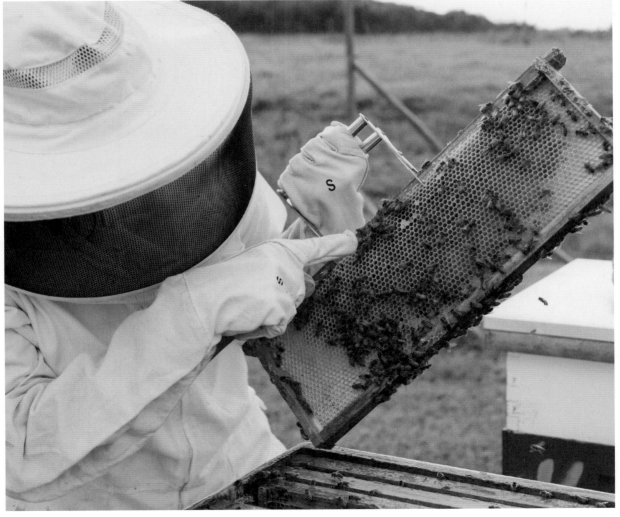

SHEAR AN ALPACA

Alpacas are domesticated members of the Camelidae family hailing from the highlands of the Andes in Bolivia, Chile, Ecuador, and Peru. They're genetically very similar to their more curmudgeonly counterpart, the llama, but also share a deep genetic history with the likes of guanacos, vicuñas, and, of course, camels.

Because alpacas have evolved for life at high elevations with temperatures that rarely exceed 53°F (12°C), alpacas have a hard time with heat. Shearing alpacas every year is therefore a necessity.

WHY ALPACAS?

There's a serious market for alpaca fleece. This fiber is hypoallergenic, five times warmer than sheep wool, and more valuable than cashmere. And with more than twenty-two natural colors of alpaca fleece, you don't have to bother with dyeing your yarn if you don't want to.

WHEN TO SHEAR

In the Northern Hemisphere, shearing alpacas is usually best done in early May, which gives the animals six subsequent months in which to regrow their fleece before winter hits. You know an alpaca is ready for shearing if the animal has about 4 in (10 cm) of fleece on its midsection.

With a little practice and the right gear, a team of just three people using a few carefully selected tools can shear an alpaca.

WHAT TO SHEAR

Alpaca fleece is sorted into three categories: blankets/primes, seconds, and thirds. Blanket-quality fleece (usually longer, softer, and cleaner—the highest grade) can be found in the alpaca's "prime" (back, sides) and "seconds" (neck, belly) areas. Fleece in the animal's "thirds" (butt and legs) is generally too short and dirty to be used for anything; although sheared, it is then discarded.

HOW TO RESTRAIN AN ALPACA

The two most popular methods for restraining alpacas are a standing position and the "Australian restrained" position.

Standing: Use a wall to keep the alpaca from lunging from side to side. This requires one or two people.

Australian restrained: Anchor the animal's front legs to one fixed point and its rear legs to another with shearing restraints

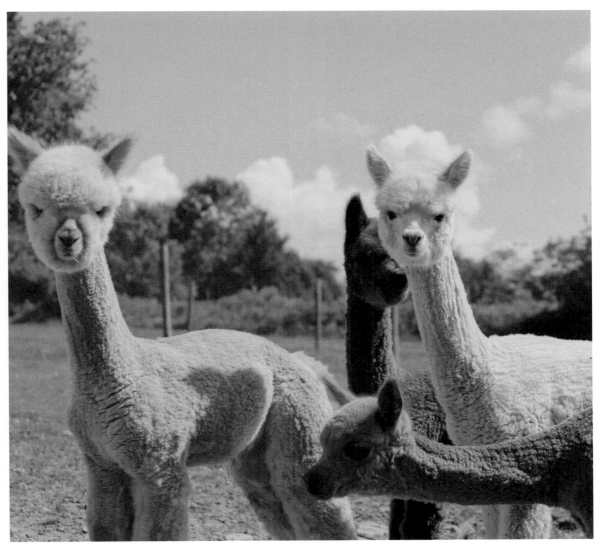

The Buck Brook
Alpaca Farm in
Roscoe, New York.

(available online) so the animal is lying immobile on the floor. Keeping the alpaca in this position, though it looks weird, can actually keep the animal calmer and safer during shearing.

WHAT YOU NEED

- Three people: shearer, handler, and fleece-remover

- Heavy-duty power shears (including handpiece, comb, and enough cutters to use a fresh one for each animal) with a motor inside the handle so you can move with the cutter; the more teeth on the comb, the closer the cut will be to the skin

- A large tarp

SHEARING, STEP BY STEP

1. Lay a large tarp on the ground so the fleece falls onto a clean surface.

2. It's essential to lubricate the shears to prevent any issues from all the heat and friction produced while shearing (30-weight motor oil works like a charm).

3. Attach the comb and cutters to the handpiece of the shears. You want to be sure the comb and cutters are aligned and tensioned properly. Not doing so can result in injuries to you and the alpaca!

4. Corral and securely restrain the first alpaca. Separating herd animals can make them anxious and create a lot of drama, so always restrain animals to be shorn within sight and smell of the rest of the herd.

5. Shear one side of the alpaca before moving on to the other side. Starting with the blankets, bring the comb along the base of the alpaca fleece so it creates a flat surface against which the cutters can do their job. Using very light downward pressure, carefully guide the shears along the alpaca's body. Keep the shears from cutting into the fleece at a steep angle. Sharp angles can wrinkle the alpaca skin in front of the shears, upping the likelihood of injury. Be especially mindful of this around the alpaca's breast and the sides of the belly.

6. Bag up the blankets and move on to the seconds, then the thirds (leave a pom-pom on the end of the tail for protection, and don't shear below the knees). Thirds can be left out for the birds (as nesting material) or composted.

7. When you've sheared every spot on one side of the alpaca, repeat the same process on the other side.

8. Cutting the fleece in front of and between an alpaca's ears is a totally cosmetic, subjective choice, though you should always trim any long hair that obstructs vision.

9. While the animal is restrained, shearers often take the opportunity to trim toenails and teeth and administer any vaccines or medication.

10. When you are ready to move on to the next alpaca, change to fresh cutters to ensure an even, safe cut. One comb should last you through at least two or three alpaca shearings.

In time and with a lot of practice, you should be able to shear an alpaca in 10 minutes or less.

How-to
CHOOSE YOUR COUNTRY DOG BREED

Herders, runners, and all-season adventurers, well-suited country dogs tend to be big, loving, protective, and driven. Farm dogs are pack animals in the truest sense of the word—and will treat you like the head of theirs. Make sure to find the breed that best suits your needs and conditions, and you will be rewarded tenfold with their protectiveness, love, and affection.

ANATOLIAN SHEPHERD

The Anatolian shepherd is an ancient breed; used by soldiers throughout the Roman Empire, they earned a reputation for surviving harsh environments. These massive dogs can weigh up to 150 lb (68 kg) and stand 29 in (74 cm) at the shoulders. But don't be fooled by their size; these pups are extremely agile, kid friendly, and very fast when they want to move. They've also got stronger sight and hearing than most dogs, making them amazing home and livestock guardians.

BORDER COLLIE

Border collies, Australian shepherds, and Australian cattle dogs are all excellent herders, wanting to chase just about anything that moves in front of them (including livestock and children). Considered to be the smartest of all dog breeds, border collies are also fast and agile, and crave affection. The more you give one of these dogs something to do, the happier it will be.

PYRENEAN MASTIFF

Packing all the punch required of livestock guarders, the Pyrenean mastiff stands out for its temperament. These beautiful giants bark less than other country dogs, adore kids, and are exceptionally mellow and always eager to please. Pretty impressive for creatures that grow to 150 lb (68 kg) and 30 in (76 cm) tall.

GREAT PYRENEES

The Great Pyrenees has become a sought-after country dog, especially for those keeping livestock. Originally bred to guard sheep in the Pyrenees Mountains in southern France, these magnificent creatures are among the most recognizable, well-loved guarding breeds. They are great with children and a variety of farm animals alike. Though they are at risk of health issues early in life, by working with a reputable breeder it is possible to minimize these risks.

BLUETICK COONHOUND

If you adopt a bluetick coonhound, rest assured you'll never have to deal with country nuisances like raccoons, squirrels, rabbits, possums, or other small wildlife. These dogs are renowned for tracking and keeping small forest creatures at bay. They're best friends to hunters, who use them to follow scents of deer or pluck downed birds out of the water. Coonhounds relish any opportunity to run, chase, fetch, or play; they love people and are extremely reliable guard dogs.

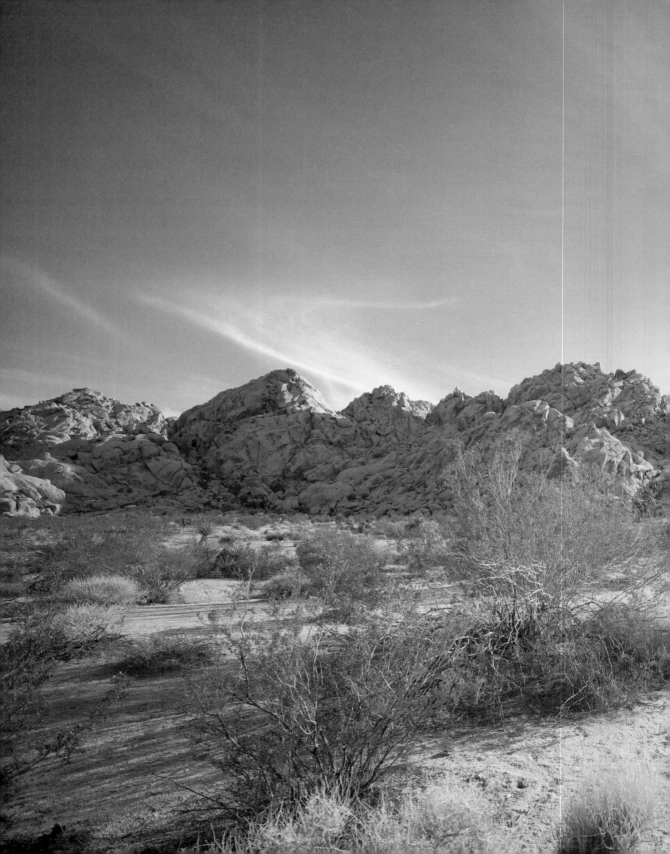

Part III

DESERT LAND

Inspiration

Dwellings

Provisions

Essentials

The Edge . . . there is no honest way to explain it because the only people who really know where it is are the ones who have gone over.
—Hunter S. Thompson

The desert, with its unusual formations and endless horizons, allows us to feel like we've left the earth. The vegetation and animals of the desert have adapted to a harsh climate, producing magical forms, colors, and shapes.

Those who inhabit these lands are rewarded with a beautiful, calm silence and radiant sunsets with deep rays of red and orange followed by a night sky so dark the stars themselves illuminate the ground. It is a place to clear your head and free yourself from distractions. A place for cleansing, solitude, introspection.

THE SHED PROJECT: OWL PEAK FARM

Lamadera, New Mexico

At Owl Peak Farm, a hidden gem in the high desert of New Mexico, a young chef named Johnny Ortiz dedicates his life to connecting the sacred land he grew up on with people from all over the world through an elaborate culinary experience forged in the wilds of the American Southwest.

Johnny Ortiz was raised in the high-desert landscape of Taos, New Mexico, in a valley below snow-capped mountains, east of the Rio Grande. Just outside town is one of the oldest inhabited structures in the entire world, the Taos Pueblo. For the past one thousand years Taos natives have lived within its ancient tan adobe walls. This is the community in which Johnny and a historical lineage of generations past have lived.

Sharing the heritage of this land through an artistic culinary expression is what fuels Johnny's work. He is dedicated to foraging and preservation, and using ingredients and methods that draw strangers from around the world to participate in an intimate history lesson that is also an indulgence of all the senses.

You can see the ultimate effect of that historic childhood on Johnny. It's in the clays he uses, in his obsession with using nature's bounty. The chef is meticulous, driven by details in his pursuit of magical, serendipitous moments. He sees meaning everywhere.

And everything Johnny does flows out of the heritage of the culture and land he comes from.

WILD ROSE PETALS

"The Pueblo is a few minutes from where I went to school," Johnny said. "I remember one day, I was walking home with my mom and she pointed out the wild roses to me; she showed me how you could eat the petals. She told me my grandfather used to eat them all the time. Every day after that, on my way home, I would eat the petals. I think that was definitely a spark there—somewhere in me, this love for food and the nature around me."

Johnny took culinary classes in high school but ended up pursuing business in college. "I knew I wanted to cook, but New Mexico has such a good in-state tuition, it was kind of neglectful to not go to college here," he said. "So I went to school for business but worked in restaurants."

When he wasn't in class, Johnny was in the kitchen, where the head chef advised him

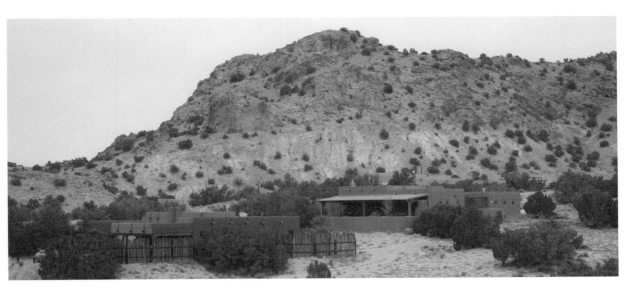

to drop out and start cooking full time if he wanted to make food his life. Which he did.

CULINARY CURIOSITIES

Johnny was just nineteen when he decided to move to Chicago and, in a stroke of luck, landed his first major restaurant job as morning prep cook at Alinea, a three-star Michelin restaurant.

"Alinea was very experimental," he said. "They broke down concepts and walls of what you can do with food. It was pretty wild to see people doing stuff with food that was totally different—you could feel an energy that opened the possibilities in my mind of what food can be."

Next, Johnny's culinary curiosities led him to Willows Inn on Lummi Island in Washington. "I wanted to learn to cook more naturally," he said.

At Willows Inn, "they foraged their own food, sourced from local farms; it was a secluded place, small scale, under the radar. It seemed like a good place to learn more, get more attention and focus," he said. Johnny stayed there for the next year before moving on to San Francisco. The now-famous three-Michelin-star restaurant Saison was just opening its doors at the time. Johnny struggled to get their attention, but eventually they hired him as a chef de partie.

"Saison had a great mix of city life and kitchen intensity, but also had a thoughtful and natural cooking atmosphere," he said. "It was upscale, natural, fire focused, and produce driven."

Four years passed, with Johnny moving up to sous chef. He was twenty-three when he hit his next plateau. "I wanted to explore my own voice in cooking," he said.

CARVING OUT HIS OWN PATH

The concept for Johnny's Shed Project grew from his unquenchable desire to express his own personal culinary vision.

"To me, Shed Project meant to continue growing," he said. Johnny envisioned foraging food for exceptional, all-inclusive dinner parties. Meals would be served on plates made of local clay. These events would be held in a small apartment near San Francisco—at least at first. "I always knew I would eventually head back home to New Mexico," he said. "The concept for it was explorative, in-the-moment food. Foraging seemed like the most pure, natural way to eat—extremely abundant, tastier, and more nurturing."

Having always admired the ceramics of the tribe he was born into, for years Johnny had wanted to learn how to make his own. "I feel like it's ingrained in my blood," he said. "For generations, my ancestors dug this clay and created pottery. Foraging for food and clay brings me closer to my family as well as the land."

> *"The concept for it was explorative, in-the-moment food. Foraging seemed like the most pure, natural way to eat—extremely abundant, tastier, and more nurturing."*

He tracked down Carol Neilson, a well-known local pottery artist in San Francisco, who taught Johnny how to make his own plates and mugs.

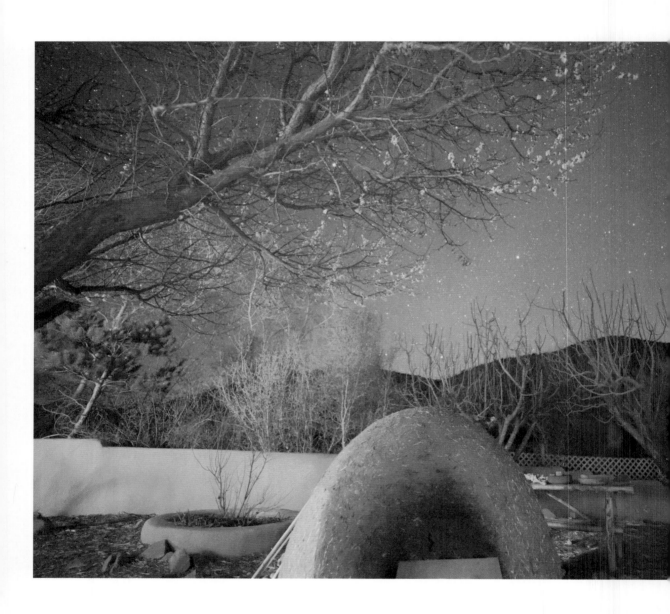

Johnny next sourced a local slab of redwood to build a beautiful dining room table that could seat ten people. The Shed Project launched from within Johnny's Bay Area apartment doors, and it wasn't long before the dinner parties proved to be a success with locals.

The groundwork was laid. Johnny knew it was time to carry what he'd germinated along his brilliant culinary journey across the country and let it flourish back home where it all started. "It was an inherent need to be back where I grew up," Johnny said. "I wanted to explore that land again."

Back home in New Mexico, Johnny continued to execute a series of nomadic dinner parties throughout the state, in locations that included a bakery, a chocolate shop, and even a woodworking shop.

Then he found Owl Peak Farm.

THE SHED PROJECT AT OWL PEAK FARM

Owl Peak Farm is a 20-acre (8-hectare) property in the town of Lamadera, a rural community in the high desert an hour west of Taos, between the Ojo Caliente Mineral Springs to the north and Abiquiú to the south (where Georgia O'Keefe famously made her desert home). The farm is at the base of a steep ridge dotted with gnarly tree tufts. The property owner, CC Culver, practices regenerative farming, which supports erosion control, organic methods for raising produce, and water monitoring for quality and conservation.

CC first met Johnny at a dinner party in Taos, and she was blown away by what the young chef was doing. "CC had apprenticed at the famous Blue Hill Farm in New York," Johnny said. "She had a goal of providing a space for small-scale farmers to produce unique, indigenous agriculture."

The two quickly worked out a partnership: Johnny would move to the farm full time and help restore the land, practicing passive, holistic high-desert planting. Using the farmhouse and produce grown on-site to support his culinary experiences would help bring in an income stream to help pay for everything.

ORTIZ IN RHYTHM

Johnny settled into a daily routine of waking up and tending to fifteen Churro sheep and his three dogs, as well as beehives, chickens, pheasants, and quail.

He makes breakfast before hopping into Mikah, his 1991 Range Rover. Johnny and Mikah's first stop is the farmers' market to shop for local and seasonal dinner ingredients. Afterward, they ascend a rocky road alongside the Rio Grande, where Johnny forages for additional food and flavor elements. These excursions are planned around the farm work, which includes felling trees for firewood, taking care of crops and produce, and working with clay to create ceramics for dinner attendees.

"I do whatever it feels like I need to do," he said. "It doesn't feel like a job, and I don't have to clock in or clock out. Every day is exciting, and I get to do what I feel I need to do. But it's hard to grow food naturally and make a living from it. If we weren't doing these dinners and selling ceramics, we would be in trouble. This year especially has been a very dry year, so it's been challenging. I think of letting go of it as a business, and being OK with things working out naturally."

That kind of open-mindedness somehow harmonizes with his precision—a dichotomy that works for him whether tending to a flock of chickens or forming a new piece of pottery.

FORAGING FOR DINNER

Most of what Johnny offers at the Shed Project are plant-based meals, although he does include locally hunted game like elk and brook trout.

"We try not to stick to any guidelines," he said, "but in winter we have more meat and root veggies. In the summer, it's more focused on plants."

> ## *"Cooking is about nurturing people, but it's also a practice of paying attention to our surroundings. "*

His favorite dishes vary as regularly as the days. Foraged ingredients have included Ponderosa pine, three-leaf sumac, native plum blossoms, sunchokes, and wild seeds.

The availability of foraged ingredients is unpredictable, which inspires Johnny to be creative and resourceful. "Things change very often, so we like to try cool new things," he said. "Cooking is about nurturing people, but it's also a practice of paying attention to our surroundings."

Not a single menu is repeated, which means people always come back to see what's different. "Nothing lasts forever, so it is important to notice nature in the moment," he said. "We do what feels natural and best throughout the seasons."

BRINGING THE COMMUNITY TOGETHER

The dinner parties make Lamadera, a town of 150 people, feel far from lonely or set apart from society. "We have so much abundance around us," Johnny said. "We have friends that come and help, and all the connections we make are deep and meaningful. I do think I am distancing myself from society, but I try to stay connected."

Johnny is now entirely focused on redefining what the Shed Project looks like, making it ever more varied and refined. He hopes to get more land and build the dinner spaces from scratch—specifically adobe, rounding out his history and his future. "I am so grateful for all the abundance around me," he says. "I can't imagine living any other way."

DESERT LIVING: THE JOSHUA TREE HOUSE

Joshua Tree, California

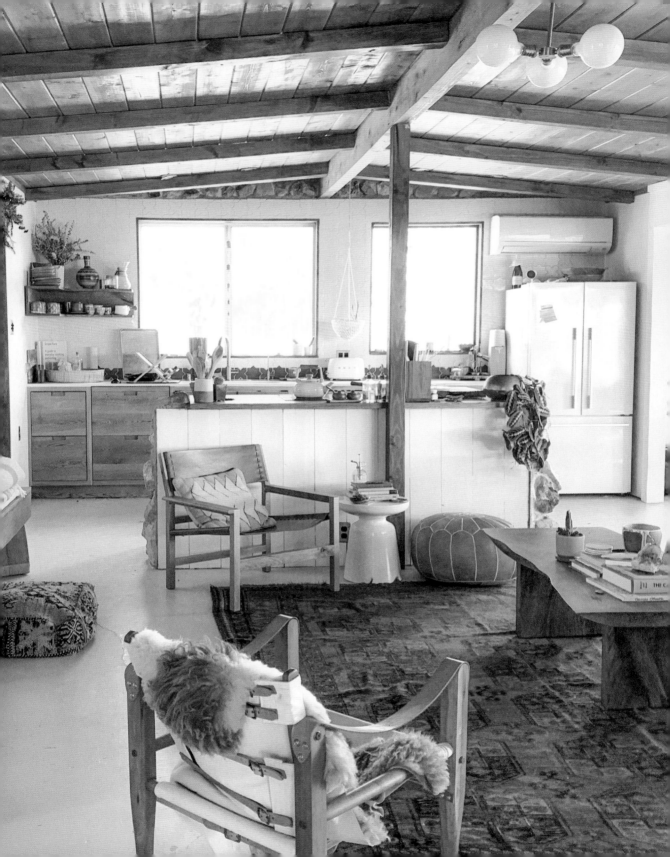

The magical, alien beauty of Joshua Tree cannot be easily explained with words. Stark and other-worldly, it's hard to imagine making this place home. But that is exactly what Sara and Rich Combs, high school sweethearts and founders of the Joshua Tree House, have done.

Sara and Rich grew up in the suburbs of Connecticut, where they first forged a connection with nature. "My home's backyard was made up of dense woods where I would spend my time making forts and mud pies," Sara said. "A part of me felt that suburbia was 'boring,' but weekend hikes and space to create and play outdoors cemented a connection and love with being in nature."

The couple attended the Maryland College of Art in Baltimore together. After graduation, they moved to San Francisco, where they spent the next seven years working in web design. Eventually, needing a break, the couple traveled to Southeast Asia, which turned out to be life-altering.

Sara and Rich returned to the states reinvigorated and inspired, ready to start a design company of their own and take the show on the road. "We started doing web design work remotely for various start-ups, and we found that as long as we got our work done on time it didn't matter exactly where or how we did it," Sara said. "We spent many afternoons pulled over in a parking lot using internet from coffee shops to get work done for clients. Our favorite approach was to spend our mornings driving, afternoons hiking or exploring, and evenings working in our motel room."

During a month-long road trip across the United States, they wound up spending a night in Joshua Tree. They fell in love, and that was that.

A PLACE TO BE

"The contrast of city to rural pulled us in immediately and heightened all of our senses," Sara said. "We were hearing the feathers in birds' wings shuffle as they flew past, wondering how we had never heard or noticed that before. At night, we looked up to the sky to shooting stars and the Milky Way; sights we had rarely seen before they became a daily occurrence." Sara and Rich couldn't stop thinking about Joshua Tree—its completely unfamiliar landscape, the creative community, the open-ended sense of possibility.

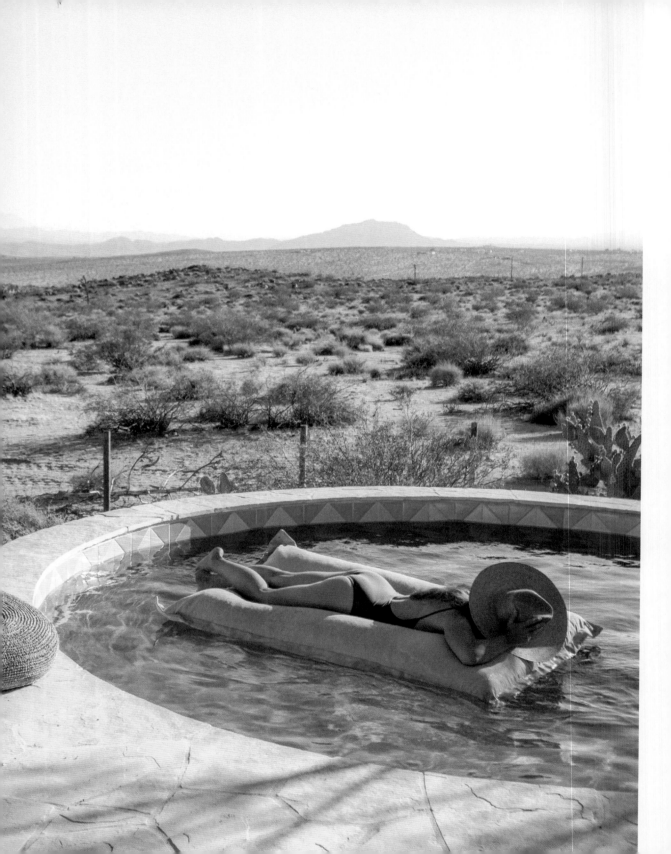

As they kept traveling throughout 2014, they grew obsessed with the idea of moving there.

The couple perused Craigslist real estate listings until they came across a home built in 1949. "It was just this one house for sale by the owner, using tiny pixelated images, but somehow our guts knew it was the one," Sara said. They inquired, but didn't hear anything back for over a month. So they decided to plan another road trip to Joshua Tree to continue their search. As fate would have it, the owner reached out that same weekend. "Before we even set foot inside the house, our eyes brightened, our hearts were racing, and our guts were telling us that this was exactly the place that we needed to be," she said. The Joshua Tree House was theirs, and it was just the beginning.

TASTY DESERT VIBES

The couple worked their designer magic to decorate the Joshua Tree House, developing their style and progressively learning more about renovation as they went along. As they were working on remodeling the Joshua Tree House, another nearby home went on the market—a 1958 casita. Boldly, they jumped into that project almost simultaneously.

"When we started on the Casita, we hired some help for larger renovation projects. We were still able to do a lot of the work ourselves, but it wasn't smart to take everything on—so we focused on our strengths, and with help, got the project done much quicker," she said.

Both the Casita and the Joshua Tree House are surrounded by hundreds of acres of protected land, offering unspoiled views of golden granite boulders, the area's namesake trees, and endless sky. The floors, walls, and ceilings of the homes are variations of tongue and groove, stone and tile, mirroring the scene outside large glass windows and doors. Understated, functional furniture, décor, and variously dated light fixtures round out spaces at once minimalist and cozy.

The couple thoroughly documented their renovation and design progress on social media, which caught on quickly with followers obsessing over the couple's tasty desert designs and lifestyle philosophy. Their following grew into the hundreds of thousands, motivating the couple to share their internet-famous homes on Airbnb for fans to experience themselves.

With the success, the couple took on a third project in Joshua Tree: the Hacienda.

THE LEARNING CURVE OF DESERT LIVING

Residents of Joshua Tree know better than to assume what weather a day will bring. "The weather can be extremely harsh; it decides for us what our plans are that day," Sara said. "It's taken a lot to let go of some of that control, and let the desert decide what's next." A recent flash flood forced them to spend a weekend filling in ditches carved away by flood washes, and taking long detours around closed roads to restock supplies. "We're learning to go with the flow—life here forces us to pause our 'busy lives' and spend an evening in candlelight every so often," she said.

The challenges have brought a newfound sense of self-sufficiency, along with a new group of people to learn from.

"It's always a little intimidating moving to an entirely new place without knowing anyone, though we've found locals to be so friendly—

it's part of why we were interested in moving here," Sara said.

"We would end up in long conversations at local shops, the farmers' market, or our local swap meet. We also found a lot of new friends through social media—others who had also recently made the decision to live rurally. We automatically felt connected to so many people here, having made the same choices to simplify our lives and move to the desert," she said.

"We're learning to go with the flow—life here forces us to pause our 'busy lives' and spend an evening in candlelight every so often."

The harshness and lack of convenience has also toughened up the two considerably. "We've learned how to relocate rattlesnakes, garden with cacti, treat a spider bite, and patch a roof," she said. "We give this rural lifestyle all of the credit for allowing us time and space to build our dreams, reconnect with nature, and find incredible fulfillment."

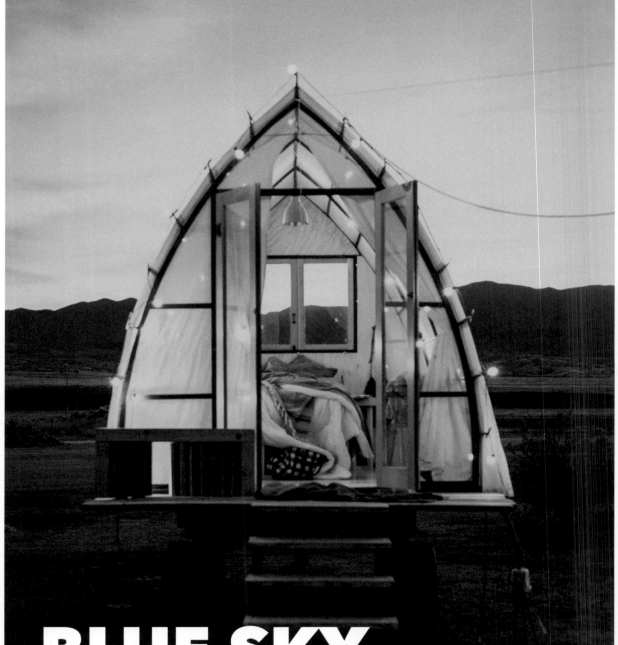

BLUE SKY CENTER

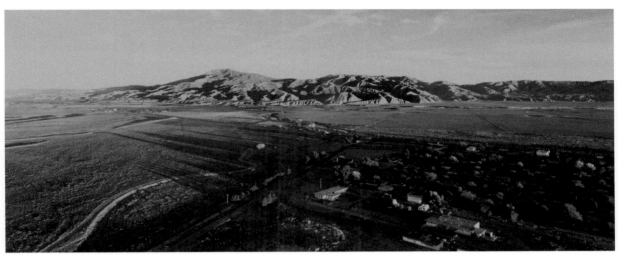

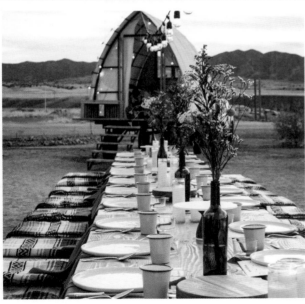

Cuyama Valley,
California

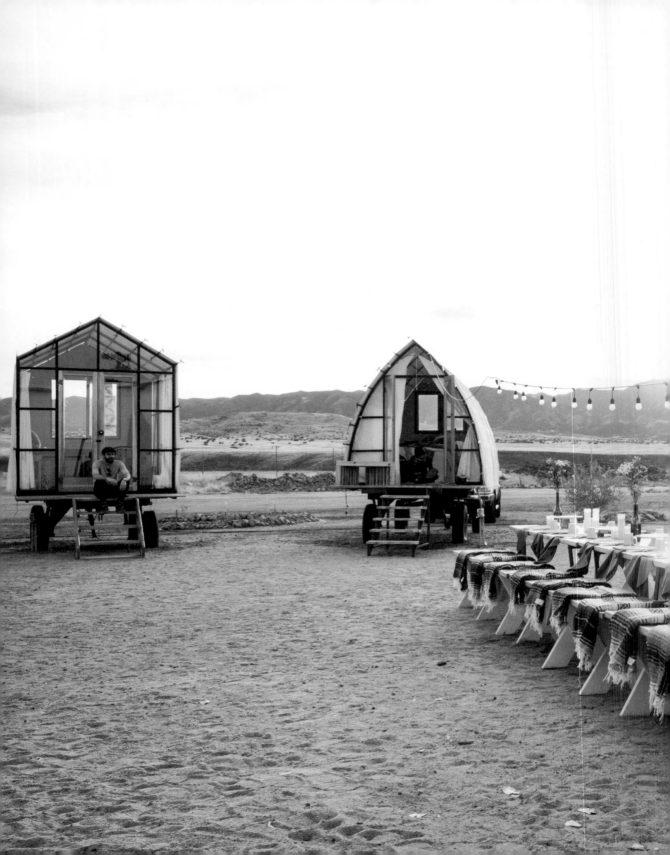

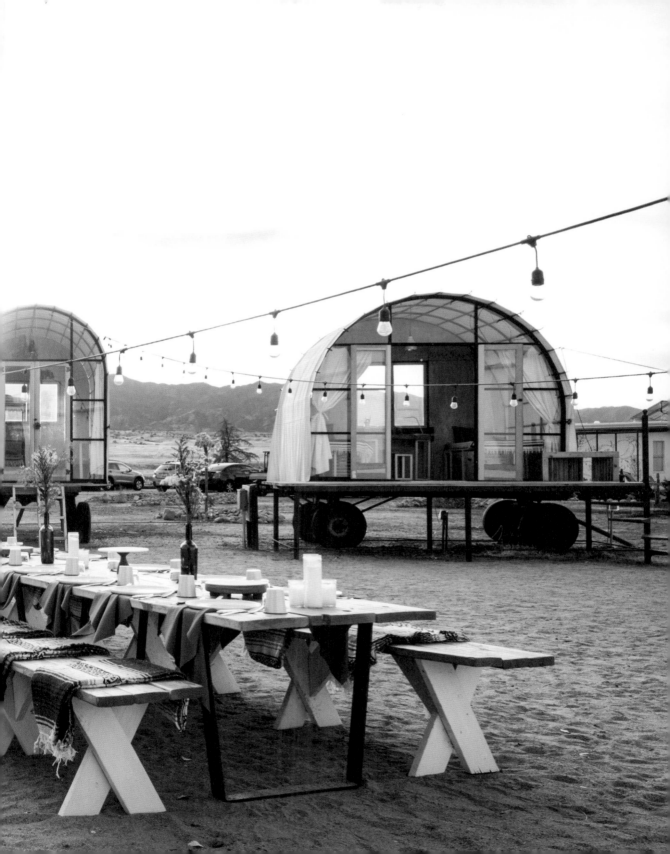

In 1949, the discovery of oil in the Cuyama Valley of Southern California turned an iconic ranch landscape in the high desert into a partially industrialized village. The Atlantic Richfield Company (ARCO) settled in and formally named a 360-acre (146-hectare) parcel of the valley floor "New Cuyama." New Cuyama prospered for some time, until the late 1970s, when ARCO withdrew from the area.

New Cuyama was left with an abandoned industrial complex, a collection of mostly derelict buildings, and a runway. But in 2012, the Zannon Family Foundation of the Santa Barbara Pistachio Company, which has a pistachio farm based in the Cuyama Valley, acquired the land. The foundation renamed it Blue Sky Center and started a nonprofit with a mission of providing support to New Cuyama while rehabilitating and regenerating the land and economy for the local community. Blue Sky Center focused its efforts on philanthropic endeavors that would transform ARCO's old headquarters into a thriving community space.

This time, the renaissance would be based on equitable partnerships, sustainable methodologies, and ongoing support for the people who call New Cuyama home.

A series of stunning, minimalistic experimental huts is just one of the many creative endeavors underway in this vibrant community of creators, makers, growers, and doers.

"It's quite a magical place; so quiet, yet so dynamic and cultural. There are real cowboys who live out here," said Em Johnson, Blue Sky Center's executive director.

Em joined the organization in 2016, with a keen interest in pushing against traditional community-development methods. After spending two years in India working with a number of nonprofits and exploring the world of rural economic development, Em was pursuing different ways to build a local community.

"There's power to enticing people into small communities. Urban settings will continue to be more expensive, disconnected, and unsustainable. Our goal is to make this a place people want to come to and help grow," Em said. Now, many local businesses are flourishing at Blue Sky.

Blue Sky's eye-catching huts are a part of a hospitality initiative developed in 2017 to support the local economy. There are five huts on the property, all welded onto trailers laid out in a semicircle designed for congregating and socializing. The huts were designed by a local architect, Jeff Shelton, initially as an experiment rather than for lodging. The huts use boat sails as roof linings, and all interior furnishings are handcrafted by local woodworkers. The unique and minimal structures found their way onto social media and quickly went viral, booking up immediately. The revenue goes straight back into the community. "It's a way to celebrate the Cuyama Valley by bringing guests to the winemakers and farmers in the town," Em said.

Also on site are local small businesses and artists that benefit from low-cost renting options. Blue Sky Center has a welding shop, car renovator, winemakers, and ranchers offering horseback riding to visitors. The center hosts community events and workshops, too, from movie nights to bread-making. Everything is off-grid, run entirely on solar.

"Cuyama is a place that *is* already, it's not a place to be made or reclaimed, or to change, or to develop," Em said. "It is a place to celebrate resiliency. It is already very unique, as is."

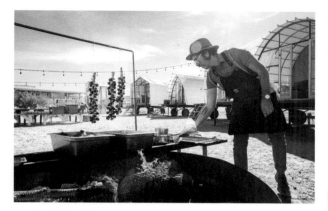

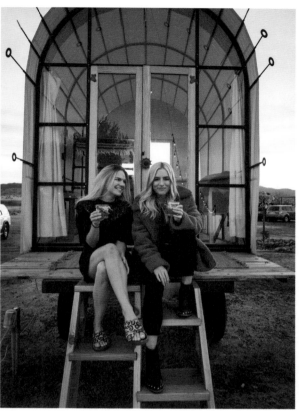

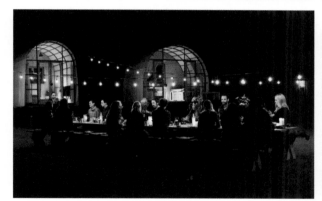

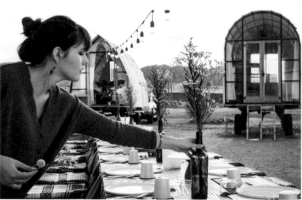

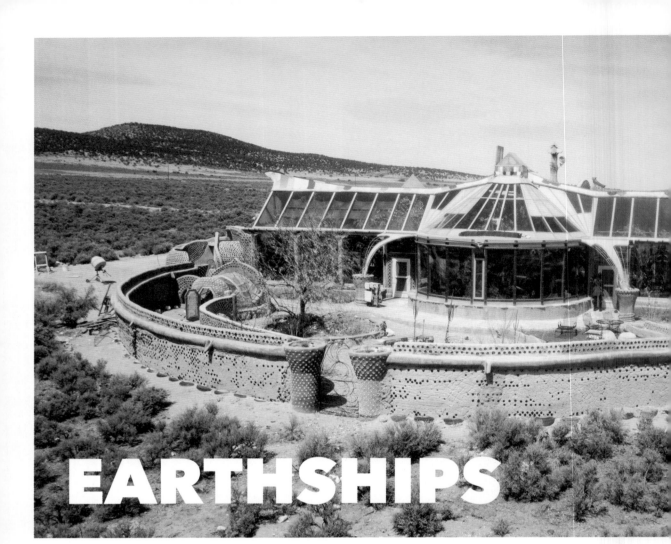

EARTHSHIPS

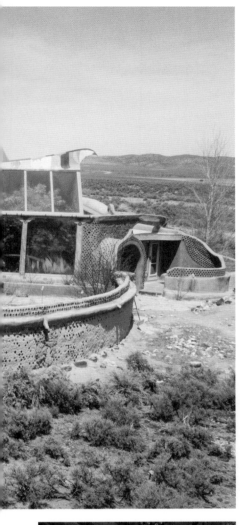

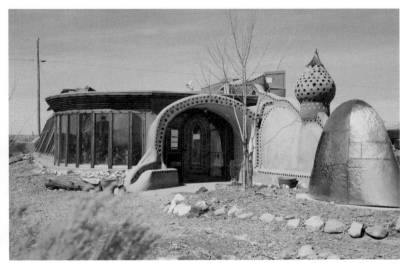

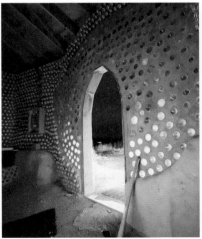

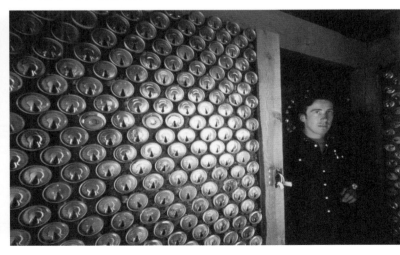

Driving along a single-lane highway in the New Mexico wilderness, wide-open desertscape on either side of you and mountains in the distance, the last thing you expect to see is a series of strange structures looming on the horizon.

Shiny objects in silvers, reds, blues, greens, and oranges catch and reflect the sun, scattering flashes of light across the golden landscape. As you turn off onto a dusty drive, the odd shapes and shades come into focus: Earthships. And at their helm is a wiry, silver-maned seventy-two-year-old activist named Michael Reynolds.

Earthships are solar-powered buildings made out of natural and upcycled materials, including dirt, tires, tin cans, and glass bottles. Michael came up with the design for Earthships in the 1970s to satisfy the six principles of human needs for off-the-grid living: thermal/solar heating and cooling, solar and wind electricity, self-contained sewage treatment, natural and recycled materials, water harvesting and long-term storage, and the capacity for internal food production.

Michael explains all this while standing in the middle of a field, shoveling and packing dirt into old tires, which he will use as the foundation of a new Earthship. "The dirt inside the tires helps retain and regulate temperature," he says. "Earthship structures are intended to be off-the-grid-ready homes, with minimal, if any, reliance on public utilities and fossil fuels. They are constructed to use available natural resources, especially energy from the sun and rain water."

Today, there are around three thousand Earthships on the planet. There's one or more in every state in the United States and in just about every country (and even in Siberia). Michael has even opened an academy in Taos, New Mexico, where students come to learn how to build Earthships themselves.

On the outside, Earthships have a very nonlinear, adobe-inspired design that has evolved considerably over the years and in the different environments they're built in. While they certainly have a groovy, hippie look, the sculpturally flowing buildings can be customized to be downright luxurious, with decked-out bathrooms, magnificent living quarters, and state-of-the-art kitchens—not what the layperson might think of when visualizing an off-grid sculpture house made out of junk.

"My dad was a builder; he built our house, and I helped him," Michael said. "I liked it, and I was always good at drawing. Architecture seemed to be a no-brainer for me." Michael attended the architectural program at the University of Cincinnati and worked for various firms to pay for college. But by graduation, Michael had determined he'd never work for other architects again. "Most architects basically make big square buildings," he said. "It was so uninspiring. But I still liked to build and draw, so I went in a direction of inventing my own type of architecture, just for myself."

Environmental concerns about waste and deforestation became pressing issues in America in the early 1970s. Michael said, "It caused me to think, well, we need trees, so why do we cut them down to build with when we have tires and cans we don't want, and they're actually pretty damn good building materials? As a matter of fact, I don't know of a better way to build. Termites don't eat tires, they don't rot, they're great for holding temperature, and

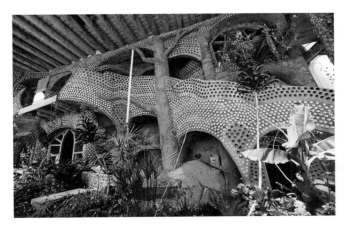

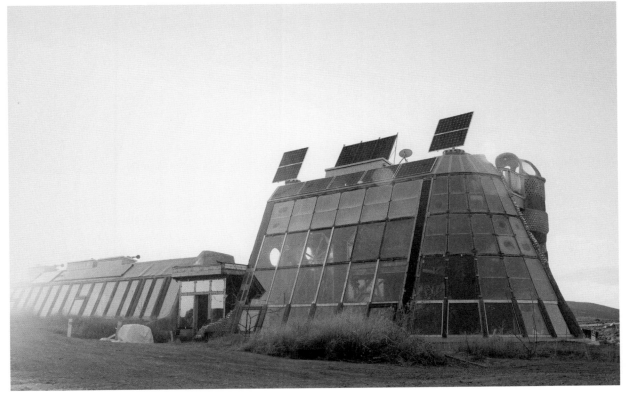
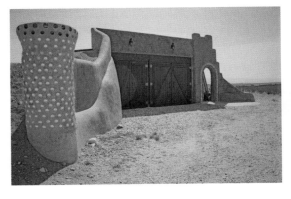
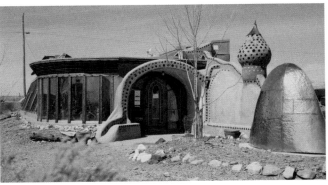

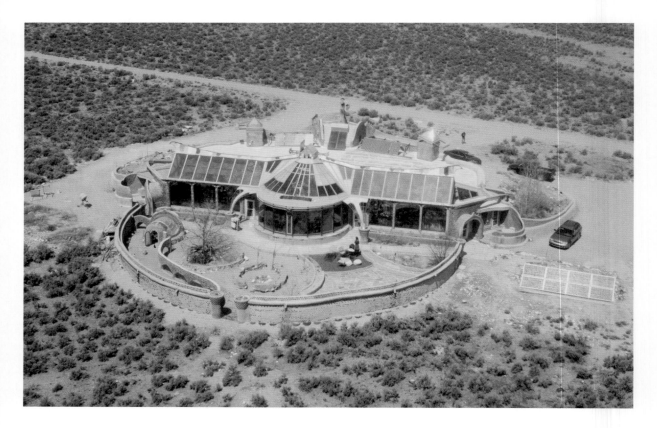

at this point they're indigenous to the entire planet."

Michael started in 1971 with a "Beer Can House," built out of steel cans. "It went to every paper in the world. Not as someone who was recycling and doing something positive for the ecology, but as a freak doing something crazy with garbage in the desert," he said. "It was a freak show story and stayed that way for many years until architects and builders started coming out to see what I was doing and embracing it."

Architectural students started to come from all over to take on apprenticeships, which organically evolved into an academy. "Over the years, we started taking steps to make these structures heat and cool themselves, produce their own electricity, and treat their own sewage; then we created conditions to grow food inside them," he said. "It just grew into these structures that are like machines that are off-the-grid, life-sustaining energy sources, and it blows people's minds."

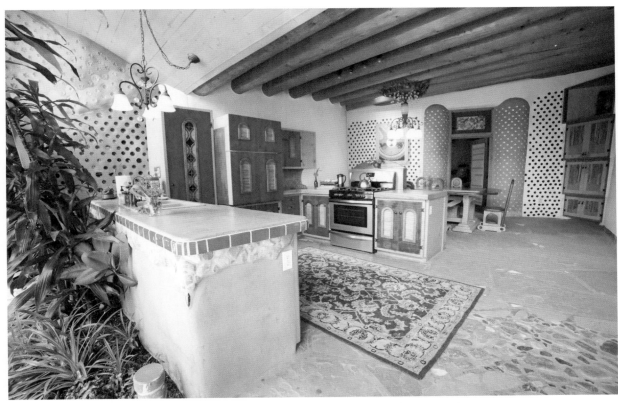

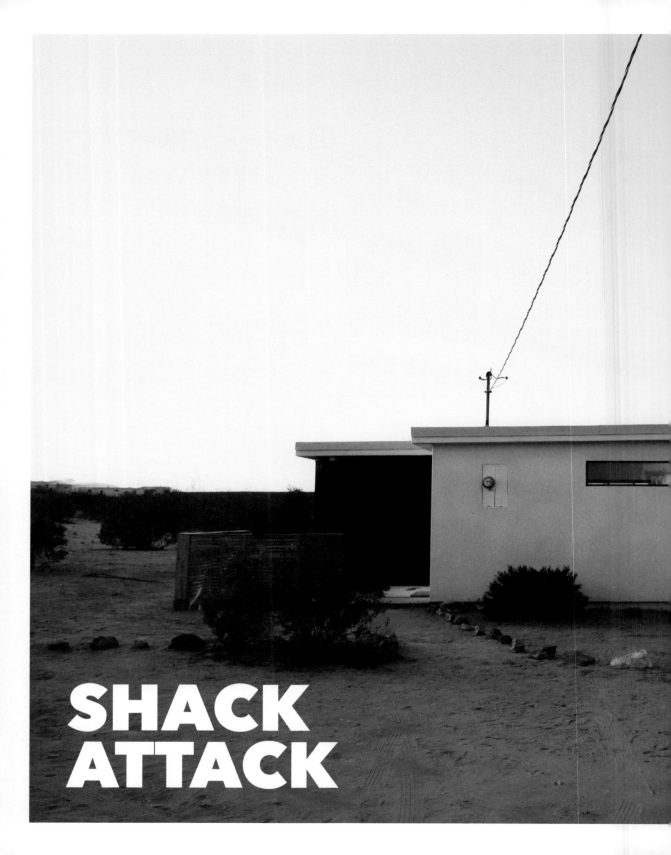

SHACK
ATTACK

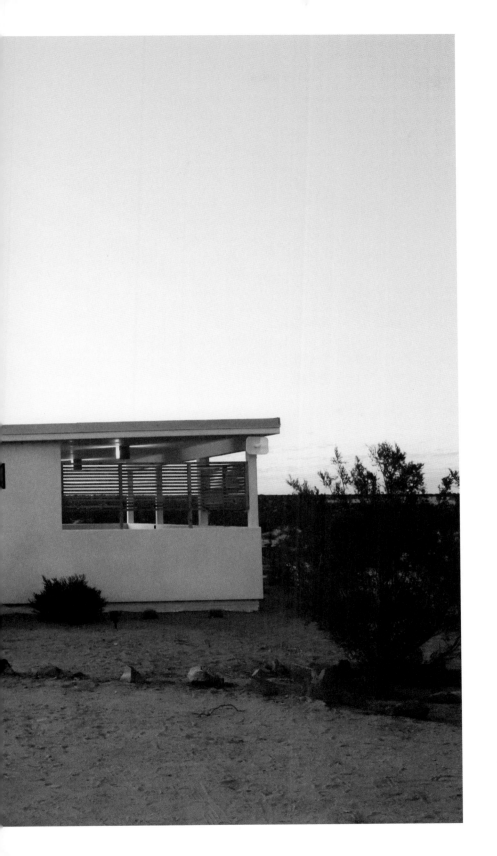

Joshua Tree,
California

It was the experience of living in Los Angeles—and leaving it—that taught Kathrin and Brian Smirke the myriad benefits of having a foot in two different worlds in order to build a fulfilled, complete life. Today, their time is split between the redwood forests along Northern California's coast and a desert property a ten-hour drive away.

"I think life is nuanced and shades of gray," Brian said. "If you think in terms of absolutes and you're unwilling to try and fail—it took that leap to the desert and getting out of the city to get to where we are today."

Kathrin and Brian met in Los Angeles while Kathrin was studying acting and Brian was playing music. Eventually, Kathrin got into production and started a clothing line, and Brian waded into real estate.

When the economy crashed in 2008, Brian found his footing in property redevelopment—specifically, flipping houses. As part of that process, he also earned his general contracting license. That venture dovetailed with Kathrin's passion for design, and the two began to work together.

"I'd just finished a project, and that coincided with our first visit to Joshua Tree. It was such a cool place, and still close to Los Angeles," she said. The couple decided to buy into some properties, which included the Shack Attack, Cabin Cabin Cabin, and Dome in the Desert. While the dome and cabin are cool by Brian's standards, it's the Shack Attack that's nearest and dearest to the Smirkes' hearts.

The Shack Attack is a lesson in possibility. The 480-square-foot (45-square-meter) 1957 bungalow was sold to the Smirkes as its only bidder at an auction in town. When Kathrin and Brian pulled their car into the drive, they found it in a state of utter disrepair. The couple pulled out a bottle of wine they'd bought at a nearby Circle K and took seats in a pair of camping chairs. "We chatted, listened to music, and got a feel for the space," Brian said.

The kitchen was in a shambles, a tumble-down space filled with animal scat and dirt. Outside the dingy windows, day drifted into night as Kathrin and Brian sat in the space, imagining what could be: a redesign that would feel at once outdoors and interior.

"It was a kitchen, bedroom nook, entry-way, family room, and then 80 square feet (45 square meters) for a bath," he said. "How do we take that little space and make it seem open and inviting so it embraces the parts of the desert that we want to embrace? We started out from a most basic level."

Brian said while the renovations were more extensive than for other properties, the clean slate made it less intimidating. "It was easier to commit to demoing down to the studs and then redoing. It was a very gradual and slow evolution. It was enticing, because it didn't feel like we were going to lose everything if something went wrong."

Kathrin and Brian opted to maximize the shack's east-facing view and build out from there. "The entryway is a glass wall with partition. A wall on one side is the entry; the other side is where the bed sits. Doing it this way allows light in and creates a bright entry, but also creates privacy so people can't look in at you sitting on the couch or in your bed."

"I was responsible for the interior," Kathrin said. "Brian built a lot of the furniture. For the Dome, we thrifted a lot: Craigslist, eBay. I just wanted to have unique things and felt like the same applied to the Shack. We came up with

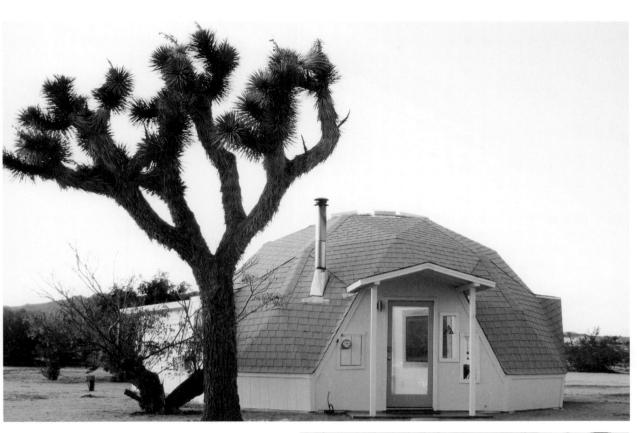

furniture pieces Brian could build so we could have as few store-bought items as possible. I wanted the Shack to be more muted and calm, with a beige-colored floor to match the ground outside. I also wanted to bring the outdoors inside, so Brian actually jackhammered a section of the floor so we could have an indoor cacti planter—like a little cacti garden."

"This has all been a gradual creep on us," Brian said. "The longer we spent in the desert, the more we were disconnecting and fixing up. We were very disconnected at first—checking on cell phones for contacts and music, no TV, doing work ourselves—it all felt very liberating. There is something almost primal about working with your hands on your own thing and reaping the benefits of your labor. There was just something fulfilling about it that I had not felt, probably ever. And it takes time to get there because sometimes it is so frustrating."

Draping a hose over a tree branch for outdoor showers and feeling some of the pressures of city life sloughing off with every bit of manual labor suited Kathrin and Brian just fine. In fact, Kathrin said she got to a point where it wasn't so easy to leave the desert— even after a weekend of working in 112°F (44°C) heat.

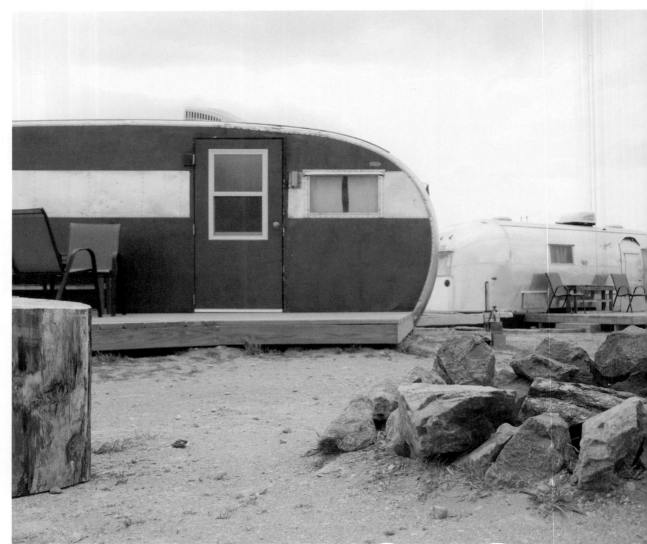

LUNA MYSTICA

Taos,
New Mexico

Trailers signify travel. They imply exploration, uncharted frontiers, and a collective nostalgia for bygone days of road trips, national parks, roadside attractions, and time spent under skies spangled with stars. Few dwellings conjure such a swelling sense of adventure as vintage trailers of the '50s, '60s, and '70s.

Walking the grounds of Hotel Luna Mystica, you can see why. Here, on a 12-acre (5-hectare) mesa in Taos, New Mexico, dotted with scrubby grass under an astoundingly big sky, with snow-capped mountains in the distance, sit almost two dozen trailers in bright flashes of silver, sky blue, turquoise, and red. Each structure has its own name—from Soy Capitan to Esmeralda—and style, and each hearkens back to an earlier, perhaps simpler time when families and ramblers set out in search of new experiences all across America, but particularly throughout the southwest.

Contrasting with that dusty iconography are the interiors. Each trailer has its own theme and color scheme, with top-of-the-line restorations that include tin backsplashes, hardwood countertops and tables, track lighting, brand-new appliances, luxury linens, vintage-style plastic chairs in every color, retro wallpaper patterns, and artwork reminiscent of the era these beauties were born in.

Behind this off-beat lodging concept are Patrick Nechvatal, Tristan Burman, and Ryan Irion. Patrick and Tristan were high school buddies who grew up in the suburbs of Albuquerque, New Mexico. Patrick went to the University of New Mexico and soon found himself in an unfulfilling internship at Hewlett-Packard. He left the tech gig and went traveling around Southeast Asia in search of inspiration. Meanwhile, Tristan had already traveled extensively, spending time in the Republic of Georgia teaching English. The friends wound up back together in New Mexico, energized to focus their efforts on something new.

In the summer of 2016, Patrick and Tristan started setting up tent sites next door to the Taos Mesa Brewery and its "Mothership," a thousand-person music venue that's home to the yearly Music on the Mothership festival. They rented out the "camping pods" to concertgoers. In short order, Patrick and Tristan befriended Ryan, one of the Taos Mesa Brewery owners. Together, they grew a vision for creating a vintage trailer park hotel.

The small crew scoped out vintage trailers from all over New Mexico and hauled them out to the property on the mesa, starting with eight trailers. The work was intense and highly collaborative as the team painstakingly restored all they could. Much of the original décor is the same, and all the cabinets are original. "It's the little details that make the trailers so special—like the curtains my mom and I made together by hand," Patrick said.

Each trailer comes equipped with a full bathroom, mini-fridge, electric stove, French press coffee, and even central air. Most have hot showers—there is also a shower house, and a firepit for each trailer. And of course, there's the brewery and Mothership next door, serving up cold pints and hosting live music every day of the week.

"Taos is one of the most special places in the entire world. The mountains are protected reservations, and the people of this region have a deep respect for the land," Patrick said. "It's so well preserved, you can feel a spiritual energy of a sacred past in the air. You feel your life is enriched just being here."

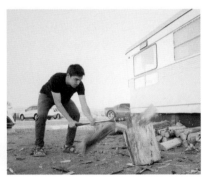
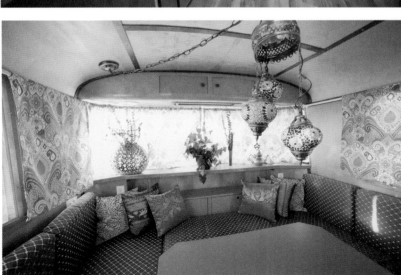

How-to
BUILD A YURT

Used as shelter for thousands of years, yurts are celebrated for their portability, ease of construction, and practicality. The structure, which originated in central Asia, is quite simple: a yurt is nothing more than a cylindrical dwelling topped with a slightly conical roof. A yurt's skeleton bears a striking resemblance to a circled, collapsible baby gate; its pantographic design allows it to be easily expanded and collapsed.

The pantograph design is commonly made from hardwoods and fasteners but can also be constructed out of galvanized pipe or, more traditionally, willow. The most common exterior cover is a heavy-duty waterproof canvas. Yurts have five main pieces: canvas, doorframe, roof ring, roof poles, and walls. While the actual work of putting the pieces together is quite simple, the precision tasks of cutting canvas to size and creating the roof ring are not for newbies.

Temporary yurt shelters start at a couple grand; permanent structures cost at least $5,000 just for the shell. As with all structures, building your own can be rewarding—but what you save in labor costs, you can easily lose in rookie mistakes.

WHAT YOU'LL NEED

- Basic tools
- Chisel and files
- Chop saw
- Drill
- Drill bits
- Drill press
- Jigsaw
- Table saw
- Router
- Sander

If you're doing everything by hand without prefab pieces, you'll need specialty tools, including an industrial sewing machine for the canvas, a mold for stretching steamed wood around to bend it, a steam box to prep the wood, and a propane burner and water container for generating the steam.

MATERIALS

Materials vary slightly depending on the kind of kit you purchase or if you build from scratch, but generally include:

- Canvas (waterproof) and thread
- Grommets (for canvas)
- Lumber (varying sizes for shell, walls, door, roof, and platform)
- Nylon string
- Rope
- Screws (galvanized)
- Wood glue
- Wooden rods

CHOOSE YOUR LOCATION

Yurts can be built with any number of add-ons, including decking (and hot tub). Make sure you scout an area with nice shade, natural light, and all the room you need for the area around the structure. Be sure there is access for a vehicle, as toting your materials and firewood will not be easy on foot.

BUILD THE PLATFORM

The platform can be poured concrete or wooden decking. Most people opt to build a permanent platform, but if you intend to take your yurt on the road you may want something that can be disassembled in pieces.

FOLLOW THE INSTRUCTIONS (OR HAVE A VERY CLEAR PLAN)

Whether you're working on a yurt by yourself, doing it with friends and family, or contracting the project out, be very clear ahead of time on what you want the finished product to look like, including where you want any room dividers or partitions to go.

First, you'll create your lattice (pantograph) with premeasured pieces of timber (2x6s [35x140 mm] are ideal). There is a huge variety of sizes, number of pieces, and cuts, so be sure to consult your instructions or plans for specifics! If you're starting from scratch, use a drill press to create holes in the pieces to connect them to form the lattice.

ADD THE AMENITIES

Year-round shelters (even in mild climates) will be more habitable with a small wood stove and (even in cold climates) a roof vent to let out trapped air and prevent mildew. Room partitions, running water, a toilet, solar power, and windows will complete a yurt that functions as a year-round home.

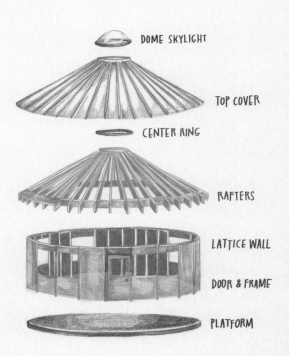

DOME SKYLIGHT

TOP COVER

CENTER RING

RAFTERS

LATTICE WALL

DOOR & FRAME

PLATFORM

How-to

BUILD A DESERT VEGETABLE GARDEN

The desert can be terribly unforgiving to nonnative plant life. Extreme temperature swings, relentless sun, and lack of water are enough to make the landscape seem inhospitable to any plant that isn't a cactus or other desert species. And yet the desert can be a wonderful place for a garden—it just requires some additional planning. With thoughtful attention to irrigation, soil, and sun, desert gardens can produce two full growing seasons of food each year and provide countless hours of rewarding outdoor activity.

Whether you're growing broccoli, celery, garlic, kale, or peas, here's how to cultivate your own desert vegetable garden.

ESTABLISH AN EAST-FACING PLOT

A desert garden needs a thoughtfully located spot that gets at least six hours of sunlight every day. Resist the urge to pick a shady location under a tree. Eastern-facing areas are best and allow for the most sun exposure throughout the winter. During the summer, it's wise to install a shade canopy so your crops don't burn. This can be as simple as tarps suspended over the beds with stakes.

MAKE DIRT

In arid lands, there's a shortage of the organic matter common in more temperate zones—like grass clippings, twigs, leaves, and other organic matter—that breaks down into nutrient-rich soil to nourish cultivated plants. Desert dirt tends to have high levels of sand, clay, gravel, and salt, so desert gardeners have to come up with their own organic additions and amendments to achieve a nourishing, moisture-retentive soil in which to successfully grow plants. Whether you make your own compost to mix in or buy bags of organic soil from a store, you'll need to add plenty of nutrient-rich soil to your growing plot. As plants grow you can continuously amend the soil with compost (food scraps, grass clippings, and even shredded newspaper can be great ways to increase water retention and add valuable nutrients to the soil). During the off-season, cover crops will help to fix nitrogen in the soil and further improve it.

BUILD RAISED BEDS

Raised beds can be a great way to contain the soil you bring into your garden and offer a bit more control over the entire process from seed to harvest. You can build your bed as long and wide as you like, or build multiple beds for different crops. The depth of the bed should be at least 12 in (30.5 cm) to allow optimal space for roots and root vegetables.

DON'T TAKE WATER FOR GRANTED

In the desert, you can't assume your plants will naturally receive water every few days or even every week. Amending the soil will help significantly with water retention when it does rain, but you will likely want to consider a rain barrel to catch and store rain from your rooftop and/or a drip irrigation system for your garden beds. Drip irrigation involves a series of hoses with holes in them that, when hooked to a main water source, slowly drip water into the soil around your plants. Spending time up front on the setup for such a system will save you the hassle of manually watering your plants throughout the growing season.

CAPITALIZE ON THE COOLER MONTHS

In the desert, the normal rules of when to grow crops can be the reverse of what you may be used to. The cooler winter months, from October through the beginning of May, are optimal for growing greens, from lettuce to Swiss chard, Brussels sprouts, and broccoli. During the winter, you won't have to water as much, and most garden pests are also dormant.

As the season heats up and your existing plants run their course, you can replace them with hot-weather crops like squash, tomatoes, corn, and peppers. Smaller-fruited varieties of plants like watermelons and tomatoes will always do better in the desert than their larger counterparts.

REAP THE BENEFITS OF DESERT PERENNIALS

While your four-season farming friends have to replant certain crops like tomatoes each spring, in the desert these plants are perennials. After they're done producing, add mulch around the base of the plant and cut it back so the plant can go dormant and save energy for the following season.

How-to
BAKE SAND BREAD

Surviving the harsh dry desert climates of the Western Sahara requires resourcefulness. In these parts, bread is sacred—bread equals life. This ancient, traditional technique was developed with no tools to work with, improvising the sand as a natural oven for baking loaves of bread.

Yield: 12 servings

BUILD A FIREPIT

Dig a shallow circular pit directly into the sand floor, just a few inches deep. Stack up a bundle of firewood over the pit and set it ablaze. While the fire burns, start working on your dough.

WHAT YOU'LL NEED

- 2 Tbsp dry yeast
- ¼ cup (60 ml) warm water
- ½ tsp sugar
- 4 cups (420 g) flour of your choosing
- 1 tsp salt
- Olive oil

PREPARING THE DOUGH

Stir the yeast into the warm water with the sugar and let it sit for about 5 minutes. Add the flour and salt and begin to knead, slowly adding more warm water if needed. Mix for about 10 minutes, then transfer the dough to a wide, shallow bowl. Coat the entire surface of the dough with olive oil and cover with a towel. Let the dough sit covered and rise for at least 30 minutes. Divide the dough into twelve medium-size balls, and knead them out into approximately 8 in (20 cm) flat discs.

HEATING THE SAND

The fire must get down to the coals, giving it enough time to heat up the sand beneath it (if you have a thermometer handy, stick it into the sand to check if it has reached at least 400°F [200°C]). When the coals from the firewood are burning red without a flame and the bread has risen after one hour, it's time to bake.

BAKING

Using a shovel, push the coals out into a circle, exposing the hot sand in the center. Place an individual piece of risen dough directly on top, and immediately cover with the hot coals. The bread should begin to bubble almost immediately. After about 8 minutes, push back the coals to expose the bread and flip it over. Quickly cover the

bread once more with the hot coals. After a total of about 15 minutes, uncover the bread. If it looks evenly charred, pull out the bread from the charcoal pit.

CLEAN AND SERVE

Use clean towels and a sharp knife to clean off the bread, removing charred edges, excess sand, and coals. Your sand-cooked desert bread is ready to be served, fresh and hot.

MAKE ESSENTIAL OILS FROM DESERT VEGETATION

Distilling essential oils from plants is not for the faint of heart. It takes specialized equipment and an extraordinarily high volume of plant matter to create oils. It can take thousands of pounds of plant material to produce just one pound of essential oils.

The most straightforward way to extract essential oils from plants is with a steam distiller. These are available for a few hundred dollars online and are simple to use. With some time spent harvesting select desert plants, a steam distiller will allow you to make a small vial of essential oil for your own use. Making a distiller at home or inverting a crock pot lid are generally inefficient approaches and will result in even lower yields—if you're going to go through the laborious process of extracting oils, it pays to invest in the right equipment. Feeling up for the challenge? Here's how to extract your own essential oils from common desert plants.

SELECT YOUR DESERT PLANTS

Common desert plants like pinyon pine, alligator juniper, rabbit brush, and desert sage are excellent choices for oil distillation and have a variety of healing qualities:

- Pinyon pine—Improves lung function, helps ward off colds; fallen pine needles and twigs can be harvested off the ground without disturbing the trees.

- Alligator juniper—Oil from the wood is anti-inflammatory and antifungal, soothes anxiety, and relaxes joints and muscles; oil from the berries can improve circulation.

- Rabbit brush—Anti-inflammatory and antimicrobial; helps to reduce muscle and menstrual cramps

- Desert sage—Pain reliever, antiseptic, aids in digestion, functions as a disinfectant, anti-inflammatory

COLLECT THE PLANTS

Until you do the work of extracting plant oil, it's hard to conceive of just how many plants it takes to make one tiny vial of essential oils. The ratio is different for every plant and fluctuates throughout the year and when the plants bloom. Suffice it to say, you will need more than you think!

PINYON PINE

ALLIGATOR JUNIPER

RABBIT BRUSH

DESERT SAGE

TRIM THE PLANTS

Use a short pair of shears to trim off stalks and stems. Chop the leaves and petals up into tiny pieces. Commercial operations use a chipper for this step.

STEAM-DISTILL THE PLANTS

Follow the instructions for your steam distiller to extract the oil, running water through the condenser and heating the flask until the water inside begins to boil. The resulting steam forces the oils from the plant matter, which are collected in the distiller's trap.

Every plant is different and dictates which steam temperatures, pressures, and times to use. If the distillation process is too hot, cold, or long for the plant you're extracting oil from, it will affect the essential oil yield and quality.

Most essential oil appears within the first 20 or 30 minutes, but a more gradual collection may continue for a couple of hours. When no more oil is being produced, turn off the heat source and allow everything to cool before pouring the oil into a vial with a screw cap.

How-to

MAKE DESERT-INSPIRED POTTERY

To make pottery is to engage in a layered process, sinking your hands into the fine grains of earth, using water and fire to form an object of art and utility with techniques that have changed very little over thousands of years.

The distinctive and enduring work of the Native American potters of the Southwestern deserts has particularly captivated modern imaginations. Marking boundaries and durations of cultural reach, many tribes embraced symbols and patterns representing religious and mythological beliefs. When you make pottery, prepare to slow down as you connect with the elements of nature.

CHOOSING THE FORM

Pottery can be made using many different techniques, materials, and tools depending on what you decide to make. If you choose to create something functional like a cup, bowl, or vase, you'll likely want to throw the clay on a potter's wheel. Or you can choose the most basic and ancient techniques of coiling or pinching to form a slab of clay into your desired shape.

SOURCING CLAY

You can choose clays that air dry and don't have to be fired, or low-fire clays that can be dried in your oven. High-fire clays, which require the high heat of a kiln, often create a more sturdy and waterproof product.

METHODS

A potter's wheel is best for creating bowls, plates, vases, or anything else you need to be perfectly symmetrical and round. It takes a lot of practice to get really skilled at throwing clay on a potter's wheel.

Pinching is fairly straightforward: Start off with a small slab of clay that you can work with in your palms. Mold it with pressure by pinching the clay into the shape you desire. The coiling technique works well to create hollow or nonsymmetrical objects with interesting textures and patterns by coiling a long, hand-rolled "snake" upon itself, then smoothing the surface and incising patterns and designs.

FIRING

If your clay requires high heat, you'll need to fire (bake) it in a kiln to for up to 12 hours in heat from 850°F (454°C) all the way up to 2000°F (1093°C), depending on the type of clay, size, and shape of your pottery. This initial firing will produce unglazed pottery; the heat removes water from the clay so the piece can be glazed without reverting to mud and breaking.

GLAZING

If you choose to decorate your pottery, you'll paint it with glaze at this stage. Glazing takes a number of forms—you can dip, brush, sponge, or etch, for starters. If there are rough surfaces or edges on a piece, sand or chisel them smooth before glazing.

SEALING

Finally, return your glazed pottery to the kiln for a second firing to seal it off. The final firing may have dramatic effects on the glaze, making the appearance of your final product pop and shine.

ACKNOWLEDGMENTS

FREDERICK PIKOVSKY:

Thank you to everyone who opened their homes to me, sharing a meal, their knowledge, and most of all their stories for this book. Thank you to Jenny Herrera and the David Black Agency, Rachel Hiles, Sara Schneider, and the Chronicle Books team. Big thanks to Nicole Caldwell for her passion and dedication to this book, and thanks to Tim Tedesco, Julie Murrell and the Hipcamp community, Main Street Farm in Livingston Manor, Chris Platis, Jasmin Jean, and Meghan Caracci.

NICOLE CALDWELL:

The world is a better place for the rugged individualism and intrepid sense of exploration possessed by the folks featured in this book. In an era of political, economic, and environmental insecurity, they dared to think differently and find creative, inspired solutions to many of the negative effects of modern society. I am deeply indebted to each of them for trusting me with their stories, for their honesty and candor, and for their commitment to living more in tune with the natural world—oftentimes at great risk, and many times with great reward.

Many thanks to our friends at Chronicle Books for believing in giving a platform to these stories, to Jenny Herrera for finding a home for this project, and to Frederick Pikovsky for choosing me as your partner for this book.

And most especially, thank you to my husband David Magbee for all the late nights, for being my sounding board, and for unflinchingly encouraging me in all I do.

IMAGE CREDITS

PAGE 2: Top row middle: Jeffrey Waldman | @jeffreywaldman; Second row right: Indy Srinath; Third row right: Steffanie Pui | @stefflovephotography; Bottom row right: Lawrence Braun | @lawrence_braun; Others: Frederick Pikovsky | @farmandland

PAGES 4-14: Frederick Pikovsky | @farmandland

PAGES 16-17: Left: Peter Crosby | @pbcrosby; Right: Frederick Pikovsky | @farmandland

PAGE 19: Top: Frederick Pikovsky | @farmandland; Bottom: Peter Crosby | @pbcrosby

PAGES 20-21: Frederick Pikovsky | @farmandland

PAGES 22: Top right: Frederick Pikovsky | @farmandland; Others: Peter Crosby | @pbcrosby

PAGES 24-25: Frederick Pikovsky | @farmandland

PAGES 26-27: Peter Crosby | @pbcrosby

PAGE 29: Peter Crosby | @pbcrosby

PAGE 31: Top right and bottom: Peter Crosby | @pbcrosby; Top left: Frederick Pikovsky | @farmandland

PAGES 32-43: Zac Ruiz | @denforourcubs

PAGES 44: Nate Burrows | @appalachianofferings

PAGES 45-47: Indy Srinath

PAGES 48-49: Danny Osterweil | dannyosterweil.com

PAGES 50-51: Frederick Pikovsky | @farmandland

PAGES 52-53: Danny Osterweil | dannyosterweil.com

PAGE 55: Top left: Frederick Pikovsky | @farmandland; Top right: Danny Osterweil | dannyosterweil.com; Bottom left: Alison Cantor; Bottom right: Daniel Saxe

PAGE 56: Top: Jeffrey Waldman | @jeffreywaldman; Others: Frederick Pikovsky | @farmandland

PAGE 57-59: Jeffrey Waldman | @jeffreywaldman

PAGE 60: Chris Danielle | @dirtandglass

PAGE 61: Top left: Chris Danielle | @dirtandglass; Others: Frederick Pikovsky | @farmandland

PAGES 63-64: Frederick Pikovsky | @farmandland

PAGE 65: Top: Chris Danielle | @dirtandglass; Bottom: Frederick Pikovsky | @farmandland

PAGES 66-67: Left: Getaway | getaway.house; Top right: Frederick Pikovsky | @farmandland; Bottom right: Getaway | getaway.house

PAGES 68-69: Getaway | getaway.house

PAGE 71: Bottom left: Frederick Pikovsky | @farmandland; Others: Getaway | getaway.house

PAGES 72-73: Frederick Pikovsky | @farmandland

PAGES 74: Bottom right: Alissa Kolom| @alikolphoto; Others: Frederick Pikovsky | @farmandland

PAGES 76-81: Ellie Lillstrom | ellie-lillstrom.com

PAGES 82-83: Contributed by Olson Kundig | olsonkundig.com; Left: Tim Bies; Right: Derek Pirozzi

PAGE 85: Top row: Tim Bies; Bottom: Contributed by Olson Kundig | olsonkundig.com

PAGES 86-91: Frederick Pikovsky | @farmandland

PAGES 103: Chris Danielle | @dirtandglass; Frederick Pikovsky | @farmandland

PAGES 107: Top: Frederick Pikovsky | @farmandland; Bottom: Jeffrey Waldman | @jeffreywaldman

PAGES 108-10: Frederick Pikovsky | @farmandland

PAGES 112-17: Steffanie Pui | @stefflovephotography

PAGES 118-19: Left: Frederick Pikovsky | @farmandland; Right: Brooke Fitts | brookefitts.photo

PAGE 121: Left: Brooke Fitts | brookefitts.photo; Right: Frederick Pikovsky | @farmandland

PAGES 122-25: Frederick Pikovsky | @farmandland

IMAGE CREDITS

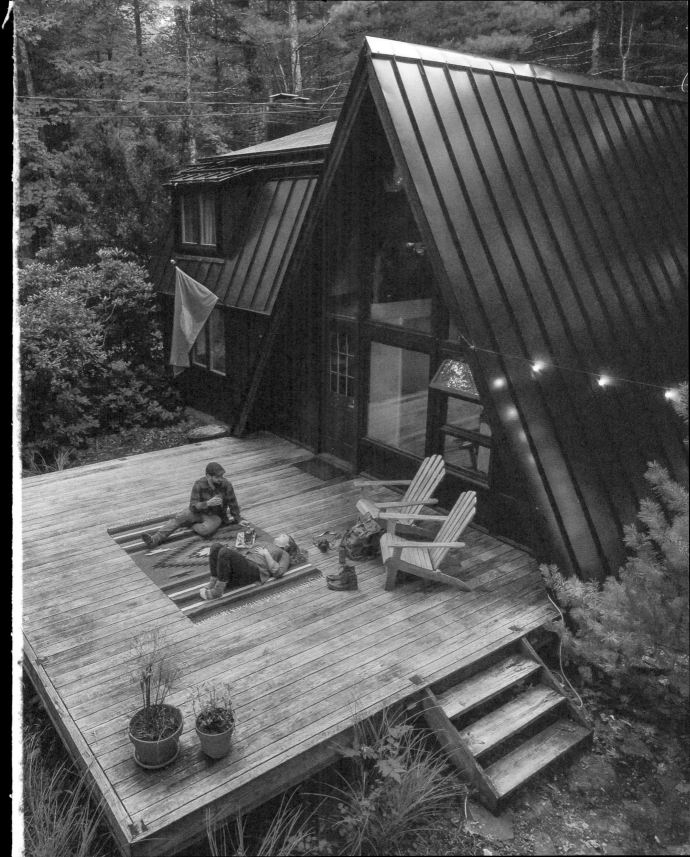

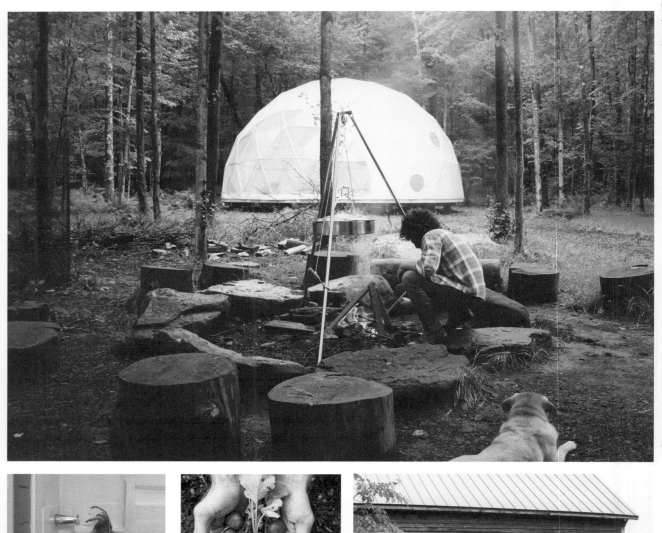

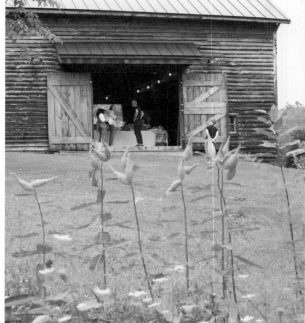